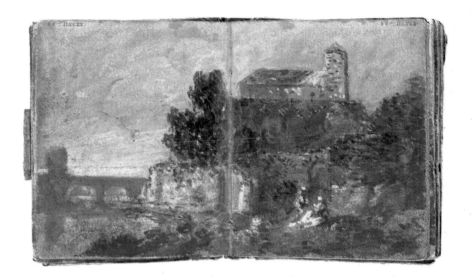

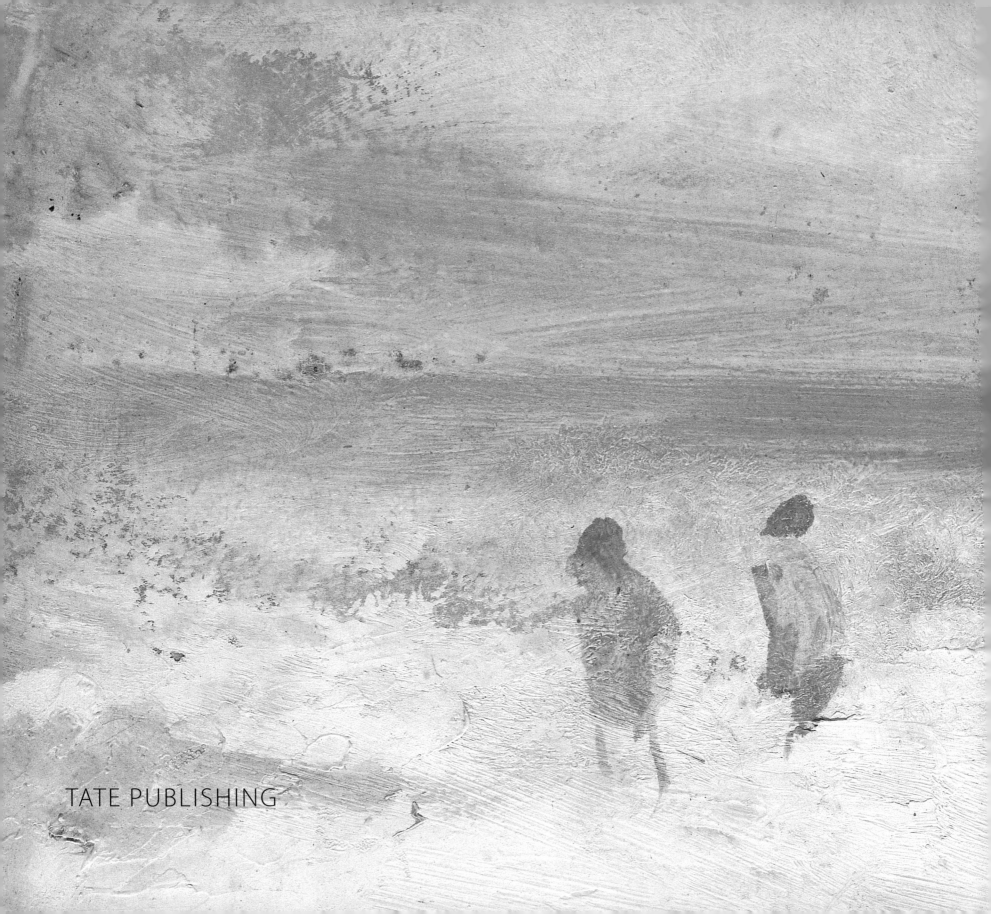

TATE PUBLISHING

Turner

IN THE TATE COLLECTION

David Blayney Brown

Front cover NORHAM CASTLE, SUNRISE *c.*1845–50 (no.125, detail)
Back cover From the *Lake of Zug and Goldau* sketchbook 1842
SWISS TOWNS (no.113)
Half title From the *Wilson* sketchbook 1796–7
THE CONVENT ON THE ROCK, after Richard Wilson (no.13)
Title page TWO FIGURES ON A BEACH WITH BOAT *c.*1840–5
(no.120, detail)

First published 2002 by order of the Tate Trustees by Tate Publishing,
a division of Tate Enterprises Ltd, Millbank, London SW1P 4RG
www.tate.org.uk/publishing
Reprinted 2004, 2005

© Tate 2002

The moral rights of the author have been asserted

A catalogue record for this book is available from the British Library

ISBN 1 85437 356 0 (pbk)
ISBN 1 85437 420 6 (hbk)

Distributed in North and South America by Harry N. Abrams, Inc.,
New York, under the following ISBN:
ISBN 0-8109-6253-5 (hbk)

Library of Congress Control Number applied for

Designed by Sarah Praill

Printed by Conti Tipocolor, Italy

Contents

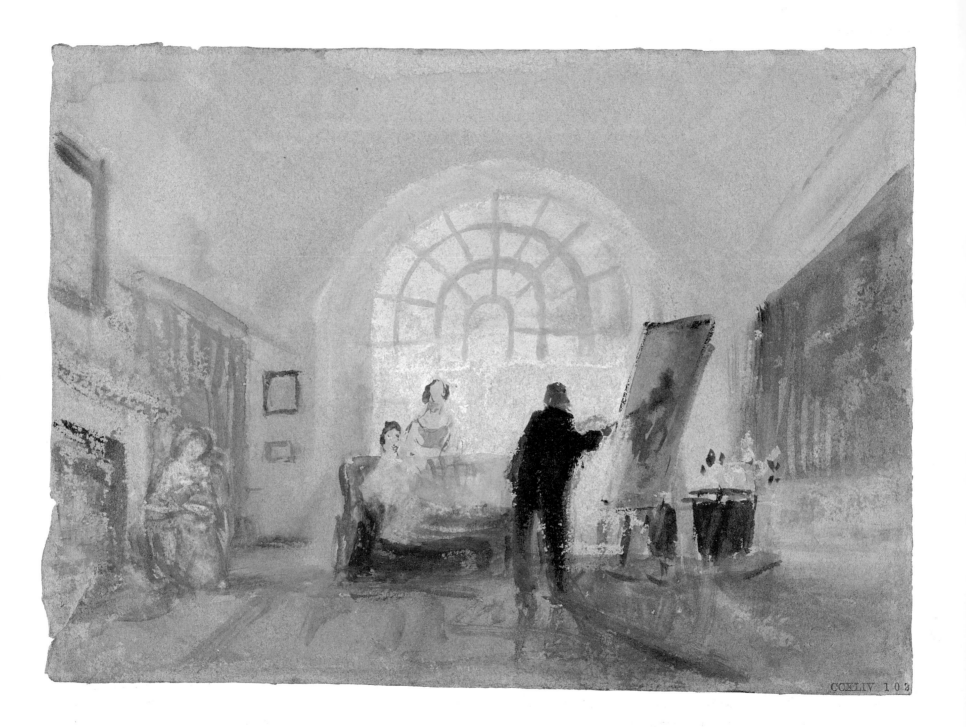

Foreword

Tate posseses the largest collection in the world of the work of J.M.W. Turner. At its heart is the Turner Bequest, the vast array of paintings and works on paper received by the nation in 1856, five years after the artist's death. The title of this collection is really a misnomer, since it was far larger than Turner himself had intended to leave. His own wishes had been to bequeath only some hundred finished pictures, which he had retained in his own possession, as a memorial gallery in his name, ideally in the National Gallery. Funds for its construction were evidently to come from the proceeds of the sale of his other property and the realisation of his investments. He made no specific provisions for the other contents of his studio, nor allowance for his relatives. The eventual scope of the 'Bequest', including all his unfinished sketches and works in progress, and around 19,000 works on paper – drawings, watercolours and sketchbooks – was decided by a Decree of the Court of Chancery in 1856. This was the final outcome of protracted litigation after his family had sued his executors for his money, exploiting technical flaws in his will and claiming he had been of unsound mind when he made it. It is an untidy story whose consequences remain controversial to this day, but it did at least ensure that the work of this complex painter was preserved in extraordinary quantity and depth, across a range of media, from works in progress to some of the most famous of his exhibited pictures. The Bequest is a unique resource.

Today it is mostly housed in the Clore Gallery at Tate Britain. Designed by the late James Stirling and constructed with funds from the Clore Foundation, this opened in 1987 with the object of bringing together the vast majority of Turner's oils and the works on paper from the Bequest which, for many years, had been in the Print Room of the British Museum. The Tate Gallery's association with the Bequest – a natural development from its role as the National Gallery's branch devoted to British art – began in 1905, when a group of twenty-one previously unexhibited oils was shown at Millbank. For the previous half-century, the Bequest had commuted between Marlborough House, the new South Kensington Museum (now the Victoria and Albert) and the National Gallery, and had been seen only in very small and selective instalments. The 1905 display generated public demand for a real Turner Gallery, and a donation from the art dealer Joseph Duveen enabled the Tate to construct a suite of rooms which opened in 1910. The Duveen Galleries remained for many years Turner's main home in London, though a small group of oils always hung, as it does today, in the National Gallery, and the works on paper were removed to the British Museum after a Thames flood in 1928. Public pressure to reunite the collection grew once more when the Royal Academy mounted a great exhibition for Turner's bicentenary in 1974. The Clore Gallery represented a sincere attempt to meet it, and to honour the wishes of Turner himself. It continues to do so.

Some things have changed since 1987. There have been modifications to the Clore Gallery itself, and the Tate Gallery's metamorphosis into Tate Britain has altered, or rather brought closer, the relationship of Turner to the rest of the collections. During its first decade, the main displays of pictures in the Clore remained relatively fixed. In future, displays are likely to change more often. This has led us, in preparing this book, to reject the formula of a room-to-room guide used for earlier books on Turner and the Clore. Instead, we have aimed to offer a glimpse into the richness and diversity of the collections themselves; to reflect some of the new scholarship that the Clore has stimulated so far; and finally to mark the other great change since 1987 – the growth of the Turner collection itself. Rich as we are in Turner, acquisitions of his work can rarely be an absolute priority. But we have been able to add exceptional works like the watercolours of *The Siege of Seringapatam* (no.21) and *The Temple of Minerva Sunius, Cape Colonna* (no.95), and we are well on the way to meeting our objective of stocking the Clore print room with an impression of every print issued by or after Turner. The works in this book have been chosen with all these aims in mind, and they have been grouped to tell at least something of the story of this greatest of British artists.

Left PETWORTH: THE ARTIST AND HIS ADMIRERS 1827 (no.79)

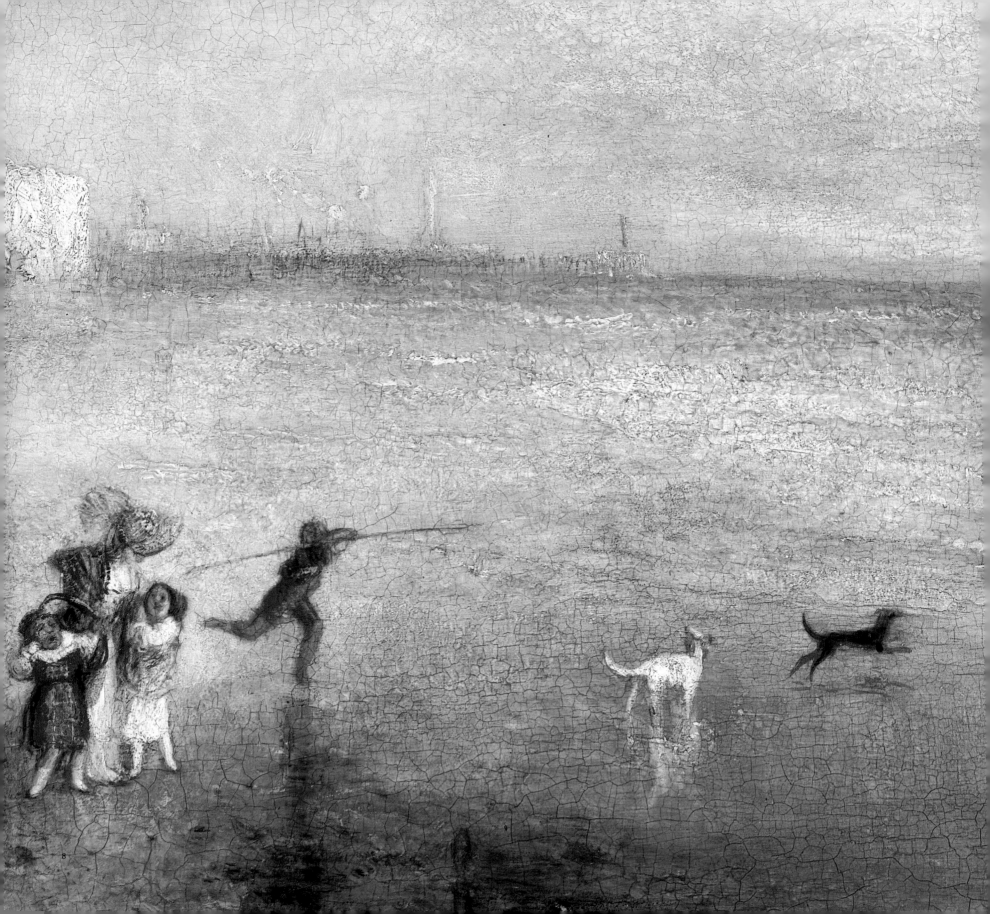

Introduction

David Blayney Brown

'Introduced today to the man who beyond all doubt is the greatest of the age; greatest in every faculty of the imagination, in every branch of scenic knowledge; at once the painter and poet of the day.'[1]

With these words, the young John Ruskin recorded his first meeting with Turner in June 1840.[1] He was already at work on *Modern Painters,* the book that would be his first and finest explanation of Turner's greatness, as he saw it, to a sceptical or forgetful age. His own passionate admiration for Turner had always been defensive, sparked originally by a hostile and insensitive review in 1836. By this time Turner had as many critics as admirers. The patrons and collectors who had supported his rise to fame had mostly died, and his later work was often ridiculed. He was still the most celebrated painter in London, with a huge reputation abroad. But even among sympathetic people, as he sipped his glass of wine at his club, the Athenaeum, took tea with his remaining patrons, or appeared at the Royal Academy, he had more the status of a living Old Master than of an artist of vital, contemporary relevance.

It would have amazed even Turner's friends that he would come to be regarded as a founding father of Modernism, for, by the 1830s and 1840s, his work – at least that part of it that was shown to the public – often seemed positively old-fashioned; and when it was not, it so far transcended all conventional ideas of what a picture should be that It defied analysis and seemed the whim of one eccentric old man. The still more remarkable things that Turner was painting in the privacy of his studio and in which Tate's collection is uniquely rich – sunsets, storms, visions of almost pure light in which the energies of the natural world seem to spring from the energy of the paint itself – were even harder to assimilate. Turner showed them only to a very few people and his intentions for them can never be fully known; it is tempting to see them as the logical conclusion of his art, his most personal statements painted for later generations who he sensed might understand them better than his own, but equally they could be *jeux d'esprit* never Intended for the public gaze.

Whether or not Turner was really an ancestor of the Impressionists, Abstraction or Abstract Expressionism has been endlessly debated, and doubtless there are art forms still in the future for which his authority will be similarly claimed. Helpful or not, such

Left THE NEW MOON, OR 'I'VE LOST MY BOAT, YOU SHAN'T HAVE YOUR HOOP' 1840 (no.105, detail)

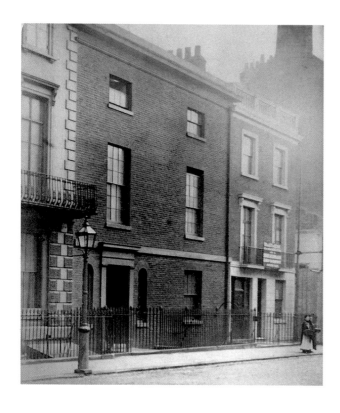

fig 1 Photograph of Turner's house
in Queen Anne Street West
Private Collection

Opposite
fig 2 A small wooden box holding four
glass bottles of paint thinners and
vehicles: one is labelled 'Acetate of
morphia', which does not appear to have
been used in painting

interpretations are likely to persist, and they stand in a paradoxical relationship to the very traditional, historicising nature of other aspects of Turner's work, and the scholarship it has inspired. Paradoxes – personal, professional, critical – abound with Turner. From poor beginnings he achieved wealth, but, in old age at least, lived in comparative squalor. Though famous, and keen to put on a display before his colleagues, he also cultivated anonymity and mystery, sometimes concealing his address or living under assumed names. Fascinated by all that was new in art or science, he was also deeply conservative. As a painter, he looked both backwards and forwards. He was apt to send pictures of the most archaic and the most up-to-date subjects to the same exhibition, or to combine in a single canvas a conventional theme and a uniquely original technique.

There can be little doubt that Turner took pleasure in these contrasts. He was fond of pairing pictures of opposing themes or appearance – ancient and modern, pale and dark – whose imagery enhanced each other. They were, in part, his response to a time of rapid and disturbing changes in Britain and the wider world. His formal studies began in the year of the French Revolution; his career prospered against the dangerous background of the Napoleonic War; and he died in the year of the Great Exhibition in which his country celebrated its hard-won industrial and imperial hegemony. Throughout, with his landscape painter's eye, he had witnessed Britain transform herself, both for good and ill, from a rural to an industrial and urban society. The observant artist could not fail to be struck by the diversities around him. But Turner's sheer range of achievement ensured that there could be no narrow consistency in his work. His output – oils, watercolours, prints, poetry – never ceases to amaze; nor do his many interests and subjects – history from ancient to modern, landscape from the ideal to the naturalistic in Britain and as far afield as possible in continental Europe, marine, literary illustration, or images of modern life that lay outside the established categories of art but were instantly definitive. It can never be easy to reconcile the painter of the early, mythological *Jason* (no.26) with that of the late *Snow Storm – Steam-Boat off a Harbour-Mouth* ... (no.106), for they seem separated by more than just the passage of forty years. Yet, there are links that will help us to make sense of Turner's purposes. Though their imagery and technique are worlds apart, each is about a man's aspirations, and the dark or wild forces of the natural world around him. Turner saw himself above all as a landscape painter dealing with just these fundamental themes, and the many aspects of his art are often more cohesive than first appears.

Different generations have seen different Turners – and in a very literal sense, for different sorts of pictures have been available to them. Turner's work will always provide materials for a wide range of interpretations. But, at least until the Turner Bequest was conserved and proper study facilities provided, these interpretations depended on which aspects of the work were put on display, and the choices made inevitably reflected prevailing tastes. At first mainly the

finished pictures were hung, though Ruskin, who took on much of the responsibility for arranging the Bequest, put on rotating exhibitions of a wide variety of the drawings and watercolours. Monet, visiting London, would base his assessment of Turner's naturalism on a picture like *Frosty Morning* (no.58), rather than on the more dazzling late studio sketches like *Rough Sea* (no.107), let alone the fantastical *Sunrise with Sea Monsters* (no.118). Yet Impressionism itself would lead to a fresh appraisal of these more private and personal works, and as the art-historical arguments for the development of Modernism took shape, Turner's vibrant colour and dynamic handling of paint came to be seen as vital steps in that direction, to be celebrated regardless of whether or not the artist himself ever expected them to be seen. More recently, there has been a reaction against the picture of Turner as a proto-Modernist, and a move to present him less as an ancestor of new art forms than as the heir to the larger European tradition – as an artist who inherited the language of the Old Masters, was immersed in history and literature, and mainly worked within the grain of the academic values he learned as a young man. Each of these views has its value, and although many modern studies of Turner tend to focus on self-contained areas of his art – for example, his literary illustrations or his tours in particular countries or regions – larger attempts to understand him in the round must take account of both.

Thus, this book brings together both finished pictures, including some of the very grandest that Turner ever exhibited, and sketches, studies and unfinished canvases with which he experimented in the privacy of his studio. To show only his finished works would be to deny the irrepressible energy and curiosity that bubbles up in his sketches and drives his art forward. At the same time, his drawings and watercolours – once again finished and otherwise – are given their due prominence and integrated into the sequence. Turner was a draughtsman before he was a painter, and matured into the greatest master of the watercolour medium, by every reasonable standard, that the world has known. The relationship between his use of watercolour and oil, though it changed profoundly in the course of his career, was always close and constructive. Prints are also included, for not only was Turner a skilful printmaker himself, he also regarded the many prints issued after his work – whose preparation he closely supervised – as highly as the original designs he made for them.

EARLY YEARS: WATERCOLOUR TOPOGRAPHY

Joseph Mallord William Turner was born in London on 23 April 1775, the son of a barber of Maiden Lane, Covent Garden. He grew up mainly in the middle of the city, with brief visits to

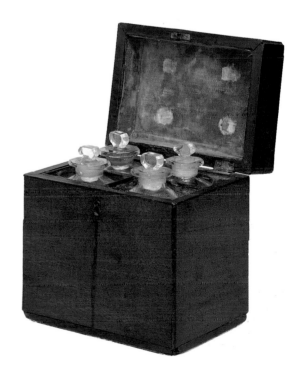

fig 3 A travelling watercolour case,
apparently improvised by Turner himself
from the cover of an almanac

fig 4 Turner's Chelsea palette for oil
painting c.1851

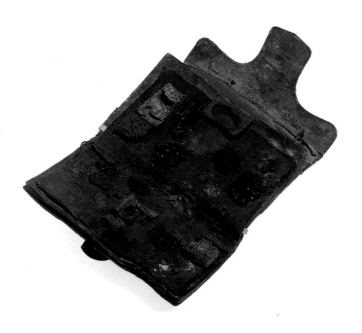

relatives in the south of England – probably occasioned by his mother's mental problems which, in 1800, required her admission to Bethlem Hospital, where she died in 1804. Many of Turner's adult characteristics – obsession with his privacy, a failure to form a conventional family, restless attachment to travel, and devotion to his work above everything – might be traced to his early experiences at home. However, his father provided stability and encouraged his early artistic efforts. He hung up drawings for sale in his shop and introduced him to customers who could be helpful, of whom there must have been plenty for Covent Garden had long been an artists' area, and the Royal Academy, the main art school and exhibition centre, lay but a short walk away at Somerset House between the Strand and the Thames. Through his father or other relatives Turner got a job making drawings for the neo-classical architect Thomas Hardwick. He proved adept at the work, and might have become an architect himself. Instead, he moved to the studio of a leading topographical draughtsman, Thomas Malton, who specialised in London views. This was in 1789, the year he also entered the Royal Academy Schools; he was then fourteen.

Although the Academy was the nation's only real school of painters, its teaching consisted mainly of drawing and the students learned more of what might be expected of them than how, in practice, they might achieve it. The Academy's President, Sir Joshua Reynolds, gave annual 'discourses' in which he extolled the hierarchical values he had imported from the older academies of Europe. Young artists were taught to take a very serious view of their chosen profession, and morally inspiring subjects from history, mythology or literature realised in the manner of the masters – which Reynolds called the 'Grand Style' – were held up as the highest forms of art. Others, such as portraiture, landscape and marine, which actually dominated the Academy's own annual exhibitions, were less esteemed, and little practical instruction was given in any of these fields, so that by the end of the century it was recognised that the Academy was in urgent need of reform. Turner was far from being a reluctant or rebellious student – indeed he seems to have been a model one – but it would be several years before he felt ready to tackle painting in oil, and his main activities in the first years of his training continued to be in the field of topographical drawing, in which he could develop independently.

Topography was then a thriving industry, and it made financial sense for a young artist needing to fund himself through his studies. A middle-class fashion for sight-seeing, and antiquarian and local historical studies, was gaining greater impetus as the revolutionary wars cut off the continent and confined the British to their own islands. A network of artists, engravers, publishers and print-sellers had grown up in London to serve a booming market, and the concentration of specialists had created a corporate style. A young artist could easily learn the basic tricks of the trade, and could also gain advantage by refinements of his own.

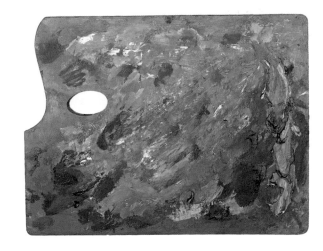

This was Turner's way. In drawing and watercolour, as later in oil, he learned through a regime of study and copying. It is astonishing that the magical late watercolours of Venice and the Swiss lakes – so luminous and subtle in their rendering of mist or cloud, moonlight or sunshine – could spring from the same hand as began its work colouring or copying outline prints of English abbeys and castles of a routinely descriptive kind. But such mastery could only be built on solid foundations, and the challenge of making such repetitive work interesting, and the results attractive, was real enough for a boy in his early teens. From mere colouring it was a logical step to embellishing views with lively groups of figures, decorative or naturalistic trees, and varied effects of weather or light; and in time such work fostered not only technical skill, but appreciation of the qualities of landscape itself.

By the mid-1790s, Turner, with his friend and contemporary Thomas Girtin, was among a group of young artists who met in the evenings at the London house of Dr Thomas Monro, a surgeon, collector and amateur artist. Here they were able to examine and copy work by the leading topographical draughtsmen of the day, one making outlines, another washing in the colour. Much of Turner's skill in the current styles of drawing was learned here. But Monro's house also contained special treasures, watercolours by a far greater master, John Robert Cozens, which transcended the precise and neat descriptions of topography and offered instead grand, generalised views of Italy and the Alps, realised in the painter's unique palette of greys, blues and purples. They were an early revelation of the expressive, emotive power of landscape, and of the potential of the watercolour medium itself when allowed to convey mood rather than mere information.

Cozens's lessons of tonal control, noble simplification and, above all, of sensitivity to atmosphere were to gain in relevance as Turner developed his topographical career; he was determined to produce works that were more than just views in the usual idiom of the period, and in the later 1790s his watercolours grew in size and grandeur, and – especially in large subjects worked up from tours in Wales at the end of the decade – in splendour of effect. The antiquarian and historical bias of the time made him alert to the memories and associations implicit in particular places – aspects that he would always exploit in his views. Combined with increasingly dramatic treatment of weather and light, and with his rapid advances of technical skill, and deployed on an increasingly large scale, they marked him out as exceptional in his generation. Exceptional also were the sheer energy and dedication he brought to his work, travelling frequently and far afield in search of material. By the later 1790s the pattern of much of his working life was already established; touring in the summer months, collecting information and filling sketchbooks, and working up the finished products of his expeditions at home in the winter. Though in later years nobody would have dreamed of calling Turner a topographical draughtsman, the habits of these

early years remained with him; only his summer tours might be to the Rhine, Rome or Switzerland, and the work of his London winters Academy pictures in which landscape was combined with a wealth of other impressions and reflections.

EARLY PATRONS AND THE OLD MASTERS

Though Turner excelled at watercolour topography, it is hard to believe he did not always yearn to do more. He signalled his determination not to be restricted to topography by choosing a marine subject for his first exhibited oil, *Fishermen at Sea* (no.8), in 1796. This was based in part on a trip to the Isle of Wight the previous year, and also on the work of a continental artist then working in London, P.J. de Loutherbourg. Turner had been taking some instruction in oil painting from Loutherbourg and, through him, had come to terms with the European tradition of sea painting stretching back to the Dutch seventeenth century. Colleagues like this could widen his horizons, and so too could the patrons who were buying and commissioning his watercolours.

These now included some of the most important collectors of the time. Despite (or perhaps because of) his very different background, and refusal to appear as anything other than himself, Turner always exerted a special appeal to a certain type of aristocratic or gentleman-patron. Men like Walter Fawkes, or the Earl of Egremont, not only valued his talent, but accepted him on his own terms as a real friend; houses like Fawkes's Farnley Hall (no.56) or Egremont's Petworth (nos.79, 80) were to be homes from home. Such close and understanding friendships as were to develop with these patrons are rare enough in the history of British art and still less common in much of Continental Europe, where artists were often more socially separated from their patrons – though, as a contemporary parallel, one thinks of the encouraging influence enlightened Spanish aristocrats had over the young (and also humbly born) Goya.

While increasing artists' professional status, the foundation of the Royal Academy had in fact tended to diminish their financial security. With no established tradition of official patronage from State, Crown or Church, artists now mostly painted their pictures to sell in the annual exhibitions, and private commissions became even rarer. Turner soon learned how important it was to make his pictures stand out in the crowded Academy shows, and was rewarded with purchases by the leading collectors. Many of them entertained him, and contributed greatly to his education. At houses like Stourhead, the Wiltshire estate of Sir Richard Colt Hoare (no.18), and Fonthill, that of William Beckford (no.17), Turner could see not only superb parkland landscapes, but important collections of Old Masters and other mementoes of Italy and the Grand Tour.

It was at Stourhead, in about 1798, that Hoare encouraged him to paint his first historical composition, set in a landscape in imitation of Claude, who for the rest of his life would be the Old Master who spoke most clearly to Turner; his last exhibits at the Royal Academy would be Claudean canvases telling the story of Dido and Aeneas (no.123) – distant echoes, perhaps, of his formative visits to Stourhead, where Hoare's father had laid out the gardens, with the superb assurance of the eighteenth century, as a realisation of Aeneas's journey to found Rome and a paradigm for the founding of his own banking dynasty.

At Fonthill, then being rebuilt as a vast Gothic 'abbey' by the architect James Wyatt (for whom Turner had already made drawings), Turner found an even more generous patron, ready not only to purchase his watercolours, but also to support his new ambitions as an oil painter. Beckford bought his *Battle of the Nile* (Royal Academy 1799; whereabouts unknown), and his *Fifth Plague of Egypt* (Royal Academy 1800; Indianapolis Museum of Art), his first great exercise in the historic Sublime.

It was in Beckford's London house, in 1799, that Turner was able to make his first extended study of Claude, in the two large pictures by the master that Beckford had just acquired from the Altieri palace in Rome. They made him 'both pleased and unhappy, because they seemed beyond the power of imitation'.[2] At the house of another important collector, John Julius Angerstein, whose pictures were later to form part of the nucleus of the National Gallery, similar feelings drove him to tears before another Claude. But such frustration was doubtless exaggerated. It was by openly taking up the challenge of the Old Masters, and even trying to excel them, that Turner was now to make much of his reputation as an oil painter. This was shrewd, for he could at once present himself as a modern British rival to earlier Continental painters – a claim not without patriotic overtones in time of war – and broaden his appeal to the major collectors. The wealthy and aristocratic in Britain had always preferred Old Masters to living artists when it came to buying 'serious' pictures, and now they had unrivalled opportunities as vast quantities of pictures from Continental Europe came onto the London art market in the wake of the French Revolution. Far from protesting at the competition, as earlier British painters like William Hogarth had done, Turner accepted it and worked with it, deliberately producing pictures that could hang in company with the Old Masters. In this he was encouraged by the collectors themselves. For the Duke of Bridgewater's magnificent picture gallery, he was commissioned to paint a companion for a stormy seascape by Willem van de Velde, recently acquired in a London sale; and the result was one of the very finest of his early marines, actually outdoing its source in size and dramatic effect. Turner was indeed fortunate to live in a time when British collectors were beginning to extend their interests to living artists, but it is debatable whether he was merely the beneficiary of this change, or whether his own emergence as an outstanding newcomer who could match or even outstrip previous masters itself created it.

Turner's most splendid pictures in the styles of former artists – ranging from Claude and Poussin to Titian and Salvator Rosa, Rembrandt or Ruysdael – were painted after 1802. That year, during the brief Piece of Amiens, Turner was able to visit the Louvre and travel across France to the Alps. This trip, his first outside Britain, was supported by a small consortium of patrons including the Earl of Yarborough, and it was Yarborough who bought a very grand view of *Macon*, exhibited the next year, in which Turner cast the winding Saône valley as an ideal Claudean panorama. In fact Turner had not paid too much attention to Claude in the Louvre, preferring, as we know from Tate's sketchbook of his Louvre observations, to concentrate on other masters less accessible in London, like Poussin whose Louvre *Déluge* would be the starting point for his own, in 1805 (no.33).

Men like Yarborough would have understood the benefits that Turner needed to draw from his trip to the Continent. Aside from their own private galleries and the London salerooms, Britain as yet possessed no public collection like Napoleon's Louvre. Artists needed to study their great predecessors, and Turner more than most. But he had also been eager to explore new landscape territory. His tours in Wales and Scotland (nos.14–18, 22–3) had given him an appetite for the wilder, grander forms of nature – mountains, waterfalls, lakes – which ultimately, in Europe, could only be matched by the Alps (late in life, he yearned to see the Niagara Falls). For all his determination to follow in the footsteps of the masters, he was committed to landscape first. His sensitivity to natural effects had been evident from the outset in the slow, heaving swell and silvery moonlight of *Fishermen at Sea* (no.8), and he had gone on to explore transient phenomena of weather and time not only in oil, but in watercolours of increasing size and splendour. He was determined to prove that the changing manifestations of the natural world were as compelling and instructive as any human drama – and indeed more so than the myths and allegories of the history painters, for they exert their own control for good or ill over human life. Already, he sensed that landscape was capable of the most profound messages, but he needed to experience it in its most extreme form. He was a natural convert to the late eighteenth-century theory of the Sublime, which claimed the highest seriousness for the arts, and favoured for its subjects places or experiences that inspired the most intense or spine-tingling reactions. So, in 1802, Switzerland and Savoy took precedence even over the Louvre; he hurried to the Alps first, and looked at pictures in Paris on the way back.

Short as the trip was, it was one of the two great turning-points of his artistic life – the other being his first tour to Italy in 1819. While the main lesson of Italy was to be colouristic, that of the Alps was conceptual. He was confronted with nature in its bleakest forms: the

mountain landscape lent itself to grand generalisation, as John Robert Cozens had realised before him, and the rapid maturing of his pictorial imagination can be traced almost day by day in the many drawings he made on the tour; so too can the development of his techniques as he responded to new and challenging subjects. In all he made nearly 400 drawings, sketches and watercolours to provide the basis for finished and commissioned work on his return; they were bound and labelled to show prospective clients. In due course a series of subjects was selected for realisation in finished watercolours, by patrons including Walter Fawkes, and in 1803 Turner sent a group of exhibits to the Royal Academy based on various aspects of his tour. Many artists had crossed the Channel during the peace, but Turner was setting out his stall as the one who had most profited by the experience, learning the lessons both of Alpine nature and of art in the Louvre. Besides the Claudean *Mâcon* he showed his large stormy marine, *Calais Pier* (London, National Gallery; fig.5), combining memories of his stormy arrival in France with knowledge of Ruysdael in Paris; oils in the manner of Poussin and Titian; and two large Swiss watercolours of the kind he hoped to produce on commission.

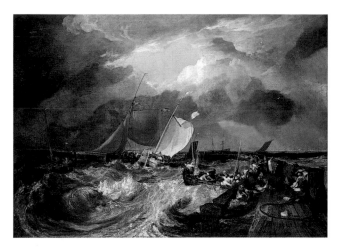

fig 5 CALAIS PIER 1803
Oil on canvas
17.2 x 24
National Gallery, London

The 1802 tour gave Turner material to draw upon for years to come, and amply confirmed that landscape was compatible with the highest aspirations of art. In 1809, a young painter, Benjamin Robert Haydon – who had taken all too literally the Academy's teachings about the superiority of history painting in the Grand Style – made his debut with a cumbersome picture of a Roman hero ambushed in a mountain pass by assassins about to crush him with a rock. The picture was controversial and much discussed in the London art world, but it was overwrought and in many ways absurd, the last gasp of an art that was itself dying. The following year, Turner showed his *Fall of an Avalanche in the Grisons* (no.51), in which a huge stone falls on an Alpine chalet. Though Turner may have heard of a lethal avalanche at Selva in the Grisons in 1808, it is hard to believe that this extraordinarily modern image of a falling rock, without a single human figure but suggestive nevertheless of the power of nature over human destiny, was not in some sense a rebuke to Haydon and all he represented with his failed picture of the forgotten rivalries of ancient Rome. Turner must also have had in mind a well-known composition of an avalanche by his early mentor Loutherbourg (fig.6), and he evidently intended to create such a scene in his own more dynamic and expressive style; but compared to Haydon's historical work, his picture provided a striking demonstration of the potential of landscape as a 'Grand Style' in its own right. Turner's Swiss memories, combined with his experience of a blizzard while staying with Fawkes at Farnley, contributed to an even more impressive effect in his *Snow Storm: Hannibal and his Army crossing the Alps*, exhibited in 1812 (no. 52). This time the subject was historical, but the work does not fit as comfortably as many of Turner's recent pictures into

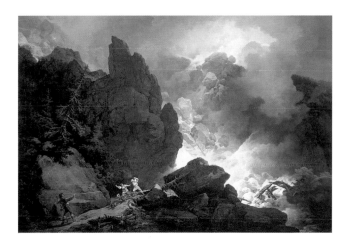

fig 6 Philip James de Loutherbourg
AN AVALANCHE IN THE ALPS 1803
Oil on canvas
109.9 x 160 (43 1/4 x 57 1/2)

the recognised category of historic landscape; the figures are diminutive, Hannibal himself is hardly discernible if at all, and it is the snow whirling through the mountain pass and obscuring the sun that commands attention and proclaims the army's defeat inevitable. Contemporary observers were unequivocal in describing the picture as a landscape – the finest, one said, that he had ever seen.

BRITISH SUBJECTS: LANDSCAPES AND MARINES

The extraordinary success of *Snow Storm* was certainly justified, but it also reflected the immense prestige that Turner now enjoyed. Another dimension of its popular appeal was that in demonstrating the failure of Hannibal's invading force, and the futility of his ambitions, it provided a historical precedent for the eventual defeat of Napoleon. Later in 1812 Napoleon's army would retreat from Moscow, itself the victim of appalling weather, and parallels between Napoleon and Hannibal were often drawn at the time by both the French and British. In painting this subject in the way he did, Turner took up what might be described as a sense of national responsibility, to reflect upon his country's hopes and fears, condition and prospects. He did so, also, in important pictures of events in the war – *The Battle of Trafalgar* (no.34) or the arrival of captured ships (no.36) – and, in a more modest way, in pictures of British landscapes and of the Thames valley from its pastoral beginnings west of London to the mouth of the estuary (nos.39, 42, 43). These were smaller and more intimate in feeling than the grand canvases intended to make an impact at the Royal Academy; and they were mainly shown in the private gallery that Turner built at his town house in Harley Street in 1803–4. This was a spacious affair, such as only a very successful artist could hope to achieve. For Turner it provided a sympathetic setting for pictures of a more subtle character, and those that needed to be seen in connected series. His British subjects, shown in the Gallery from 1806, were just such works; together they formed a reassuring and patriotic commentary on the nation's continuity and resilience in time of war.

No less than the Academy pictures, they acknowledged the Old Masters. But instead of the Renaissance and Baroque painters of the Grand Style and the classical tradition, their models were the quieter masters of seventeenth-century Holland – especially Aelbert Cuyp, whose fields and rivers bathed in golden or silvery light were admired by British collectors. Turner's British subjects developed their effects of misty light and atmosphere; they were filled also with sharply observed details of contemporary life and industry that owed much to the narrative genre of other Dutch painters of the time. But Turner's pictures were far from academic exercises. Lively in subject, and fresh and luminous in colour, they

SNOW STORM: HANNIBAL AND HIS ARMY CROSSING THE ALPS 1812 (no.52, detail)

actually offended some traditionally minded connoisseurs who thought Turner a mere parodist of the masters he professed to admire; they called Turner a 'white painter' for the brightness of these British scenes, and worried about his influence over other impressionable artists.

Besides study of Cuyp, these pictures reflected particular aspects of Turner's own working practice at this time: a greater dependence on sketching and study in the open air, direct from the motif; a closer relationship between his handling of oil and watercolour. From 1805, Turner kept a succession of summer or weekend properties by the Thames west of London, and the easy access to rustic or river scenery that these provided encouraged him to sketch regularly in both media, close to the subject. Having mastered the essentials of watercolour while still very young, Turner had gone on, with characteristically high ambition, to try to match in watercolour the density and richness – as well as the scale – of oil painting; the enterprise had chimed with the new taste for grand exhibition watercolours, following the establishment of separate exhibitions for works on paper.

But having proved a point, Turner felt no need to labour it. Relaxing by the Thames, he showed he could use watercolour with a bold spontaneity to render the tremble of trees in a breeze or the sparkle of light on water (no.38). The washes are thinly diluted and applied rapidly, with brush or even thumb if it served the purpose; and the tone of the paper is allowed to contribute to the required effect, left bare or shining through the transparent colour. The same qualities, more remarkably, Turner was now managing to transfer to his sketches in oil. Outdoor oil sketching was now enjoying a vogue, and Turner took advantage of his explorations of the Thames to make his own oil studies from nature (no.37). Some were of particular landscape motifs – trees, hedges, groups of buildings – but others were more carefully worked out compositions on larger canvas of the same size Turner used for exhibition, suggesting that he, like his contemporary John Constable, was actually thinking of making pictures before the motif rather than simply assembling reference materials. These are built up in very thinly diluted paint over a white ground to give clarity and luminosity to the colours – exactly as if Turner were working with watercolour.

By this time, Turner was also becoming competent in the main techniques of printmaking, and he himself contributed the etched outlines to the plates prepared from his designs to his series of landscape prints, the *Liber Studiorum* (no.47). The *Liber* was the product of an artist who already felt uniquely confident of his art in all its known branches, and ready to dictate terms to his colleagues. Its categories of landscape – historical, ideal, pastoral, mountainous, marine, architectural – covered all the forms recognised at the time, but in Turner's hands were capable of infinite variety and refinement. We can see this if, for example, we apply the criteria of the *Liber* to the beautiful painting *Frosty Morning* of 1813

(no.58); judged by them, it is a pastoral with figures, but its qualities lie beyond its formal content, as the title itself proclaims. We are not told where we are (actually, in Yorkshire) or who the figures are (probably the little girl with the rabbit-skin round her neck is one of Turner's daughters) – but only what sort of a morning it is. That is the true subject, and how wonderfully Turner has realised it, building up subtle gradations of tone to suggest freezing mist beginning to be dispersed by the first feeble gleams of winter dawn, and scraping and working the paint in the foreground to show the rime on earth or grass. The starkness of the composition also plays its part in creating the effect of numbing cold. As Monet realised, this was a work of extraordinary naturalism; but it is not so much the content of the picture that makes it so, as the atmospheric and painterly methods that Turner has brought to bear upon it. They render the prosaic remarkable.

ITALY, 1819

Frosty Morning was a product of Turner's travels round Britain, which remained a regular feature of his professional and personal life. The ending of the war brought wider opportunities, which he took up first in 1817, with a visit to the battlefield of Waterloo (no.60) and a tour of the Rhine of which he produced a series of finished watercolours (no.61); like many of his earlier Swiss scenes, these were bought by Fawkes, who in 1819 held the first of two exhibitions of his Turner watercolours at his London house. In autumn that year, Turner began his first tour of Italy.

He was forty-four years old, and at the height of his powers. But he was sufficiently the product of the eighteenth century, and formed by the predominantly classical tastes of his first teachers and patrons, to undertake this trip in a spirit of humility. For artists, Italy was still the great challenge, a land whose history and culture were the roots of western civilisation, the models for art, and whose landscape was an ideal of perfection; as Turner himself remarked, it was 'Terra Pictura', 'the land of all beauty'.[3] Before the war, it had been the place to see when young; Turner's visit was inevitably delayed, but still one senses that he was awed by it, made almost a student again. He kept himself to himself, even avoiding the lively international circle of artists in Rome, and stocked his sketch-books with memoranda about art, architecture and antiquities more than with views of places. It was as if he was filling the gaps in his education, making up lost time, as much as thinking of his future as a painter; and, for him, that liberation of the spirit that Italy so often engendered in the Romantics was obscured, or at least delayed, by the sheer weight of information he had to absorb.

But no painter from the north, and Turner least of all, could fail to be impressed by the Italian light and atmosphere – by the brilliant blue sky, or the sharpness and clarity that the

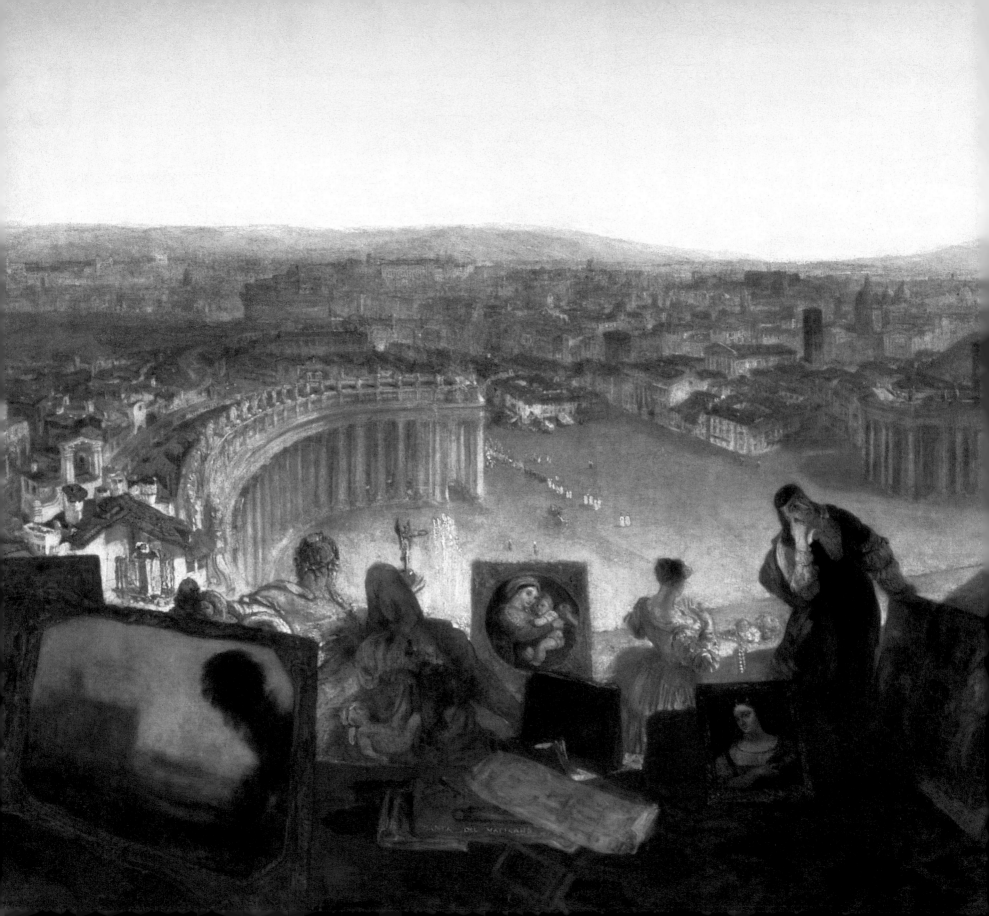

sunlight imparts to all colours. Turner had felt this early in the tour, and his watercolours of Lake Como (no.67) and Venice (no.66) – which, significantly, lacked the weighty classical associations of Rome – show a new freshness and purity of colour. Here, transparent washes over white paper create the effects he required, but equally remarkable are studies of Rome and the Campagna made in a mixture of watercolour and gouache over a grey preparation, in which he found he could capture the hotter, heavier atmosphere of afternoon or evening, or the gloom of night (no.68). In these coloured drawings, rather than in the almost obsessive, driven pencil notations in his sketchbooks, Turner seems born again.

His impressions were combined, within the remarkably short space of two months following his return to London, in the huge canvas *Rome, from the Vatican* that he painted for the Royal Academy in 1820 (no.69). It is a magnificent but disturbing work whose many tensions reveal, more clearly perhaps than he intended or even knew, the shifting tectonic plates on which his art then rested. Planned as the tribute to Italy that he must have felt was expected of him (and indeed the Academy's President, his friend Sir Thomas Lawrence, had declared Rome 'entirely congenial' to his genius[4]), it centres its survey of art and history on the figure of Raphael, seen with his mistress and model, and specimens of his own and other artists' work beneath his decorations in the Vatican loggia. This gesture was graceful and apt, for not only was Raphael's tercentenary now being celebrated, but Lawrence was the owner of an unrivalled collection of the master's drawings. But in an anachronism typical of Turner, we look across time from Raphael's loggia to Bernini's later arcades in St Peter's Square, and then across Rome to the distant mountains. The history claimed in the picture's title – Raphael 'preparing his Pictures for the Decoration of the Loggia'—is to be taken no more literally than the startling anomalies of perspective by which Turner, who was in fact the Academy's Professor of Perspective and was clearly putting on a virtuoso display of his skills, has managed to compress so much into his view. Yet most striking of all is the vivid azure sky – itself no more than the truth – that calls out for attention. From the shadowy loggia, the realm of art and history, we look out to sun and air. Even if unconsciously, Turner foretold his own future.

OLD FRIENDS, NEW AUDIENCES: LATER ENGLISH SUBJECTS, TOPOGRAPHY AND LITERARY ILLUSTRATION

Rome, from the Vatican was a grand public statement, painted to impress colleagues and critics with the painter's skill and erudition. The landscape and traditions of Italy would be more happily assimilated in the pictures Turner painted during and after his second visit, in 1828. Meanwhile, Turner's work in the 1820s struck a more relaxed or modest note as he branched out in new directions, often encouraged by friends or patrons.

In 1827 he stayed with the architect John Nash at his summer home on the Isle of Wight, and painted some wonderfully fresh oil studies of the newly-established Cowes Regatta (no.82), in connection with commissions for two pictures of the event; both sketches and finished oils are among his earliest and most impressive images of modern life and leisure, transcending the conventions of marine painting and anticipating Impressionism in their expressive handling and sensitivity to transient effects. The social life of the castle itself, with its musical evenings and garden parties, inspired further sketches in oil and watercolour.

Turner had also, by this time, renewed his connection with Lord Egremont, which had lapsed for some years, and he was a frequent guest at Petworth from 1825 until the Earl's death in 1837. Fawkes's death in October 1825 doubtless made him all the more appreciative of a regular welcome in another, if far grander, country house. Egremont gave him a studio of his own where he could work undisturbed; he produced oil sketches and pictures of the park and other scenes connected with his host (no.81, fig.7) as well as the famous series of over a hundred coloured drawings of the house, its splendid interiors and his fellow guests, who included many other painters (nos.79, 80). These intimate and revealing works were among his first experiments in a new combination of media, gouache on blue paper; the vivid, saturated colours were wholly appropriate to render the rich effects of rooms lit by firelight or lamp-light, or the dazzling sunsets across Petworth Park.

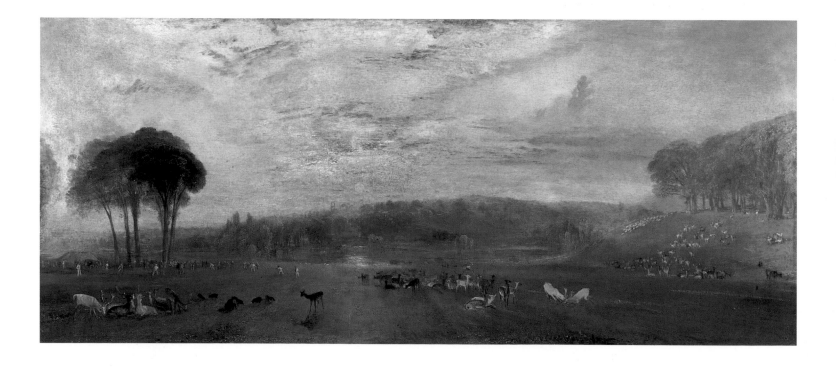

The Petworth sketches were made entirely for his own pleasure, though in time he was to apply their technical methods to drawings made for commercial engraving. This was also the decade when Turner's work for the engraver expanded greatly, to service a new boom in the publishing industry. While popular interest in travel at home in Britain had remained consistent, the end of the Napoleonic War brought renewed opportunities for European travel to a wider middle-class public, creating in turn demand for guide-books and images of places.

Travel stories and memoirs were also an important element in the popular literature of the time, whether in poetry or novels or in the new Annuals and 'Keepsake' publications that now began to appear. All these needed to be illustrated, and the invention in the early 1820s of more durable steel plates for engraving allowed much larger and more profitable print runs. Turner had always been keen to secure a popular audience for his work, and was now quick to turn this expanding market to his advantage. Having begun by producing work to order from publishers and engravers, he had since preferred to initiate or control publishing ventures himself. While working on the *Liber Studiorum,* he had undertaken his first substantial topographical series, *Picturesque Views on the Southern Coast of England* (1811–26), preparing watercolours for engraving.

Now, in the 1820s, he devoted much of his time to further surveys of this kind – the *Rivers of England* (1822–7; no.74), the *Ports of England* (1825–8; nos.86) and, as his crowning achievement in this vein, *Picturesque Views in England and Wales* (1825–39; no.85). These series, prepared in watercolours of increasing conceptual complexity and technical virtuosity, and superbly engraved by the best engravers under his close supervision, enabled him to present a definitive view of his own country in the aftermath of the Napoleonic War; and in views of the Loire and Seine – intended to form part of a larger survey of the great rivers of Europe – he extended his range to the Continent (no.87–9, 90–1).

It was his friend Samuel Rogers, banker, collector and poet and host of a celebrated London salon (fig.7), who first encouraged Turner to illustrate contemporary poetry. Turner had already produced landscape and topographical illustrations for authors including Walter Scott, for whose *Provincial Antiquities of Scotland* he concluded a set of drawings in 1821; moreover he had always been fond of poetry, and for many years had written his own, adding lines as appropriate to the titles of his exhibited work in the accompanying catalogues. In 1826, Rogers commissioned from him a set of illustrations for his own poem *Italy,* hoping thereby to secure a greater success than the work had met with in an earlier, plain edition. Taking his friend's lines as a starting point, and referring to his own memories of the Alps in 1802 and Italy in 1819–20, Turner produced wonderfully evocative series of vignettes (nos.77–8), which were engraved on the printed page. They proved a huge

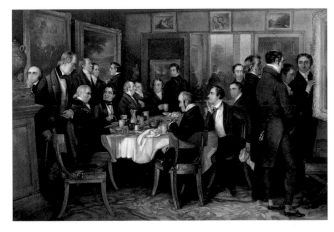

fig 8 Charles Mottram
SAMUEL ROGERS AT HIS BREAKFAST TABLE
Engraving
33.7 x 43.2 (12 1/8 x 17)
T04907

success, earning record sales for the book and adding greatly to his own reputation. He went on to illustrate Rogers's *Collected Poems*, and editions of other poets and authors living and dead – Byron, Scott (nos.71–2) and Milton (no.100) among others – that have always been regarded as among the finest achievements of English book illustration.

Turner's early training as an illustrative topographer had taught him how to deploy imagery and allusions to bring out the meaning and memories of a place, and his mature work for the engraver built on this experience, whether he was working on the expansive scale of his watercolours for *England and Wales,* or in the concise and restricted form of the vignettes. Objects or narrative are always carefully chosen, and the effects of weather and light that are introduced, spectacular though they are in themselves, also play their own symbolic roles. And no less remarkable than their concise and telling imagery is the variety of techniques that Turner brought to his engravers' drawings. These reflected wider developments in his art, especially his growing preoccupation with colour rather than tone; but as the engravers, limited to black and white, could only work in terms of tone, Turner's drawings cannot always have been easy for them to interpret. Turner had by now concluded that gradations of tone through a limited range of colour – the traditional method of painting – did not reflect the way the eye perceives the world; instead it seemed to him that an object struck by light is refracted into fragments of pure colour in infinite variety. He was now constantly experimenting with the working of colour in separate colour studies, both in oil and watercolour; sometimes these laid out the composition or colour patterns of a projected picture or drawing, sometimes they were experiments only. He had also begun to build up his watercolours through countless tiny spots of intense, jewel-like colour, on white paper in the watercolours for *Rivers* and *Ports of England,* or in gouache on coloured paper in the French rivers series. The results were virtuoso performances, which Turner intended to challenge his engravers to ever more refinement and variety in the rendering of form through light and atmosphere. Hard as their task must have been, the results justified his expectations; the many prints after Turner – which numbered not far short of a thousand by the time of his death – include most of the finest examples of the greatest age of London printmaking.

THE SECOND VISIT TO ITALY, 1828–9

It was, increasingly, through prints that Turner's work was known — especially on the Continent. Those unfamiliar with his actual pictures and watercolours were often surprised or even shocked when they saw them. This was certainly the case in Rome late in 1828, when, having returned to Italy that autumn, Turner held a small exhibition of his recent work. This second visit was very different from the first. Having studied hard in 1819, Turner

now spent most of his time painting in oil rather than drawing in pencil or watercolour. He was also more sociable. If Rome itself was a test for an artist, Turner was now ready to face another – the scrutiny of his European colleagues. His reputation had preceded him but not much was known of his real style, or of his recent developments in colour and handling. Both came as a shock.

Turner's Roman exhibition of work done in the city included the first state of *Regulus* (no.93). It was not, presumably, very finished, as Turner reworked it for exhibition in London in 1830, but even in its final state, as we see it today, it would have failed to satisfy many of its Roman visitors, for it had none of the hard, meticulous finish of the many German and Austrian painters then in Rome, nor the neo-classical refinement of the Italians themselves. All these artists were capable of spontaneous and painterly effects when indulging in their private pleasure of oil sketching outdoors, but thought them puzzling in an exhibition canvas. Paradoxically, Turner seems to have taken little or no part in their *plein air* activities, and his own oil sketches in Rome were more abstract composition studies, meditations on the Claudean formula of classic landscapes or idealised sea-ports which had so long conditioned the European view of Italy.

The most damning verdicts on Turner's exhibition came from the Germans, while the Austrian Josef Anton Koch wrote a scurrilous review quoting the jibe 'Crapped is not painted' – which also circulated in an anonymous caricature – and claiming that it hardly mattered which way up the pictures were hung: the show was, he added, 'much visited, ridiculed and hooted'.[5] Similar reactions would occur in Munich in 1845, when, intending a tribute to cultural revival under Ludwig of Bavaria, Turner sent his *Opening of the Walhalla* (no.103) to an international exhibition; after much laughter, it was sent back, damaged, with a bill for repairs to the frame, but the nub of the criticism was, as one observer put it, 'want of exactness of portraiture in the place represented'.[6] This was not only to miss the point of Turner, but to take no account of the British painterly tradition from which he sprang.

Turner had been able to learn the smooth, refined facture of Continental painting from his early teacher Loutherbourg, and his first oil, *Fishermen at Sea* (no.8), had been a quite successful attempt in that manner. But he had soon repudiated it in favour of the more robust, expressive British style that already seemed a better vehicle for portraying the vitality of nature, and as early as 1808 a German writer had censured the 'studied neglect' (*studienartig Sorglosigkeit*) of his handling.[7] The urge to unlock, as it were, the energy of the elements through the energy of paint became one of the dominant themes of his art, expressed not only in finished pictures painted in increasingly dynamic techniques, but, even more powerfully, in the sketches of storms, rough seas or skies that, in his later years, occupied much of his private time in the studio (nos.104, 107). Extraordinary though these

are, they are as much the logical outcome of a school of painting that had always placed emphasis on expression rather than finish, as of Turner's own fascination with the phenomena of nature. The rich, painterly styles of his contemporaries Constable and Lawrence, for example, proved as mystifying to the Paris critics as Turner did in Rome when, in 1824, they appeared in the 'Salon des Anglais'. The bourgeois critic Etienne Delécluze attacked 'affected negligence' that 'failed to address the precise form of objects'; though he was not, he added, entirely certain that the British manner was only suitable for 'the English countryside, the ocean's storms or scenes with sailors', and would 'reserve judgement until some great English painter [who] has successfully treated in this manner the calm, majestic and enchanting scenes of Italy, can offer works in which the style and execution will permit comparison with Poussin's *Polyphemus*'.[8] If this sounds like a challenge to Turner – who did not send to the 1824 Salon – to prove the suitability of the British style to classic subjects, one wonders what the French critics would have made of *Ulysses deriding Polyphemus* and others Turner painted after his return from Italy. The visit had certainly reawakened Turner's classical imagination – indeed some of these compositions seem to have occurred to him while in Rome – but the crimsons, golds and blues, and thick, even rough impasto with which these antique visions were realised struck even admirers like the American landscape painter Thomas Cole as a step too far. Cole's comments on Turner's 1829 pictures made a point of separating their colours from their subjects, and much Turner criticism in the 1830s and 1840s was to continue in this vein, contrasting – sometimes in sorrow, sometimes with sarcasm – his often traditional themes with his unrestrained execution; for it was not only outside Britain that his later manner proved hard to take. But for Turner form and colour were inseparable from meaning.

LATE WORKS: OIL AND WATERCOLOUR

Although Turner – now self-confident enough to enjoy a joke at his own expense – once claimed he had been inspired to paint *Ulysses* by a music-hall song, it was an example of the 'wonderful range of mind' that had impressed Constable as he sat beside him at dinner.[9] He read widely, and his friends now included leading figures in many fields. The lessons and impressions he absorbed from them were combined very freely in his work, and contributed also to its increasing range and variety in his later years. He continued to paint landscapes and marines, often of a wild and stormy character, but these could fall into extremes of tradition and innovation – sometimes 'historical' in style and subject, or, in the case of his magnificently turbulent *Snow Storm – Steam-Boat off a Harbour's Mouth* (no.106), at once a triumphant account of natural forces such as only he could paint, and a hymn to progress in the form of the brave steamer riding out the storm. Likewise, classical and historic

landscapes – now distinctly old-fashioned in all but their extraordinary techniques – were set alongside the uncompromisingly contemporary. If Turner seemed at times to be telling the history of his own art – even to be assembling a one-man National Gallery in his many essays in the styles of the Old Masters – he was also clearly determined to bring the art up to date. This accounts not only for his vivid images of steam and rail – unlike anything else in painting at the time – but also for the transfigured style of his last farewells to Claude, the Dido and Aeneas pictures shown in 1850 (no.123); and also, surely, for those unexhibited canvases like *Norham Castle* (no.125) in which he reconsidered past subjects in all the luminous and atmospheric abstraction of his late style, distilling the elements of essentially classical compositions to their purest form.

Turner's practice in the media of oil and watercolour had become increasingly similar, indeed almost interchangeable. His oils were frequently painted over a white ground which gave brilliance and luminosity to the pigments just as white paper does to watercolour; and in both media Turner now preferred to work up his compositions in fine dottings, stipplings and hatchings of bright and varied colours over a broad, abstract framework of colour – laid out in transparent washes on paper, or in patterns of strong colour masses of red or yellow on canvas, as can still be seen in the unfinished or abandoned canvases from his studio. He had long been famous for his virtuoso and unpredictable techniques in all media, so that the processes by which he conjured a living work of art from an apparently crude and unpromising embryo came to be described in terms of magic or miracle; 'without form and void, like chaos before the creation' was how one observer described the bafflingly vague canvases that Turner carried to completion in the exhibition room on the Royal Academy Varnishing Days.[10] These very public performances became legendary, while his methods in bringing forward his watercolours, on the much rarer occasions when he could be observed drawing, were no less memorable; a colleague, William Leighton Leitch, recalled him making finished watercolours several at a time:

> each of the matchless drawings ... was executed there in a day. Turner's method
> was to float-in his broken colours while the paper was wet ... he stretched the paper
> on boards, and, after plunging them in water, he dropped the colours onto the
> paper while it was wet, making *marblings* and gradations throughout the work.
> His completing process was marvellously rapid, for he indicated his masses and
> incidents, took out half-lights, scraped out high lights, and dragged, hatched and
> stippled until the design was finished. This swiftness, grounded ... in early life,
> enabled Turner to preserve the purity and luminosity of his work, and to paint
> at a prodigiously rapid rate ... [11]

Turner had continued to extend and refine his skills as a draughtsman throughout the 1830s, not least in the countless drawings he made on the Continental travels that remained a feature of his professional life. Small pencil memoranda were noted in sketchbooks; though the pages might be very small, Turner's mark-making was now so concise that he could produce several different views or details on a single sheet. For watercolours he used larger books, soft-bound so that they could be kept in his pockets and produced whenever needed. Turner worked in this way across Europe: 1833, for example, had seen a particularly extensive and productive tour along the Rhine and Neckar rivers, through Munich and Salzburg to Linz and as far as Vienna; typically, while in the city he stocked up with a new sketchbook, and went to work in the Belvedere Gallery and the Wienerwald. No less remarkable was a circular tour in 1835 through the Netherlands and north to Copenhagen, then across the Baltic past Riigen and through Prussia to Berlin – where alas we do not know if he entered Schinkel's new picture gallery and saw the work of his German contemporaries like Caspar David Friedrich; then through Prague, and back across Bavaria and north up the Rhine. There were other tours besides, and one can only wonder at the energy and boldness of this ageing artist whose command of languages – although he tried – was minimal at best.

The 1833 tour had terminated at Venice, and the city that had exercised such a liberating effect on his watercolour technique in 1819 became a recurring theme of his late art. He painted a series of oils for exhibition (nos.97, 111, 112) and began others, while Venice was the subject of some of his most magical late watercolours – many of them made during a stay in 1840 (no.110). While his comprehension of Venice was imaginative and historical, alive to its traditions and ceremonies, it also reflected the growing contemporary interest in the city as a tourist attraction, and was not, as has sometimes been claimed, wholly conditioned by Romantic melancholy at its fading beauty. For all his hard work there, sometimes observed by his fellow artists, he came also in a sense as a tourist himself, staying with other prosperous visitors in the Europa Hotel and enjoying the cafes, theatres and firework displays on festivals and saints' days. Turner was perhaps even more of a tourist on his last visits to Switzerland in the 1840s, when he spent most of his time in the cities or by the lakes in a favourite hotel like The Swan at Lucerne, with its view of Mont Rigi and its constant changes of colour and effect. These were holidays as well as working trips.

In his late concern for Venice and Switzerland, Turner's personal experience and interests converged with those of his potential collectors and patrons, and his awareness of their likely appeal must partly account for his determination to market his Swiss subjects, at least, more aggressively. Whereas in former years, many of his finished watercolours had been made on commission or for engraving, he now set out actively to promote his Swiss

work. In 1840 and 1843 he prepared 'sample studies' of selected subjects (nos.114, 115) for an agent and dealer, Thomas Griffith, to show to prospective clients; these would give sufficient idea of the appearance of a finished work to serve as the basis for commissions. The response was less enthusiastic than Turner had hoped, for even some of his more devoted patrons were surprised by his late style. Ruskin – whose earlier admiration had now been extended to enthusiastic collecting and who was in time to acquire eight of the fifteen finished watercolours Turner made in 1842 and 1843 – was among those who did recognise the superlative quality of this late body of work. The finished watercolours of 1842 have long been regarded as Turner's consummate achievement as a draughtsman, but their essential qualities – monumentality and grandeur of composition, spectacular atmospheric effects of diffused light or mist hovering over water, brilliant but subtle colour, integration of human or animal life to give a sense of organic wholeness to the landscape – are also present in his sample studies and in the more spontaneous watercolours confided to his bound sketchbooks. They reach a pitch of perfection in watercolour that has never since been matched, and if some of Turner's contemporaries found them difficult – or, as Ruskin records Griffith telling Turner, 'a little different from your usual style'[12] – this was because even in the work of this most remarkable of artists, they had nothing to compare them with.

Here, as in the late oils, Turner occupied a class of his own; but now he did so as much by transcending himself as by outstripping his contemporaries and predecessors. Once he had centred his ambitions on the Old Masters, on outdoing, as a modern painter and a Briton, Claude or Poussin, Ruysdael, Titian or Rembrandt. The proofs of his success were now accumulated in his London Gallery – by now neglected, certainly, but awaiting resurrection and bequeathed to the nation for the memorial gallery in his honour. He knew he had no need of modesty, but his ambitions here were as much for his country and his profession as for himself. Yet, understandable as this competitive spirit may be in a man from low beginnings who had to shout loudly to be heard, and who was brought up in an age still profoundly attached to tradition, it is neither the most attractive nor the most interesting aspect of Turner. Nor does it justify his special place in the history of his art. The paradox of the man of tradition who seems also to bridge the gap between the eighteenth century and modernism will always be with us. But still more fascinating, surely, is the artist who was compelled constantly to re-examine and reinvent his own art, to question its bases of meaning and technique. Tate's collection, with its unique representation both of Turner's finished 'public' work and the private experiments of his studio, shows us an artist who, in the end, can only be judged by his own standard. If the essence of the Romantic artist is a refusal to fit a pattern, a compulsion to strike out alone into new and uncharted territory, then Turner is indeed one of the greatest of them all.

Overleaf
BLUE SEA AND DISTANT SHIP
c. 1843–5 (no.119, detail)

Two of Turner's earliest dated drawings belong to 1787, when he signed another version of the same view of Folly Bridge and one of a country house not far from Oxford, Nuneham Courtenay. He was then twelve years old. Although he was to become familiar with the Oxford area, from visits to an uncle at Sunningwell, these first views of the city were copied from an engraving by Edward Rooker after the topographical watercolourist Michael 'Angelo' Rooker, published in the annual University calendar, the Oxford Almanack, in 1780. Turner's first efforts at drawing were encouraged by his father, who is said to have exhibited them for sale in the window of his barber's shop, and, two years later in 1789, had him apprenticed to the London architectural draughtsman Thomas Malton. Turner's father also obtained him an invitation to stay with his friends, the Narraway family, near Bristol in 1791. During his stay, his fondness for drawing the Avon Gorge won him the nickname 'the Prince of the Rocks'. With its bright palette and cursive, graceful trees his watercolour of the river near the cliff known as Wallis's Wall is typical of Turner's early watercolours of picturesque landscapes. Already alert to commercial possibilities, he seems to have intended to have it engraved with others in a set of 'Twelve Views of the River Avon'. With commissions in mind, he also drew country seats in the Bristol area. His view of Captain Fowler's property, Cote House on Durdham Downs, was made in his Bristol and Malmesbury sketchbook; a finished watercolour version, which the Captain may well have bought, is in the Cecil Higgins Art Gallery, Bedford.

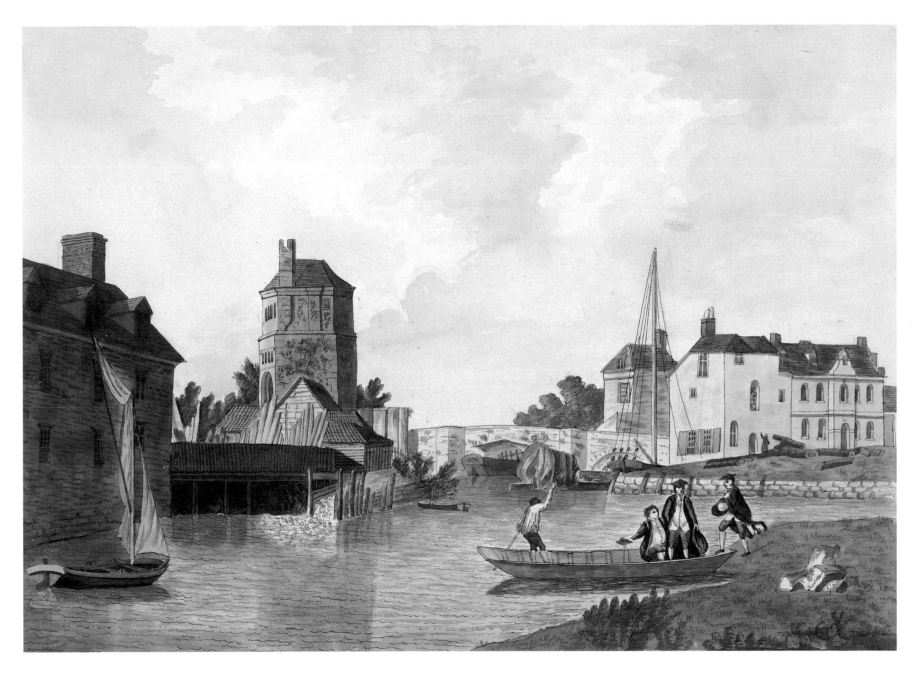

1 FOLLY BRIDGE FROM BACON'S TOWER, OXFORD 1787
Pencil and watercolour with pen and ink
30.8 x 43.2 (12 ⅛ x 17)
Turner Bequest; I A: D00001

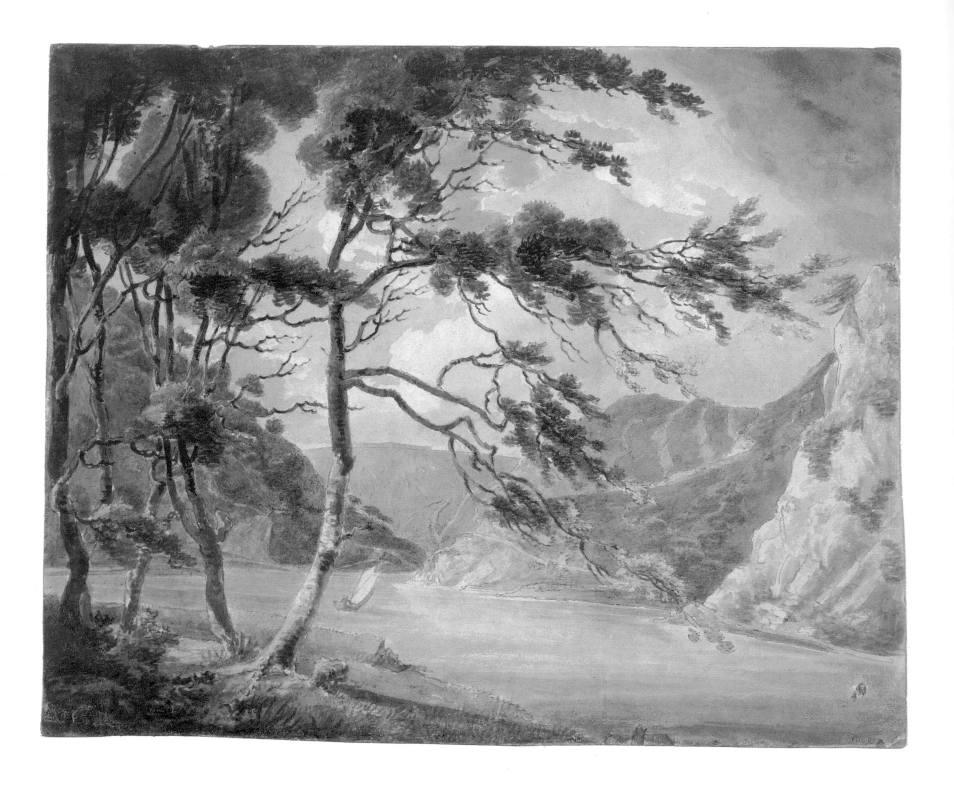

36

2 THE AVON NEAR WALLIS'S WALL 1791
Pencil and watercolour with pen and ink
23.7 x 29.4 (9 ¼ x 11 ⅝)
Turner Bequest; VII B: D00109

3 CAPTAIN FOWLER'S SEAT, DURDHAM DOWNS
Pencil, ink and watercolour
18.5 x 26.3 (7 ¼ x 10 ¼)
Turner Bequest; VI 17 verso; D00096

Although born and brought up in London, and resident there almost all his life, Turner actually made relatively few views of the inner city. This is perhaps surprising, as his first training was in the field of achitectural draughtsmanship and topography, and with practitioners specialising in London subjects. His view of the Oxford Street Pantheon, a famous theatre and entertainment complex, the morning after it was destroyed by fire in 1792, is exceptional, but must have been prompted by the significance of its loss, with its potential for a work of vivid, almost journalistic topicality. Turner was then just seventeen years old, but produced far more than a competent rendering of the ruined building; the rosy glow of dawn light, catching the icicles left by the firemen's hoses, and the bustle of the foreground all show his precocious skills as a watercolourist. The watercolour was shown at the Royal Academy in 1792. In London it was the Thames, whether crowded with shipping and commercial life in the centre of town, or its more pastoral upper reaches to the West, that interested him most. His view of York House from the water is an unfinished example of his early architectural subjects, showing clearly how these were typically made, local colour being added over a preliminary structure set out in pencil and monochrome washes of blue or grey. For the more picturesque subject of the Thames at Millbank by moonlight, in which the distant urban fabric scarcely registers at all, he used the more painterly medium of oil, with which he was beginning to experiment by the mid-1790s.

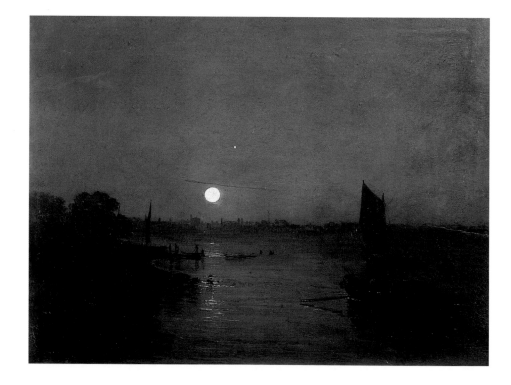

4 LONDON: YORK HOUSE WATERGATE, WESTMINSTER
WITH THE YORK BUILDINGS WATERWORKS 1794–5
Pencil and watercolour
29.8 x 41.9 (11¾ x 16½)
Turner Bequest; XXVII W: D00684

5 MOONLIGHT, A STUDY AT MILLBANK 1797
Oil on mahogany panel
31.5 x 40.5 (12⅜ x 15⅞)
Turner Bequest; N00459: B & J 2

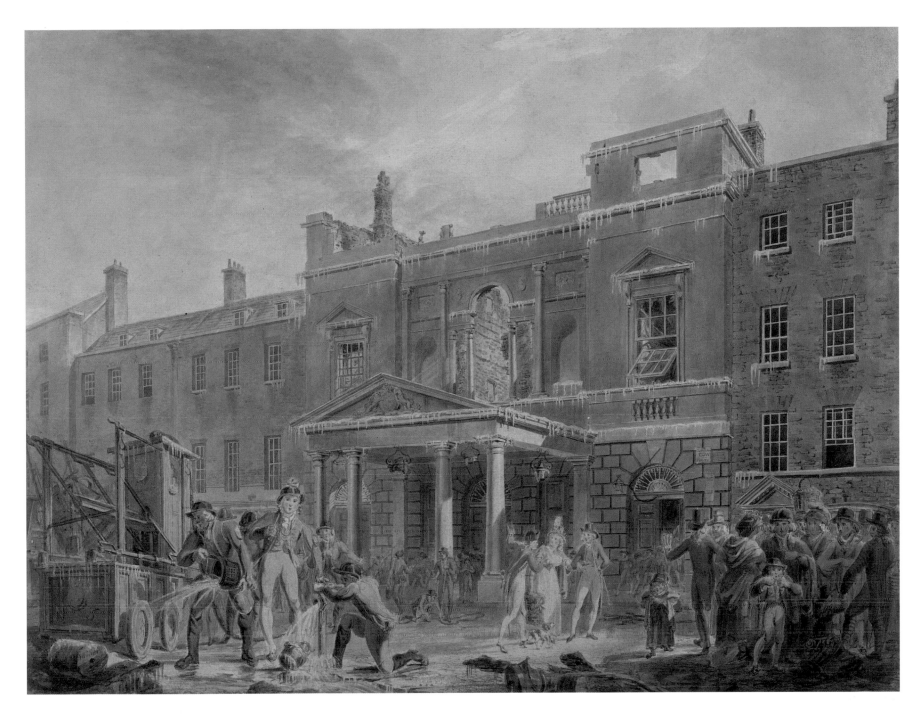

6 THE PANTHEON, OXFORD STREET, THE MORNING AFTER THE FIRE 1792
Pencil and watercolour
51 6 x 64 (20¼ x 25¼)
Turner Bequest; IX A: D00121

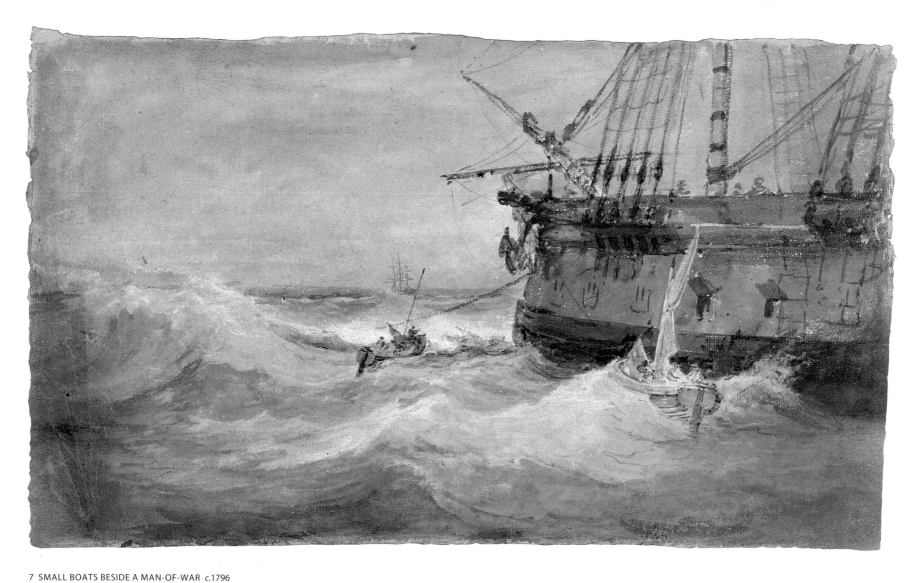

7 SMALL BOATS BESIDE A MAN-OF-WAR *c.*1796
Pencil, watercolour and gouache on buff paper
35.4 x 59.3 (13⁷⁄₈ x 23³⁄₈)
Turner Bequest; XXXIII e: D00902

Turner's very first drawings seem to have been made at Margate, where in the mid-1780s he was sent to stay with relatives of his mother and, in the words of his first biographer, Walter Thornbury, 'first saw the sea' and 'learnt the physiognomy of the waves'.[13] A group of marine and beach studies in Tate's collection of about a decade later may also have been made on a visit to the town, then a small fishing community and still to develop into a popular seaside resort. On the other hand, they could also derive from the visit to the Isle of Wight, in the late summer of 1795, which gave rise to his first oil painting exhibited at the Royal Academy the following year, *Fishermen at Sea*. This showed the Needles in the background. Turner's drawings, often of fishing subjects, might be related to this, while their combination of watercolour and gouache on toned paper suggests he was working towards pictorial effects. Most show views from the shore, but this study of small boats going out to a man-of-war in choppy seas is exceptional in being taken from a viewpoint in open water, as is the 1796 picture.

Fishermen at Sea , unlike Tate's other early Turner oils, did not come from the Turner Bequest. Turner sold it from the Academy exhibition to a General Stewart, from whom it descended to the Fairfax-Cholmeley family.

8 FISHERMEN AT SEA 1796
Oil on canvas
91.5 x 122.4 (36 x 48 ⅛)
T01585: B & J 1

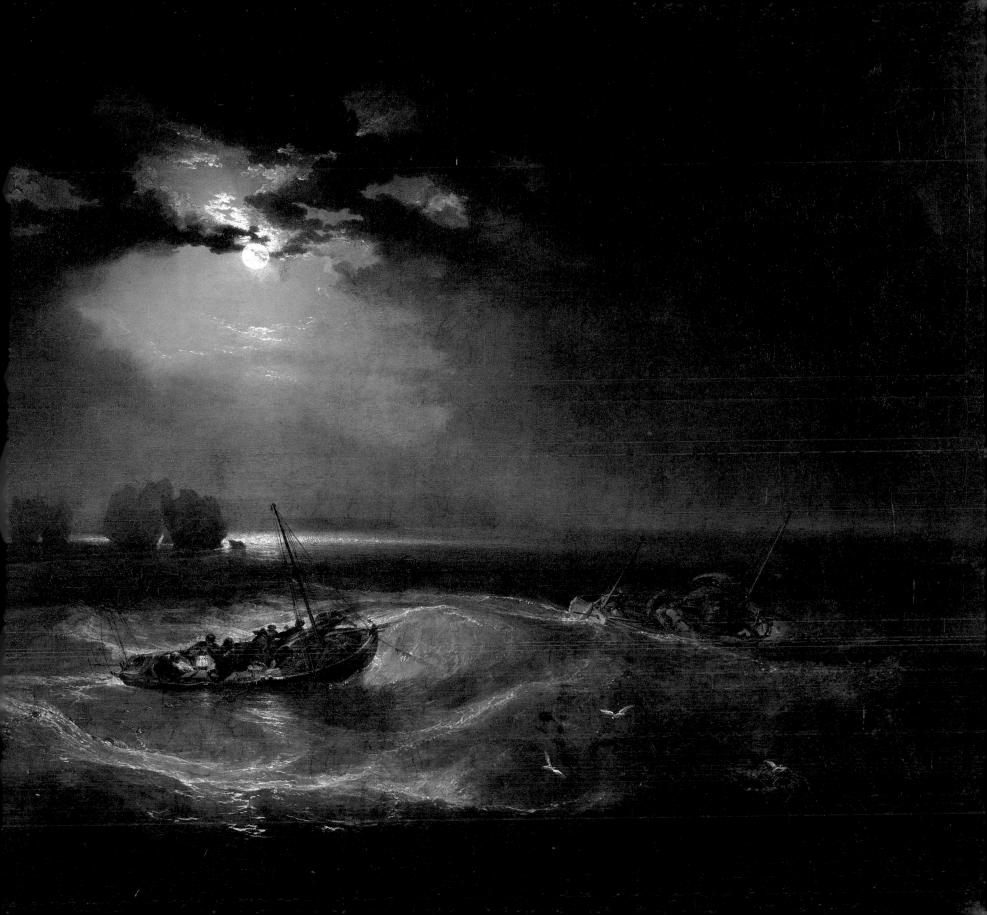

One of the most fruitful of Turner's early tours was to the north of England in 1797. This took him to Yorkshire, Northumberland and the Lake District. In his *North of England* sketchbook used during the journey he made a quick pencil sketch of Norham Castle, set on its cliff beside the River Tweed. On-the-spot memoranda like these were intended to provide material for watercolours and pictures to be painted back in London, and indeed the following year he showed a watercolour, *Norham Castle on the Tweed, Summer's Morn*, at the Royal Academy and about the same time painted another; both are in private collections. Tate owns two large and richly-toned colour studies which must have been made in connection with these finished watercolours. Both anticipate the sunrise effect of the exhibited work, which was shown with a quotation describing dawn from James Thomson's poem *The Seasons*. 1798 was the first year that artists were allowed to submit such text to the Academy catalogue, and Turner took full advantage, choosing passages that amplified the natural dramas of weather and light played out in his pictures.

The picturesque silhouette of Norham was a subject that haunted Turner all his life. He used one of the early watercolours as the basis for a design in his *Liber Studiorum* (see no.47) and revisited the subject in a late, unexhibited painting (no.125). Turner's picture of Buttermere Lake was also based on the 1797 tour, and appeared in the 1798 Academy. This too was given a quotation from Thomson's poem, describing a rainbow after a shower.

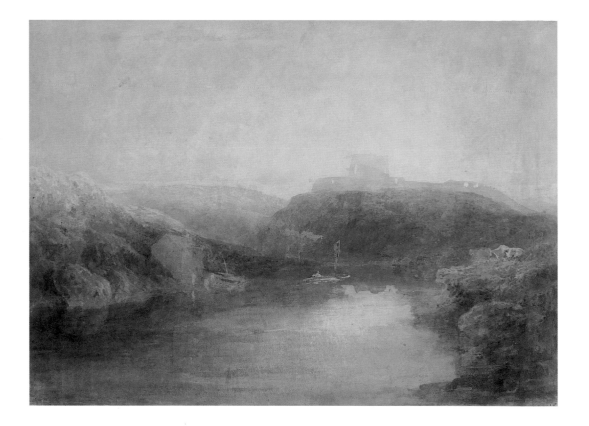

9 NORHAM CASTLE, SUNRISE 1797–8
Pen and watercolour
54.2 x 74.8 (21¼ x 29¼)
Turner Bequest; LC: D02344

10 BUTTERMERE LAKE, WITH PART OF
CROMACKWATER, CUMBERLAND, A SHOWER
1798
Oil on canvas
91.5 x 122 (36⅛ x 48)
Turner Bequest; N00460: B & J 7

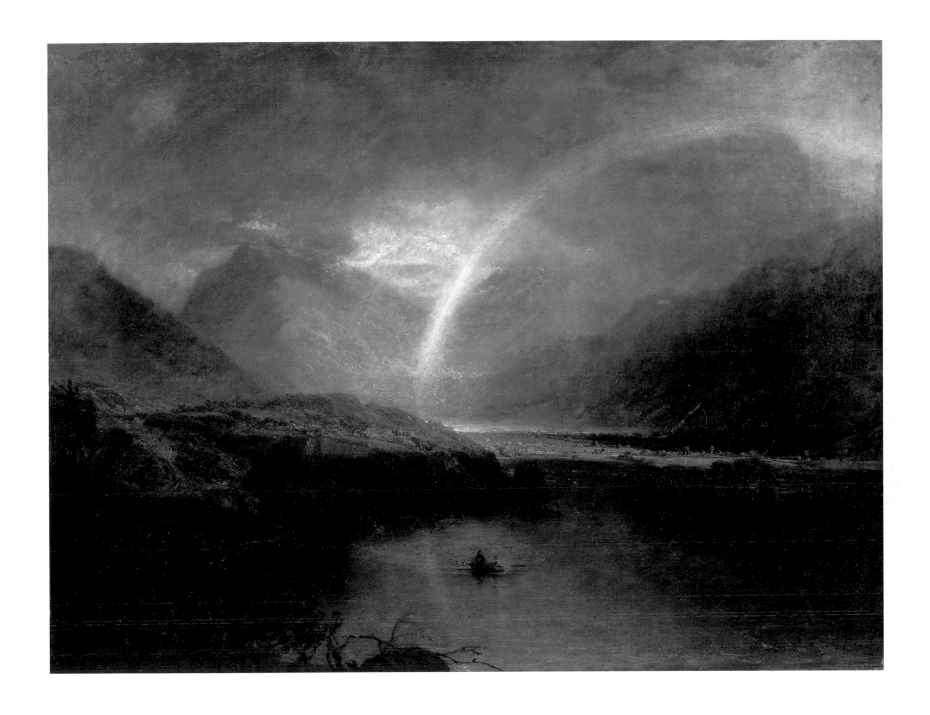

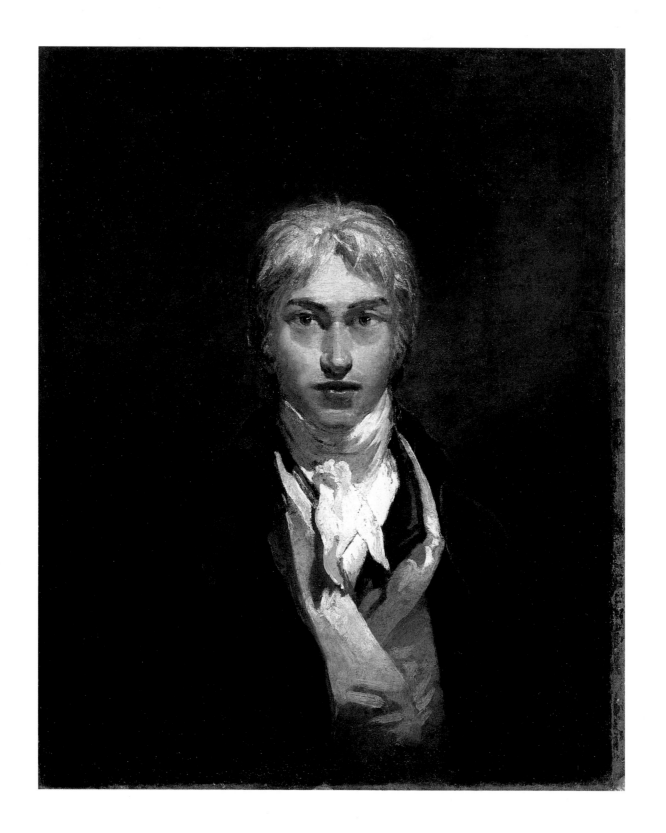

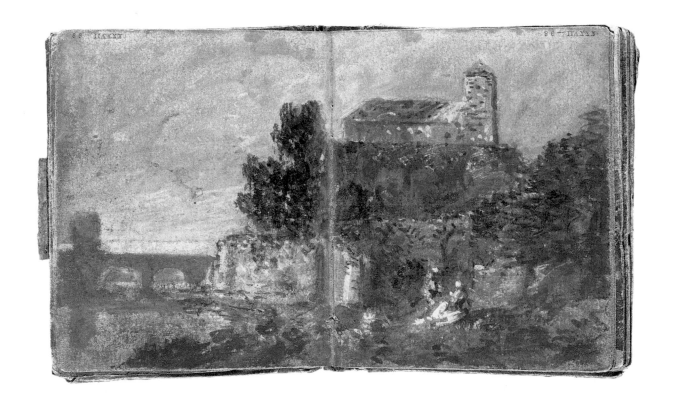

12 SELF-PORTRAIT c 1799
Oil on canvas
74.5 x 58.5 (29 ¼ x 23)
Turner Bequest; N00458: B & J 25

13 From the *Wilson* sketchbook 1796–7
THE CONVENT ON THE ROCK, after Richard Wilson
Watercolour and gouache on blue paper
prepared with a red-brown wash
On two pages each 11.3 x 9.3 (4 ½ x 3 ⅞)
Turner Bequest; XXXVII 98, 99: D01215, 01216

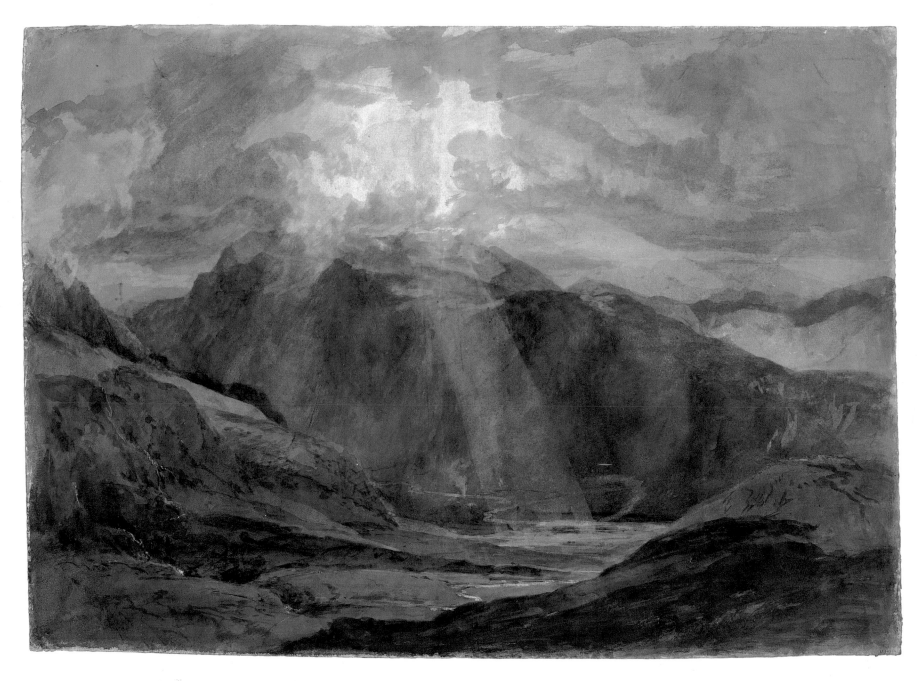

14 NANT PERIS, LOOKING TOWARDS SNOWDON 1799–1800
Pencil and watercolour with stopping-out and scraping-out
55.1 x 77 (21³/₄ x 30³/₈)
Turner Bequest; LX (a) A: D03642

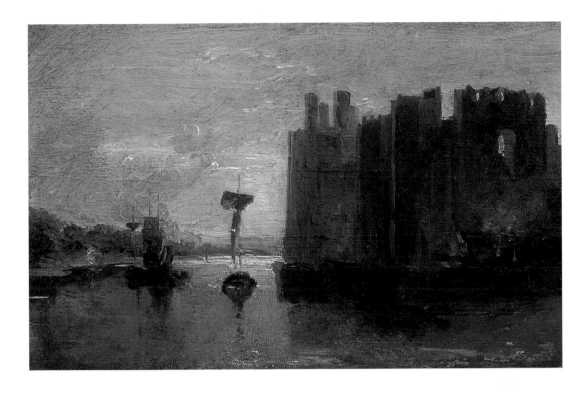

In 1798 and 1799, Turner made tours of Wales, drawing the mountains and the castles built by Edward I in the late thirteenth century. His view of Nant Peris is one of a series of large watercolour studies made on the second tour. They show how impressed he was by the bleak grandeur of the scenery. Broadly washed in sombre colours, sometimes on sheets folded down the middle, but often with bold lighting effects and pictorially resolved compositions, they were intended as references for finished watercolours. Among Tate's relatively few finished Turner watercolours is a distant view of Caernarvon Castle, which he showed at the Royal Academy in 1800. It did not find a buyer, but the previous year the great collector John Julius Angerstein bought another, closer view of the castle from the exhibition (now in a private collection). It was probably with this in mind that Turner made the small oil sketch of a similar view, with the same vivid sunset lighting. As well as the history and scenery of Wales, Turner was very interested in the modern industry springing up in the valleys since the Industrial Revolution. His drawing of a tilt forge, a water-driven mechanism for the welding of iron, is one of a number of drawings in Tate's collection made on his visits to ironworks such as that at Cyfarthfa, Merthyr Tydfil, in 1798.

15 CAERNARVON CASTLE *c.*1798
Oil on pine panel
15.1 x 23 (6 x 9)
Turner Bequest; N01867: B & J 28

16 AN IRON FOUNDRY 1798
Watercolour
24.8 x 34.3 (9 ¾ x 13 ½)
Turner Bequest; XXXIII B; D00873

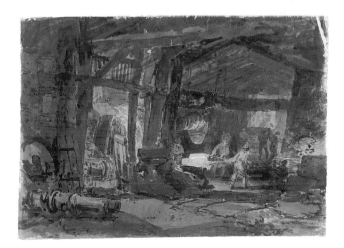

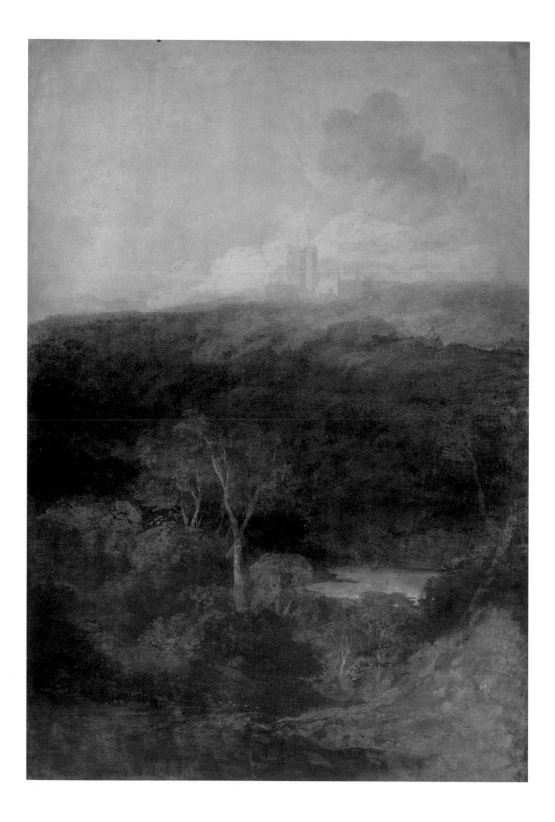

By the mid-1790s, Turner had attracted the attention of leading collectors and patrons. They gave him commissions and invited him to visit and paint their country estates. The name of William Beckford, the fabulously wealthy and eccentric collector, author and builder of the Gothic Fonthill Abbey in Wiltshire, appears in Tate's *Smaller South Wales* sketchbook, in connection with a picture of 'The Plague of Egypt', as early as 1796 or 1797. This suggests that such new acquaintances were extending Turner's interests to historical subject matter even at a time when his exhibited oils were only landscapes or marines, though it was not until 1800 that Beckford bought his *Fifth Plague of Egypt* (Indianapolis Museum of Art) from the Academy, and it is not certain whether this particular subject was first commissioned. Beckford did however order five large watercolours of Fonthill, designed in 1793 by James Wyatt, showing the building and grounds at different times of day. Tate's *Fonthill* sketchbook contains drawings and watercolours made at Fonthill over three weeks in late summer, 1799. One of these is the basis of the more elaborate composition of the abbey seen across rolling woodland; its large size and complex technique suggest it was to be developed into a finished subject.

17 VIEW OF FONTHILL ABBEY *c.*1800
Pencil and watercolour with stopping-out
105.5 x 71.1 (41 ½ x 28)
Turner Bequest; LXX P; D04167

18 VIEW OVER THE LAKE AT STOURHEAD ?1799
Pencil and watercolour
41.6 x 54.4 (16 ⅜ x 21 ½) sheet
40.4 x 54 (16 x 21 ¼) image
Turner Bequest; XLIV f: D01918

53

While Fonthill was Gothic, and its grounds wildly picturesque, it was also to be the home of two great classical paintings by Claude, bought by Beckford in 1799. Claude was the presiding spirit of another Wiltshire estate that Turner had known since about 1795 – Stourhead, the home of the amateur antiquary, Sir Richard Colt Hoare. While Turner visited it mainly in connection with commissions for watercolours of Salisbury and its Gothic cathedral, it impressed him most for its collections of Old Master pictures, including works by Claude, and its gardens laid out by its owner's grandfather in Claudean style. Colt Hoare may have proposed some watercolours of these, for which Turner's view of the lake, the less finished of two versions in Tate, could have been made. A drawing the patron had made in Italy some years earlier was the starting point for Turner's first oil of a historic landscape painted in Claude's style. The Stourhead gardens were based on the story of Aeneas's foundation of Rome – to parallel that of the Hoare banking dynasty – and Turner's picture shows Aeneas being told that he can enter the Underworld, where he seeks his father's shade, only with a sacred golden bough as an offering to Proserpine. Hoare did not in fact buy the picture, but acquired another of the same subject in 1815 (Yale Center for British Art, New Haven).

19 AENEAS AND THE SIBYL, LAKE AVERNUS c.1798
Oil on canvas
76.5 x 98.5 (30 ⅛ x 38 ¾)
Turner Bequest; N00463: B & J 34

Since the opening of the Clore Gallery in 1987, there have been many additions to the collections of the Turner Bequest – especially of prints by and after Turner to show the wide scope of his work for the engraver and as an original printmaker, the means by which he was most widely known in his lifetime, and the origin of much of his considerable wealth. Dr Thomas Whitaker's *History of the Parish of Whalley* (1800–1) was typical of the antiquarian publications popular at the time, for which Turner designed illustrations. Turner was commissioned to work on this book, for the engraver James Basire, through Charles Towneley, a great collector of classical sculpture and a neighbour of Whitaker in Lancashire. Though Whitaker observed that Turner 'has all the irritability of youthful genius',[14] his methodical rendering of stone crosses, ornamental brasses and misericords at Whalley Abbey shows his willingness to produce a variety of routine work to order, rather than the landscape and architectural views that were by now his main stock-in-trade as a graphic artist and gave him more scope for pictorial invention and effect. The exceptional breadth of Turner's output by this time is also seen in his watercolour of the siege of Seringapatam, another quite recent acquisition and one of a set of three probably commissioned – again perhaps for engraving – to capitalise on the topical capture of Tipoo Sultan's fortress by General Baird in May 1799. The British artillery have breached the north-west bastion and advance across the River Cauvery. Tate also owns one of two colour studies connected with the series. The watercolour – Turner's first surviving battle subject – was probably based on a print after a drawing by Captain Alexander Allan, who was present at the siege.

20 James Basire (1769–1822) after Turner
ANCIENT CROSSES AT WHALLEY 1800
For Whitaker's *History of the Parish of Whalley*, vol. I, pl.4
Engraving, published state
26.1 x 20.8 (10¼ x 8⅛); 30.9 x 24.2 (12½ x 9½);
28.9 x 24 (11⅝ x 9½)
Purchased; T05926: R. 53

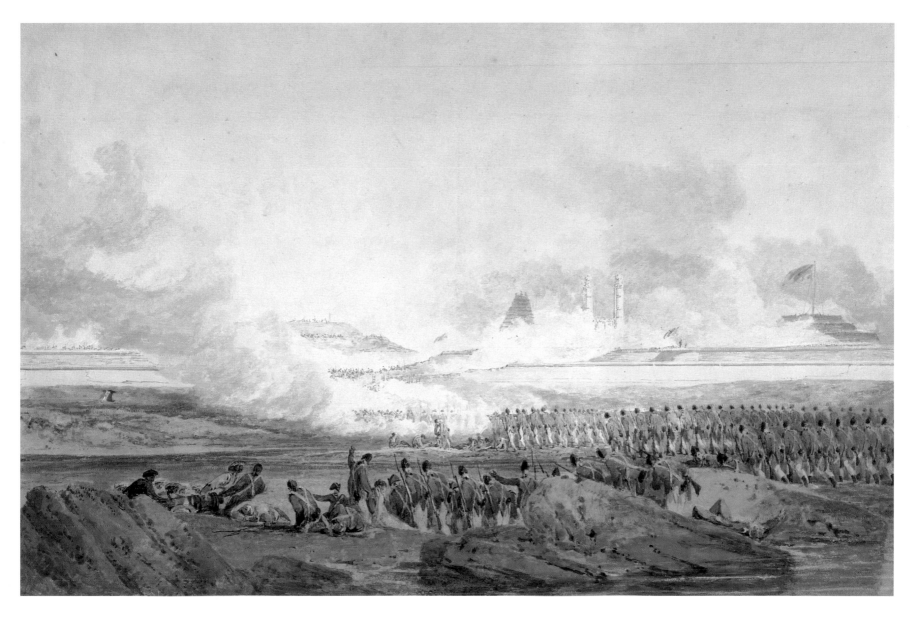

21 THE SIEGE OF SERINGAPATAM c.1800
Pencil and watercolour with gouache and scraping-out
42.1 x 65.4 (16 ⁵/₈ x 25 ³/₄)
Purchased; T04160

In July and August 1801 Turner made his first tour of Scotland, which he found 'more picturesque' than Wales, with finer mountains and 'rocks of larger masses'.[15] The starting point for his tour was Edinburgh, from which he set out on 18 July. His study of the distant profile of Edinburgh Castle and St. Giles's is one of a number of similar views of the city in his *Edinburgh* sketchbook. Begun in pencil and lightly but expressively touched with watercolour, it was perhaps made on the spot. Another favourite subject was Inverary, the model estate village and seat of the Duke of Argyll beside Loch Shira. He made various studies, both coloured and in a method he seems to have developed specifically for the Scottish tour – drawing in pencil on large sheets of paper first washed with a solution of 'India Ink and Tobacco water', and then adding highlights of 'liquid white of his own preparing'. Tate owns more than sixty of these monochrome drawings, which Ruskin christened 'Scottish Pencils'.

22 INVERARY CASTLE 1801
Pencil and white gouache on paper
prepared with a buff wash
33.2 x 48.3 (13 x 19 ¼)
Turner Bequest, LVIII 9; D03388

23 From the *Edinburgh* sketchbook 1801
ST. GILES'S AND EDINBURGH CASTLE FROM THE
EAST; ST. ANTHONY'S CHAPEL IN THE FOREGROUND
Pencil and watercolour
19.5 x 12.5 (7 ⅝ x 4 ⅞)
Turner Bequest; LV 5 v, 6: D02818,02819

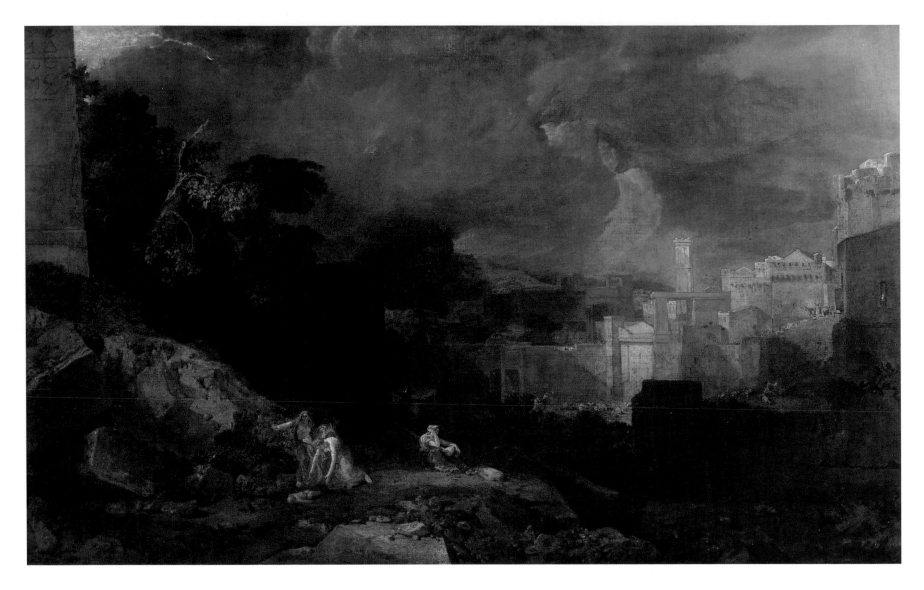

24 THE TENTH PLAGUE OF EGYPT 1802
Oil on canvas
142 x 236 (56 ½ x 93)
Turner Bequest; N00470: B & J 17

Turner had first appeared as a painter of historic landscape at the Royal Academy in 1800, when he showed his *Fifth Plague of Egypt* (Indianapolis Museum of Art). The *Tenth Plague* was exhibited two years later, with a quotation from the relevant passage in Exodus xii, 29–30, describing how 'at midnight the Lord smote all the first-born in the land'. Both pictures showed Turner's aspirations towards the highest branch of painting, the historical Grand Style, and his engagement with the contemporary taste for the Sublime, as well as with the art of Nicolas Poussin which he was able to study in more detail in the Louvre later in 1802. While more modest in scale, *Jason* was also an ambitious work, taking its subject from classical mythology – probably from an English translation of the *Argonautics* of Apollonius Rhodius. Jason steals up on the dragon which he must overcome in his quest for the Golden Fleece. Turner shows the creature as a serpent, its coils dimly emerging from the shadows, and omits the Fleece itself, interpreting the encounter of good and evil, reason and bestiality, largely in terms of the opposition of light and darkness. Contemporary critics recognised the work's 'romantic and mysterious', and essentially poetic, character, its appeal to the imagination, which they contrasted to the more literal French artists – '*geometers* of painting' – whom Turner was shortly to see in Paris.[16] There is a drawing of Jason in the *Calais Pier* sketchbook, one of those he took with him on the trip. Besides vivid drawings of his landing on the French shore in stormy weather, this contains numerous studies connected with historical compositions and some of his most important pictures of the period. The drawing of the dying Python relates to a similar theme to *Jason*, the serpent's combat with Apollo, which is the subject of another Tate picture, *Apollo and Python* (exhibited in 1811).

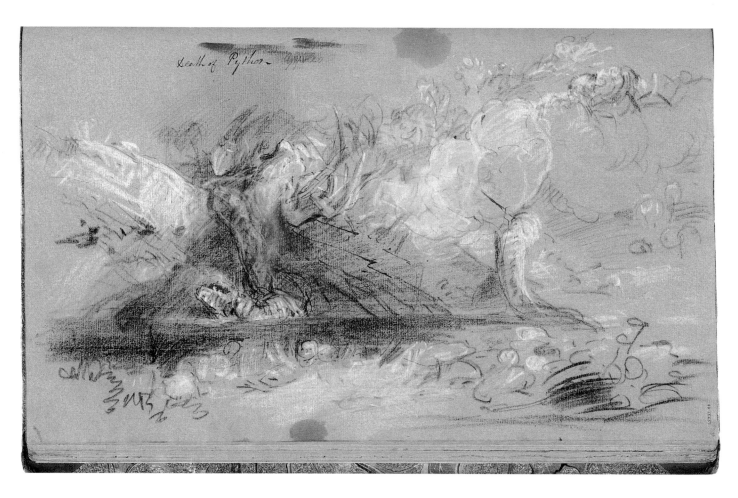

25 From the *Calais Pier* sketchbook *c.*1802
STUDY FOR 'APOLLO AND PYTHON'
Black and white chalks, pen and ink on blue paper
43.6 x 27.1 (17 ⅛ x 10 ⅝)
Turner Bequest, LXXXI, 68; D04970

26 JASON 1802
Oil on canvas
90 x 119.5 (35 ½ x 47 ⅛)
Turner Bequest; N00471: B & J 19

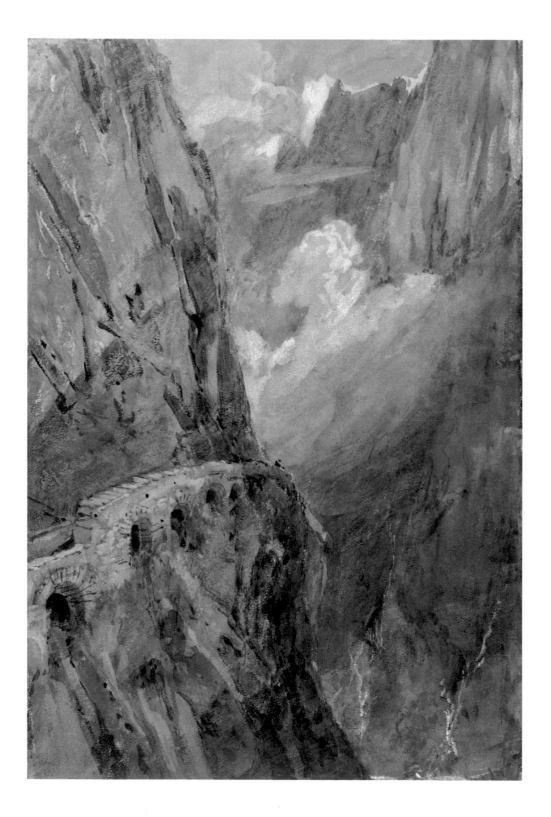

Among the most important of all Turner's tours was his first trip to the Continent in 1802, during the Peace of Amiens. He visited the Alps and Paris, with the aid of a grant from a group of patrons who wanted to give him the opportunity of studying the pictures in the Louvre. In Switzerland and Savoy, he was able to build on the experience of mountain scenery he had already enjoyed in Wales and Scotland, and amass a wealth of material for future watercolours and pictures. Tate has seven sketchbooks used in the Alps. The *Swiss Figures* book contains what its title suggests, studies of the characteristic types and costumes he encountered, but also the odd drawing of more intimate or erotic scenes which may owe as much to his imagination as to his traveller's experiences. A much larger book, now partly broken up, is the *St Gothard and Mont Blanc*. Leather-bound, and with its white pages prepared in advance with a grey tint, this was used for more elaborate studies of the most spectacular scenery, which he felt would translate most directly to finished pictures. Most often, he probably worked on the spot in pencil or chalk and added watercolour or gouache later. The coloured study made from the Devil's Bridge over the River Reuss is one of two from the book recording this famous landmark in the Schollenen gorge above Wassen. It served as the basis of two finished works, a watercolour (Abbot Hall Art Gallery, Kendal) and an oil (Birmingham City Art Gallery).

27 THE SCHOLLENEN GORGE FROM THE
DEVIL'S BRIDGE 1802
Pencil, watercolour and gouache on paper
prepared with a grey wash
47 x 31.4 (18½ x 12⅜)
Turner Bequest; LXXV 33: D04625

28 From the *Swiss Figures* sketchbook 1802
SWISS FIGURES
Pencil and watercolour
16.1 x 19.5 (6¼ x 7¾)
Turner Bequest LXXVIII, 17 verso, 18; D04816, 04817

On his return from the Alps in 1802, Turner spent some days in Paris. The *Studies in the Louvre* sketchbook, in which his annotated copy of Titian's *Christ crowned with Thorns* appears, is the main surviving evidence of the original purpose of his tour in the minds of the consortium of 'noblemen' who had largely paid for it – 'to study on the Continent the works of the great masters'.[17] The Titian is still in the Louvre today, but Turner was also able to see many pictures from Italy and the Netherlands that had been brought as plunder to swell the so-called Musée Napoléon – including the great Venetian altarpiece of *St Peter Martyr*, which he regarded, like most of his generation, as Titian's masterpiece. His comments on the *Crowning with Thorns* reveal his own sensibilities in their emphasis on how colour and contrasts of light and shade lend emotional substance to 'the flesh of Christ … the soul of the piece shrinking under the force of the Brutal'. Turner's admiration for Titian's and Veronese's pictures in the Louvre, and for Poussin's *Déluge* which he also discussed in his sketchbook, became apparent when he exhibited his own *Deluge* (see below). This probably appeared in the 1805 exhibition in his own Gallery, with his *Shipwreck*, for which the double-page drawing in the *Shipwreck* sketchbook is a study. Here, as he brushes his dark washes in an oppressive vortex around the hull of the doomed ship, Turner seems to turn chiaroscuro to the same tragic purpose as Titian had done.

29 From the Studies in the *Louvre* sketchbook 1802
COPY OF TITIAN'S 'CHRIST CROWNED WITH THORNS'
Pencil and watercolour
12.7 x 11.5 (5 x 4 ½)
Turner Bequest; LXXII 51 v, 52: D04339, 04340

... Pillar is whose different as to
effect the most powerfull in the flesh
the drapery common only so extend the
height upon the Soldier to the right the
and the being yellow help up warmth
and mellow the flesh of Christ shed
is the Soul of the piece shrinking
under the force of the brutal Soldier with
filial resignation yet with dignity he
abhear to bear their insults while
the irritation of the dogs endeavate
excesive pain and exertion to
sustain it —

As on a freems brown
Ground paners brown and timber the
flesh is thicker than in the tenbra but
the same process, the Crimson drapery

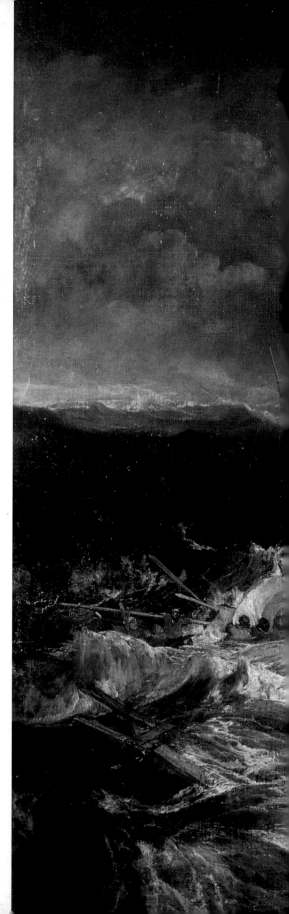

30 From the *Shipwreck (No.1)* sketchbook
STUDY FOR 'THE SHIPWRECK' *c*.1804
Pen and brown ink and watercolour
11.7 x 18.1 (4 ⅝ x 7 ⅛)
Turner Bequest; LXXXVII 16, 17: D05391, 05392

31 THE SHIPWRECK 1805
Oil on canvas
170.5 x 241.5 (67 ⅛ x 95 ⅛)
Turner Bequest; N00476: B & J 54

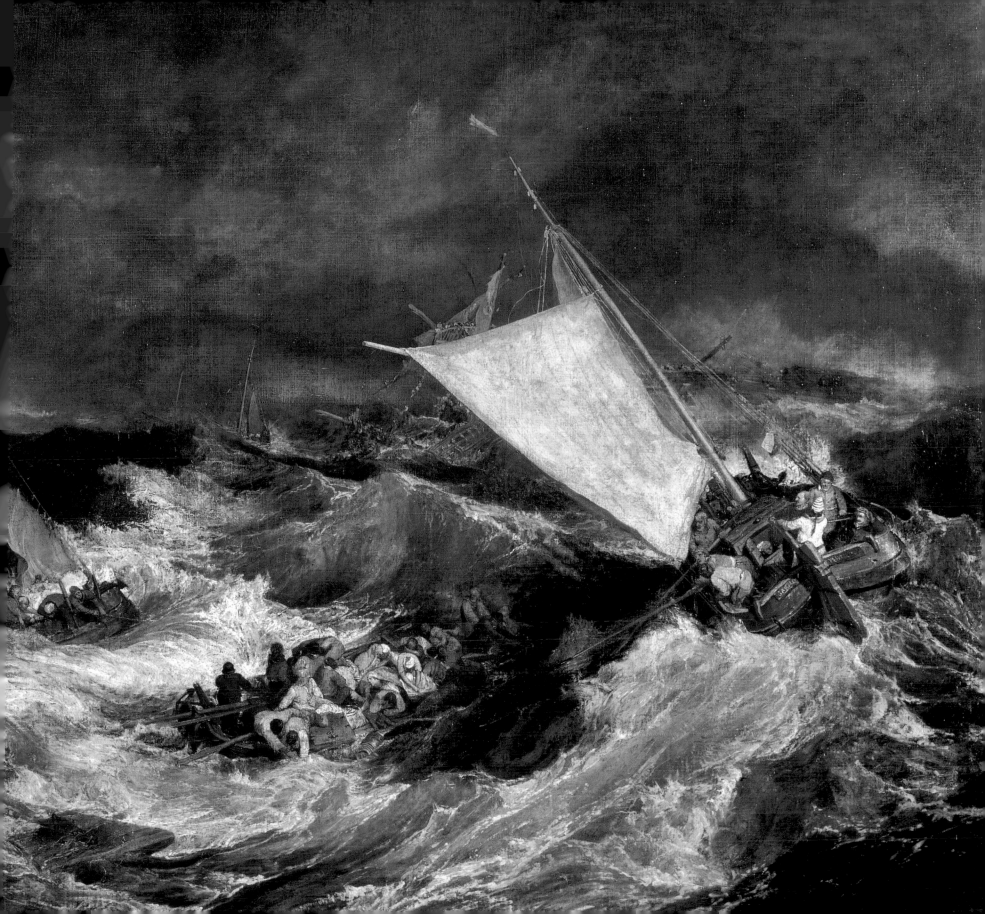

An impressive tribute to Poussin's work in the Louvre and an exercise in the Grand Style at its grandest, Turner's *Deluge* must have been exactly the sort of picture his noble patrons hoped would emerge from his studies in Paris. But Tate's collections provide evidence to suggest it had a more urgent contemporary message. In Tate's *Academies* sketchbook, in a list of current patrons, appears the name of John Joshua Proby, first Earl of Carysfort, beside a 'Historical' work priced at £300. Though the subject is unspecified, the price would fit a picture of this size and date, and moreover a mezzotint of *The Deluge* engraved by J. P. Quilley in 1828 was dedicated to Carysfort. If, as seems likely, the Earl intended to buy the picture, Turner's treatment of the biblical narrative seems also to be calculated to appeal to him. Carysfort was a supporter of the anti-slavery movement, and would have responded warmly to Turner's rendering in the right foreground of a heroic negro helping to rescue a drowning woman.

The *Goddess of Discord* is another transcription of Poussin with contemporary messages. Discord chooses the apple that was eventually awarded by Paris to the goddess Aphrodite, leading to the Trojan War. Like the Punic War between ancient Rome and Carthage, this had parallels in Turner's mind with the modern Napoleonic War, and he sets his classical narrative in Alpine scenery, a reminder that it had been Napoleon's invasion of Italy by way of the Alps in 1796, and his annexation of the Swiss Cantons in 1798, that had helped start it. The presiding dragon – in mythology the brother of the one slain by Jason in his quest for the Golden Fleece (see no.26) – appears almost as an emanation of the mountains.

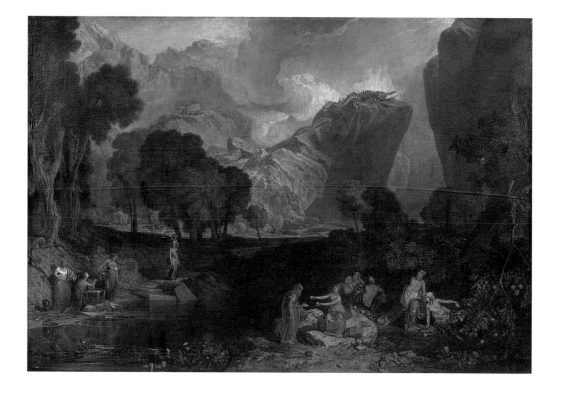

32 THE GODDESS OF DISCORD CHOOSING THE APPLE OF
CONTENTION IN THE GARDEN OF THE HESPERIDES 1806
Oil on canvas
155 x 218.5 (61 ⅛ x 86)
Turner Bequest; N00477: B & J 57

33 THE DELUGE ?1805
Oil on canvas
143 x 235 (56 ¼ x 92 ¾)
Turner Bequest; N00493: B & J 55

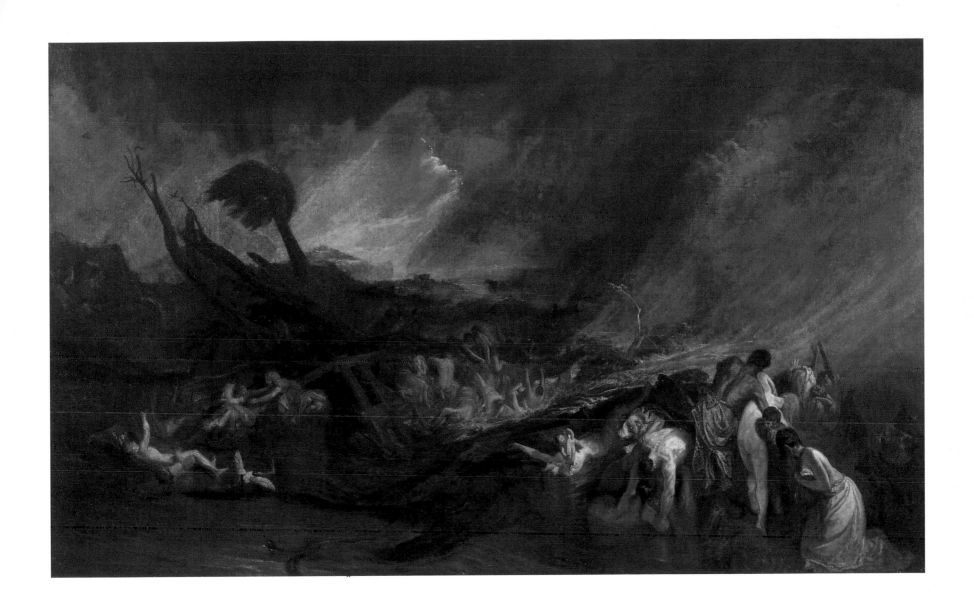

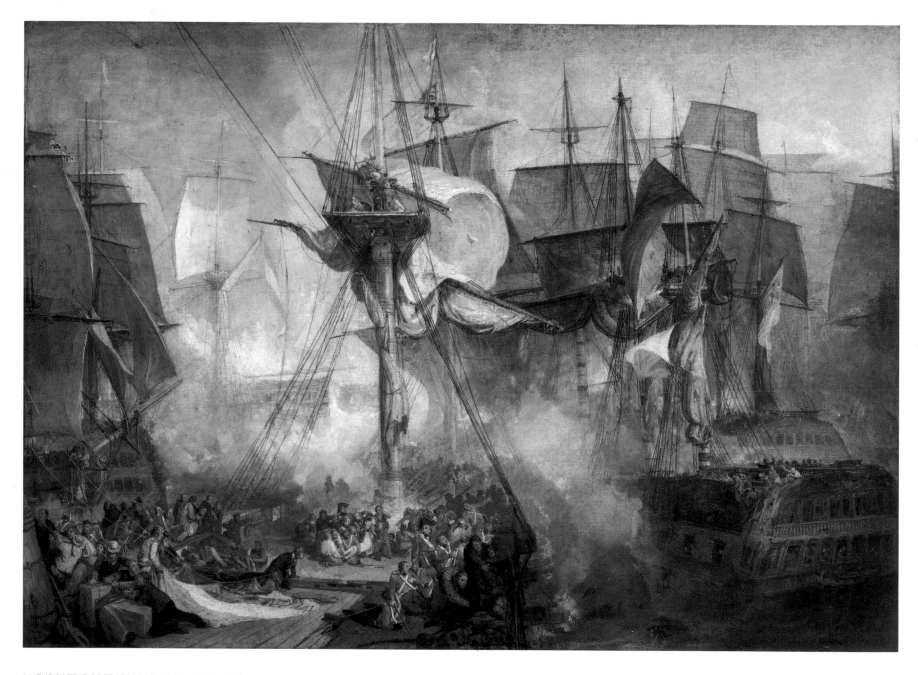

34 THE BATTLE OF TRAFALGAR, AS SEEN FROM THE
MIZEN STARBOARD SHROUDS OF THE VICTORY 1806
(reworked 1808)
Oil on canvas
171 x 239 (67 ¼ x 94)
Turner Bequest; N00480: B & J 58

The maritime events of the Napoleonic War enabled Turner to combine marine painting with contemporary reportage. His first modern battle subject, *The Battle of the Nile*, had been exhibited in 1799 but is now lost. It depicted Nelson's victory over the French fleet in Aboukir Bay and apppeared in competition with four other pictures of the battle in the Royal Academy. Nelson's final victory at Trafalgar on 21 October 1805, during which he lost his life, was an even greater challenge to painters, for they had to blend national celebration with national mourning. Turner went to Sheerness that December to see Nelson's flagship the *Victory* arrive with his body on board. He boarded the ship as soon as he could and interviewed her crew. His drawing of the quarterdeck, carefully annotated with pointers to splinter marks and damaged rails and a record of the capacity of the guns, is one of a number of Tate drawings associated with this trip and with the commemorative picture he planned for the following spring. These include memoranda in his *Nelson* sketchbook and larger separate sheets, notably a coloured key and description of the main action of his picture; this was probably given to visitors who saw it in his Gallery in 1806, rather like the Salon *livrets* which he must have remembered from his visit to Paris. The picture combines the moment of Nelson's death, struck down by a French sniper, with the French concession of defeat, symbolised by the tricolour being laid on the *Victory*'s deck.

35 THE QUARTERDECK OF THE 'VICTORY' 1805
Pencil, watercolour, pen and ink
42.4 x 56.5 (16 ¾ x 22 ¼)
Turner Bequest; CXXI S: D08275

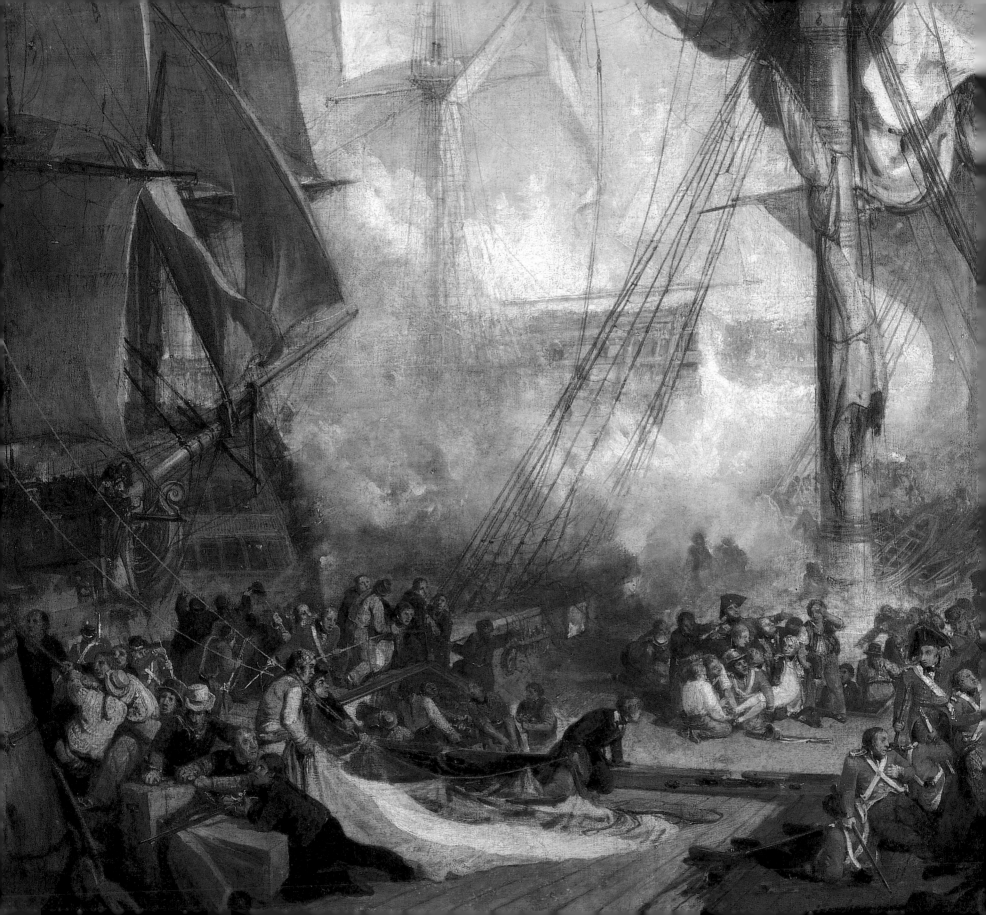

Turner's *Spithead* was a more controversial subject. Following
a misguided attempt by the British to preempt a possible alliance
between neutral Denmark and Napoleon by bombarding
Copenhagen and seizing the Danish fleet, the captured Danish
ships arrived under escort at Portsmouth late in 1807. Once again
Turner went to watch; Tate's *Spithead* sketchbook contains his
observations, and the picture, first shown at his gallery in 1808,
shows two of the ships, the *Three Crowns* and the *Denmark*, that
arrived on 1 November. Possibly Turner also provided this picture
with an explanatory document, since one reviewer, John Landseer,
described its subject very clearly. Its current, non-specific title
dates from its reappearance in the Academy the following year,
by which time – mainly due to the British provocation – Denmark
had indeed joined Napoleon and the whole episode had become
so contentious that Turner dissociated himself and his picture
from it.

36 SPITHEAD: BOAT'S CREW RECOVERING AN ANCHOR 1808
Oil on canvas
171.5 x 235 (67 ½ x 92 ⅝)
Turner Bequest; N00481: B & J 80

In 1805, Turner undertook a concentrated programme of sketching from nature along the Thames west of London, working on canvas, panels of mahogany veneer, and in watercolour. This was prompted by his having taken a weekend and holiday property, Sion or Syon Ferry house at Isleworth, and by his concern to develop a distinctive style of English pastoral landscape to counterbalance his grander pictures. His watercolour view of Benson is one of a series of freely brushed, freshly coloured studies originally in his *Thames from Reading to Walton* sketchbook, one of the five in Tate associated with this campaign of open-air work. Here the effect is one of vivid naturalism, as it is again in the oil sketch made near Walton Bridges, one of eighteen in the collection made on a trip from Isleworth to Windsor, and then along the Wey, a tributary of the Thames, as far as Godalming. Although oil sketching from nature was currently in vogue – and being brought to a high level of sophistication by Constable – Turner usually preferred to work outdoors in watercolour and the Thames and Wey panels constitute an exceptional group. Tate's fifteen sketches or unfinished compositions on canvas, of both the pastoral Thames and the Estuary (see no.44), are also exceptional. They were painted very loosely, in thinly diluted paint, over a white ground, on unstretched canvas presumably tacked to a board support. Many of these too were probably outdoor work, as a friend of Turner's, the Revd H.S. Trimmer, remembered him painting in his boat 'on a large canvas direct from Nature'.[18] Again, Turner was assimilating a greater naturalism and luminosity into his work. It is possible that some of the finished pictures he was soon exhibiting of the Thames, such as his view of Dorchester shown in 1810, may have been begun in this way and completed in the studio. In this picture, Turner has moved beyond a literal view, bringing the spire of Abingdon church into closer focus than is possible from the meadows at Dorchester, over six miles away. Turner bought the picture back in 1829, when it was sold by its original purchaser, George Hibbert.

37 THE THAMES NEAR WALTON BRIDGES 1805
Oil on mahogany veneer
37 x 73.5 (14 ⅝ x 29)
Turner Bequest; N02680: B & J 184

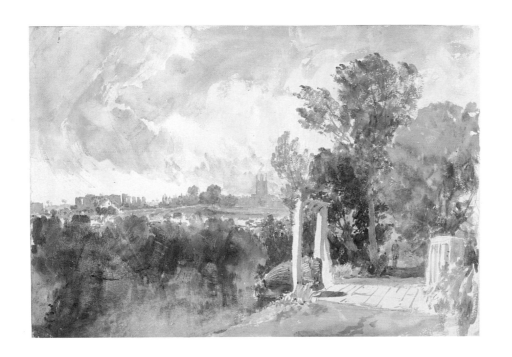

38 BENSON NEAR WALLINGFORD 1805
Pencil and watercolour
25.9 x 37.1 (10 ⅛ x 14 ⅝)
Turner Bequest; XCV 13: D05917

39 DORCHESTER MEAD, OXFORDSHIRE 1810
Oil on canvas
101.5 x 130 (40 x 51 ¼)
Turner Bequest; N00485: B & J 107

Turner's fresh interest in English subjects in the first decade of the new century extended beyond pure landscape to scenes of working life. In part this arose from his concern with realism, but it also responded to the new fashion for narrative 'genre', initiated by the young Scottish painter David Wilkie. Turner painted his *Country Blacksmith* as a riposte to Wilkie's *Village Politicians* shown at the Royal Academy in 1806; both pictures focused on vigorous debate or dispute among rustic characters and were modelled on seventeenth-century Dutch low-life painting, while having a distinct contemporary resonance – in Wilkie's case revolutionary Jacobinism among the rural poor, in Turner's the price rises occasioned at the smithy by the Pig Iron Duty Bill of 1806. In the 1807 Academy, Turner's picture was hung alongside Wilkie's latest success, *The Blind Fiddler* (Tate), which, some observers felt, it 'flung into eclipse'.[19] Turner himself was sufficiently fond of the picture to buy it back in 1827 when it was sold from the estate of its original purchaser, Lord De Tabley. Wilkie also helped to influence Turner's *Harvest Home*, apparently an unfinished picture intended, together with a reaping scene, for his patron the Earl of Essex and depicting events on his Hertfordshire estate, Cassiobury Park. Tate has drawings for both subjects, the one for this picture labelled 'Ld Essex's Harvest Home'. According to a contemporary account, Turner was put off finishing it by 'some remarks' about his work. Contemporary agricultural practice is also the main theme of his Windsor view, exhibited at his Gallery in 1809. If its workaday title and location of the subject as 'near Slough' seem perverse for a view including the royal castle, these did at least emphasise the crop rotation and turnip cultivation introduced on the royal lands by 'Farmer George', King George III, which helped to maintain food supplies during the Napoleonic War.

40 A COUNTRY BLACKSMITH DISPUTING UPON
THE PRICE OF IRON, AND THE PRICE CHARGED
TO THE BUTCHER FOR SHOEING HIS PONEY 1807
Oil on pine panel
55 x 78 (21 ⅝ x 30 ⅝)
Turner Bequest; N00478: B & J 68

41 HARVEST HOME *c.*1809
Oil on pine panel
90.5 x 120.5 (35 ⅝ x 47 ½)
Turner Bequest; N00559: B & J 209

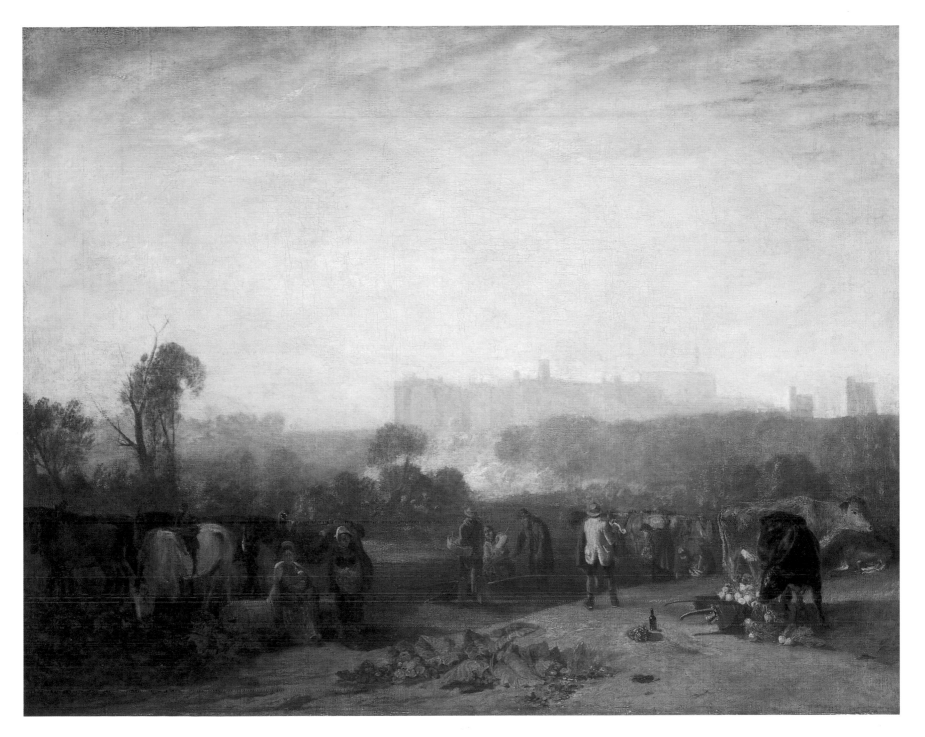

42 PLOUGHING UP TURNIPS, NEAR SLOUGH 1809
Oil on canvas
102 x 130 (40 ⅛ x 51 ¼)
Turner Bequest; N00486: B & J 89

Having first trained as an architectural draughtsman, and occasionally venturing as an architect himself, Turner had a lifelong interest in buildings. This proved particularly useful when he came to prepare large illustrations for his lectures as Professor of Perspective at the Royal Academy, given from 1811. His views of the Brocklesby Mausoleum and of the Academy's Great Room at Somerset House were both made for these and are among the large number of his lecture props at Tate today. The first was based on memoranda taken on a visit to Brocklesby, the Lincolnshire seat of his patron the Earl of Yarborough, perhaps in 1797. Tate's *Brocklesby Mausoleum* sketchbook has been given various dates ranging up to about 1804. The building had been completed in 1794 to the design of James Wyatt. A large aquatint by F.C. Lewis, undated but certainly made after Turner's election as Royal Academician in 1802, reproduces a view of the exterior, perhaps a joint work of the architect as well as Turner. Since Turner had apparently made finished watercolour views of the house and mausoleum, which were later destroyed in a fire, it is possible that his lecture illustration was based on an earlier watercolour that formed a companion to the exterior view. A number of the illustrations depicted actual historic or recent buildings. The Great Room was a subject of special interest to Turner and his audience, since it was the Academy's principal exhibition room.

45 INTERIOR OF BROCKLESBY MAUSOLEUM,
lecture diagram 76 c.1810
Pencil and watercolour
64 x 49 (25 1/4 x 19 1/4)
Turner Bequest; CXCV 130: D17101

46 THE INTERIOR OF THE GREAT ROOM,
SOMERSET HOUSE, lecture diagram 26 *c.*1810
Pencil and watercolour
66.9 x 100 (26 ³/₈ x 39 ³/₈)
Turner Bequest; CXCV 70: D17040

47 THE CRYPT OF KIRKSTALL ABBEY 1812
First published state from the Liber Studiorum
Etching, aquatint and mezzotint
18.1 x 26.4 (7 ¹/₈ x 10 ³/₈), 30 x 44.1 (11 ³/₄ x 17 ³/₈),
21.1 x 29.2 (8 ⁵/₈ x 11¹/₂)
Presented by A.A. Allan through the National Art
Collections Fund 1925: A00898

Turner presented an impression of the Brocklesby aquatint
to his friend Sir John Soane, the Academy's Professor of
Architecture, in 1804, and that same year Soane's wife bought,
from the exhibition in Turner's Gallery, the watercolour on
which the later mezzotint of Kirkstall was based. Originally made
in 1798, this complex, asymmetric view of the crypt with its
gloomy vaulting probably reminded the Soanes of prints by
Piranesi, which they also collected. The print of this subject
was one of those Turner engraved himself for his series of
illustrations of different landscape types, the *Liber Studiorum*,
which he began in 1807. It was made for the 'Architectural'
category of the *Liber*.

In the late summer of 1813 Turner toured in Devon. The weather was hot and fine, and he made one of his occasional experiments with oil sketching outdoors, prompted by artist-friends Charles Eastlake and Ambrose Johns, who accompanied him on his outings. Johns provided him with a portable painting-box and other requisites. Tate has twelve of the fifteen surviving sketches, of which the view of the Plym from Boringdon Park is the largest and most pictorial, including figures and animals; the effect is that of a classic panorama on the Claudean formula that Turner described in one of the plates to his *Liber Studiorum* as 'The bridge in the Middle Distance'. His painting *Crossing the Brook,* exhibited at the Royal Academy in 1815, achieves the same on a grander scale, translating his recollections of the Tamar estuary into a paraphrase of Claude. The two girls in the foreground are said to be Turner's illegitimate daughters, and he was always reluctant to sell the picture. In contrast to the formal grandeur of his estuary views, his finished watercolour of Ivy Bridge is a more concentrated and picturesque account of the dense trees and rock-strewn banks of the River Erme. The coach and passengers crossing the bridge surely mark Turner's own visits to it, in 1811 as well as 1813. The watercolour was one of only four engraved for a set of views of the 'Rivers of Devon' proposed by Turner's publishers, the Cookes, but subsequently abandoned.

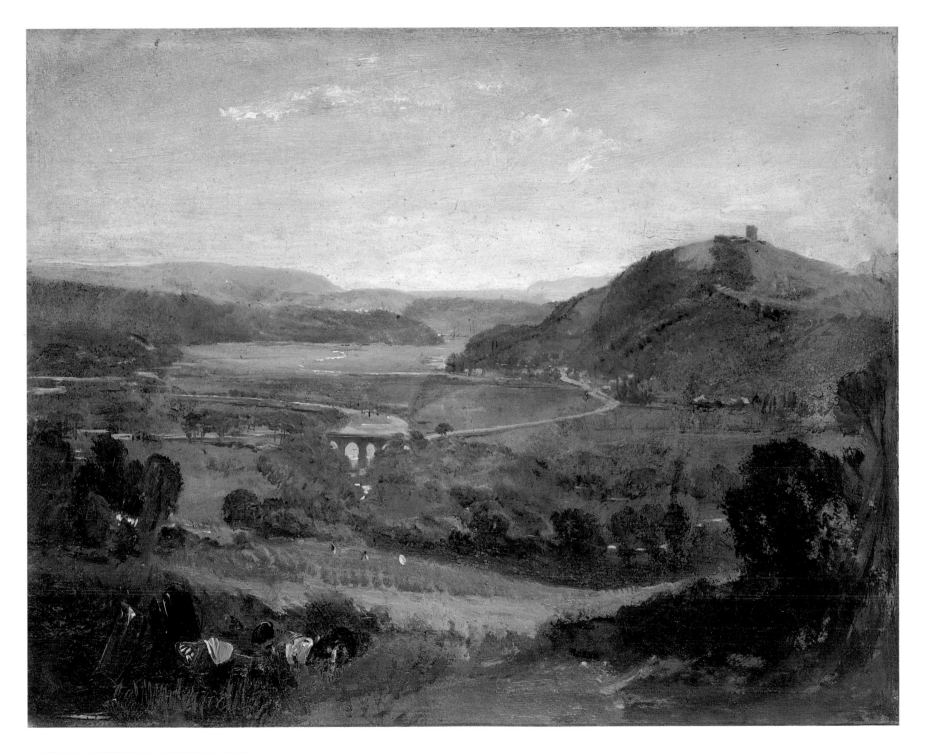

48 THE PLYM ESTUARY FROM BORINGDON PARK 1813
Oil on prepared paper
23.5 x 29.8 (9 ¼ x 11 ¾)
Turner Bequest; CXXX E: D02911: B & J 217

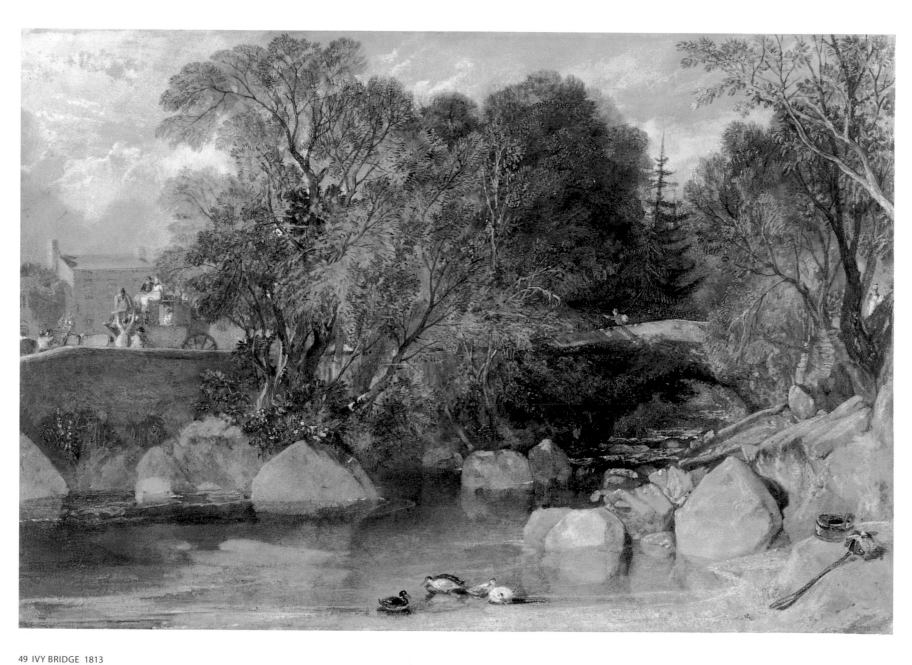

49 IVY BRIDGE 1813
Watercolour
28 x 40.8 (11 x 16)
Turner Bequest; CCVIII X: D18157

50 CROSSING THE BROOK 1815
Oil on canvas
193 x 165 (76 x 65)
Turner Bequest; N00497: B & J 130

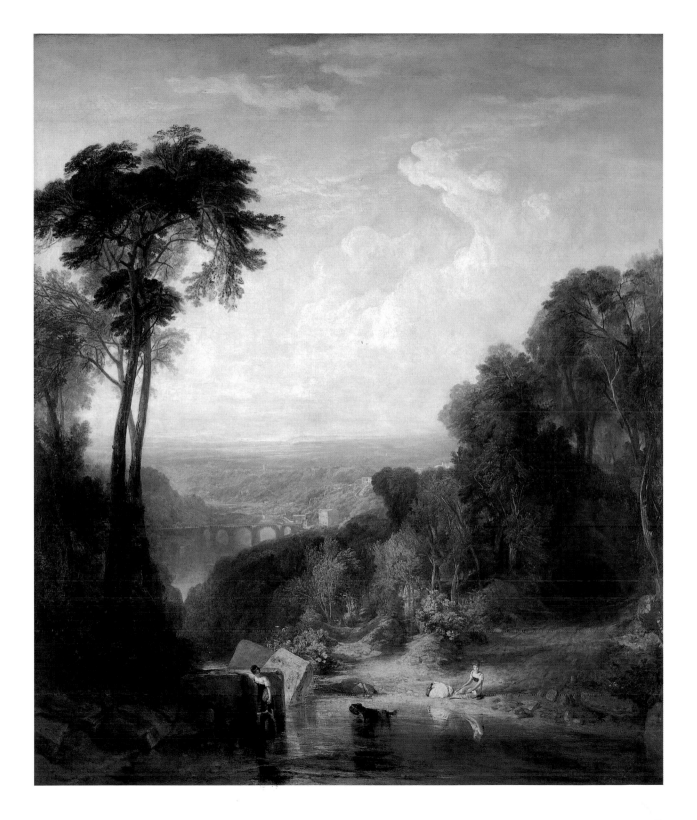

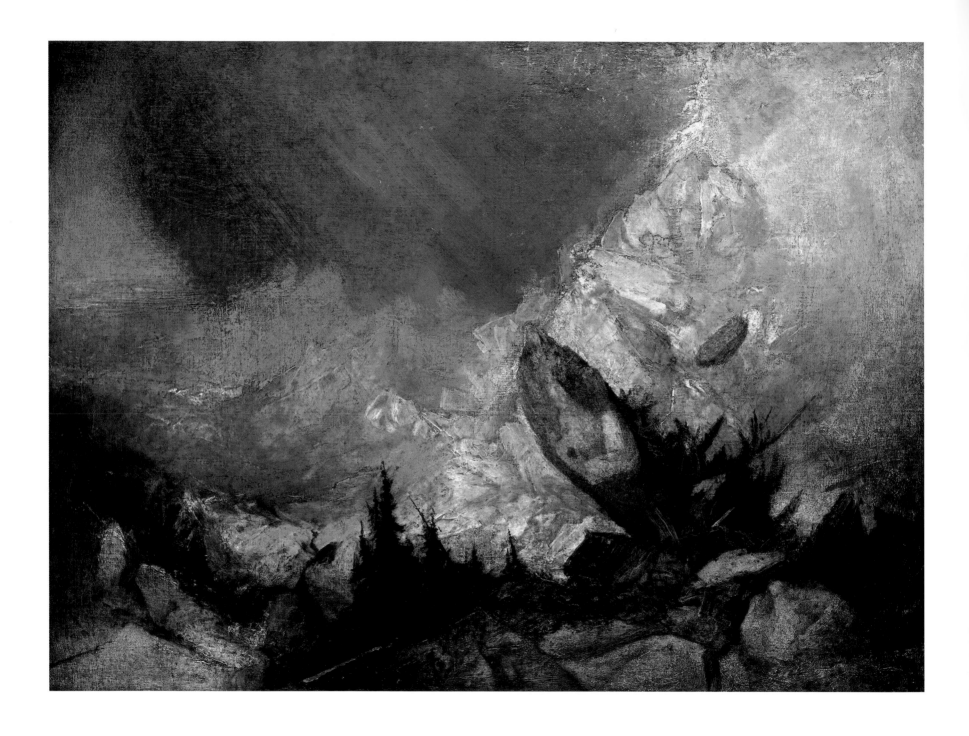

Turner's Alpine tour in 1802 provided him with a wealth of material for pictures and watercolours in the following years. Here, he combined his recollections with largely imaginary effects of extreme weather, which he could not have experienced for himself in the benign conditions of late summer. His *Avalanche in the Grisons,* exhibited in 1810, took him into territory as well as circumstances he had not seen, for his route had actually missed the Grisons altogether. But he was probably prompted to imagine them, from his drawings of other mountain valleys, by reading of a disastrous avalanche at Selva in the Grisons in December 1810, when twenty-five people were killed in a single chalet. His picture shows just such a chalet crushed by a huge rock, but no figures; it is otherwise a pure landscape, a work of natural history constructed around the wildest forces of nature. Yet it also had a contemporary historical significance, for it had been with his crushing of the Grisons provinces that Napoleon had launched his first blows at the Swiss republic. In 1812, Turner made a further coded reference to Napoleon, this time through an analogy with the ancient Carthaginian, Hannibal, who had invaded Italy via the Alps. In the year of Napoleon's fatal Russian campaign, which marked the beginning of the end of his dreams of a European empire, *Snowstorm: Hannibal and his Army crossing the Alps* reduced its alleged subject to virtual invisibility in an apocalyptic mountain blizzard – a timely British snub to Napoleon's inflated ambitions. The blizzard was not a complete invention, for it was based on one seen a couple of years earlier when Turner was staying with his patron Walter Fawkes in Yorkshire. On that occasion, Turner is said to have told his host's son that later he would see the blizzard again, and call it Hannibal crossing the Alps.

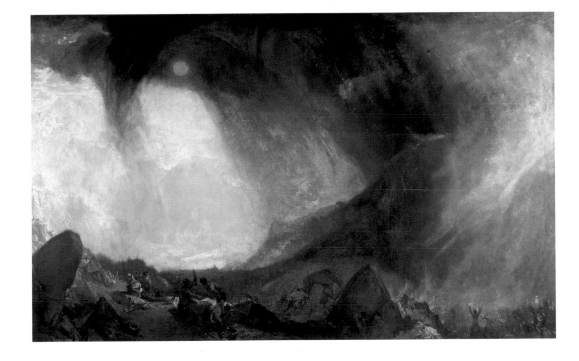

51 THE FALL OF AN AVALANCHE IN THE
GRISONS 1810
Oil on canvas
90 x 120 (35 ½ x 47 ¼)
Turner Bequest; N00489: B & J 109

52 SNOW STORM: HANNIBAL AND HIS ARMY
CROSSING THE ALPS 1812
Oil on canvas
146 x 237.5 (57 ½ x 93 ½)
Turner Bequest; N00490: B & J 126

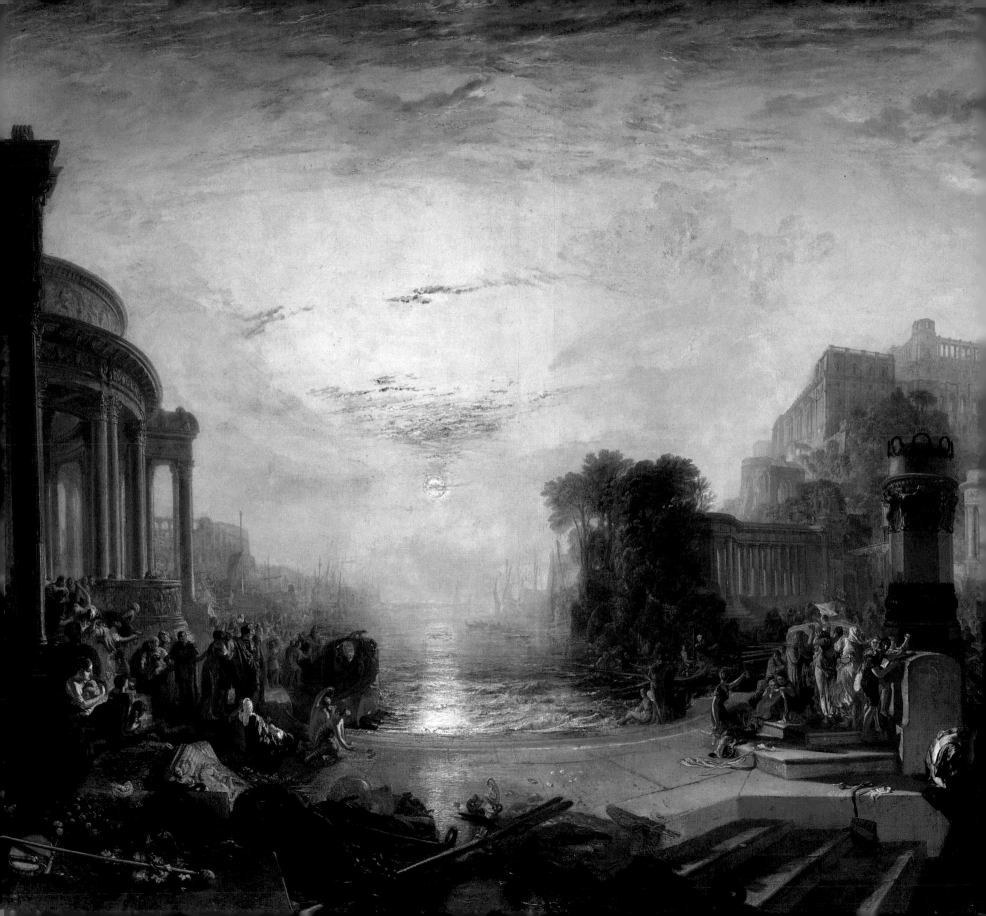

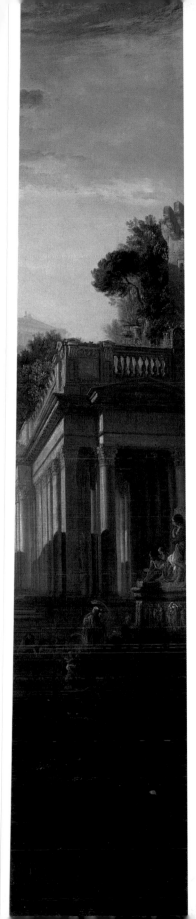

Of all the Old Masters, Claude was Turner's favourite, as often coming to mind when he looked at real landscape as when he was inventing compositions in the studio. Besides his direct nature studies in oil and watercolour made along the Thames in 1805 (see nos.37, 38), Turner had also made many others in which the river scenery was transformed into Claudean vistas and inhabited by mythical and historical figures. His *Studies for Pictures: Isleworth* sketchbook contains both nature studies and ideas for scenes of classical history, among them the first, coloured design for *Dido and Aeneas*, exhibited at the Royal Academy in 1814. Turner painted many pictures on the theme of the love affair between Dido, Queen of Carthage, and Aeneas, who was delayed by it from his ultimate destiny as founder of Rome. Here, the newly arrived Aeneas encounters the Queen on her early morning departure for hunting and 'sylvan games'. Turner's two greatest essays in Claude's style were *Dido building Carthage* and *The Decline of the Carthaginian Empire*, exhibited at the Royal Academy in 1815 and 1817. They were conceived as a pair on the theme of the rise and fall of empires – seen by Turner's Romantic generation as a historical inevitability once again proved by the fall of Napoleon but eventually bound to overtake the victorious British too. Today they are separated, only the latter being at Tate while the former, as Turner requested, hangs in the National Gallery alongside Claude himself.

53 THE DECLINE OF THE CARTHAGINIAN
EMPIRE 1817
Oil on canvas
170 x 238.5 (67 x 94)
Turner Bequest; N00499: B & J 135

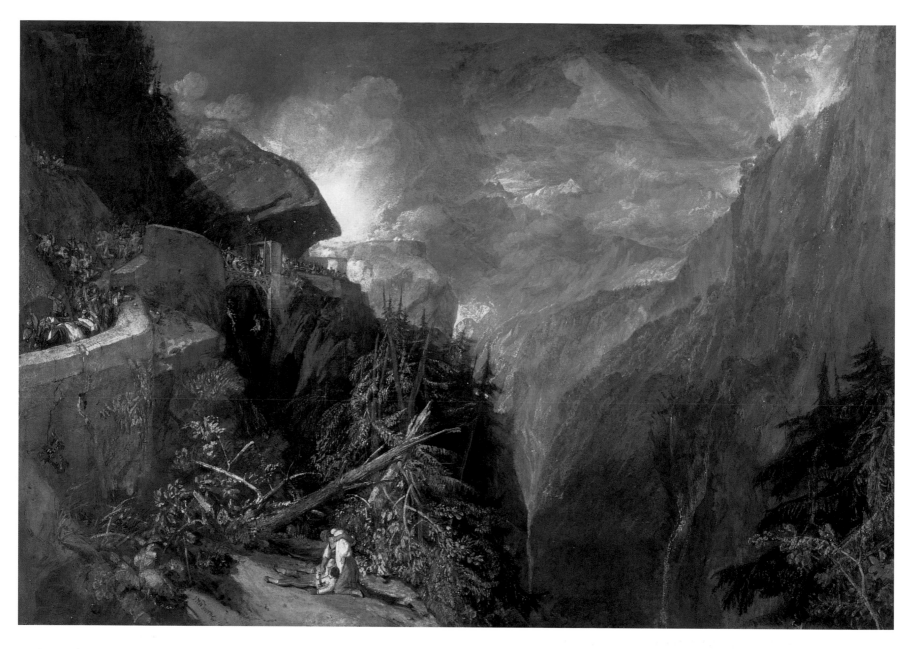

59 THE BATTLE OF FORT ROCK, VAL D'AOUSTE, PIEDMONT, 1796 1815
Watercolour and gouache
69.6 x 101.5 (27 ³/₈ x 40)
Turner Bequest; LXXX G: D04900

As the Napoleonic War came to an end, many artists including Turner responded to the challenge of these momentous events. His own closest encounter with them had been in 1802, when his Alpine tour had taken him through territory that had recently witnessed significant fighting during Napoleon's invasions of Italy. His watercolour of *The Battle of Fort Rock,* shown at the Royal Academy in 1815, supposedly referred back to an incident during Napoleon's first Italian campaign in 1796. In fact it was a characteristic work of imagination as much as memory, for while the magnificent landscape setting was based on drawings made during the 1802 tour, no battle is known to have taken place at Fort Roch in the Aosta valley. It is possible that Turner had conflated this scenery with accounts of one at Fort Bard, a narrow defile off the Saint Bernard Pass, where in 1800, before their important victory at Marengo, the French had been halted by the Austrians, but, mounting their cannon on the roof of a nearby church, had blasted the fort into submission.

In the watercolour, Mont Blanc and the Alps rear above the battle, apparently indifferent to human conflict, but Turner's compassion is evident in the Alpine villager tending a wounded soldier in the foreground. In his later painting commemorating the Battle of Waterloo, it restrained him from overt celebration of victory and moved him instead to a meditation on the sorrows and sufferings of battle, shared alike by friend and foe. Based on a visit to the battlefield in 1817 and exhibited the following year, the picture does not show the battle itself but its aftermath, when the dead and dying litter the field and their loved ones search for them by the light of flares – lit more to deter looters than for their benefit. In the background, the farm buildings of Hougoumont are still burning. Turner took his characteristically Romantic conception of individual suffering and tragedy from the verses from Byron's poem *Childe Harold's Pilgrimage* – which he quoted with the picture – describing 'friend and foe … in one red burial blent'.

Overleaf
60 THE FIELD OF WATERLOO 1818
Oil on canvas
147.5 x 239 (58 x 94)
Turner Bequest; N00500: B & J 138

101

Turner's 1817 tour also took him along the Rhine from Cologne to Mainz, travelling upstream along the west bank and returning mainly by boat. Afterwards he toured the Netherlands. Tate has three sketchbooks associated with the Rhine trip, the *Waterloo and Rhine* and *Rhine*, used exclusively on the continent, and the *Itinerary Rhine Tour* used then and afterwards at Raby Castle, where Turner went directly on his return and where he may have finished the watercolours based on his drawings, which he sold very soon afterwards to Walter Fawkes. Later, Turner repeated some of these subjects in a larger or more elaborate form for other patrons. Other repetitions were made for a set of Rhine views proposed by Turner's publisher, W.B. Cooke. Tate has two colour studies of Sooneck and Bacharach, one (not that reproduced here) on paper watermarked 1819. Both were probably made in anticipation of the second watercolour of the subject made around 1820 (Aberdeen Art Gallery). Another Tate sketchbook, the *Dort,* used on the Dutch part of the tour, contains pencil sketches of the towns of Brill and Masensluys from offshore, which provided the background for *Entrance to the Meuse*. The sunlit shoreline and profile of Brill church, set low against the vast, billowing sky, combine with the full title to give a very precise fix on the picture's location – the dangerous sandbank on which Turner's merchant-ship has foundered, losing its cargo of oranges. This disaster is a pun on the current financial difficulties of the Dutch House of Orange, which had made huge investments on the London markets but suffered heavy losses in 1817–18 when sterling fell in value and the Bank of England sold off its gold bullion, imposing the use of notes or silver instead.

61 BURG SOONECK WITH BACHARACH IN THE DISTANCE;
COLOUR STUDY *c.*1819–20
Watercolour
40.3 x 56.7 (15 7/8 x 22 1/4)
Turner Bequest; CCLXIII 182: D25304

62 ENTRANCE TO THE MEUSE: ORANGE-MERCHANT ON THE
BAR, GOING TO PIECES; BRILL CHURCH BEARING S.E. BY S.,
MASENSLUYS E. BY S. 1819
Oil on canvas
175.5 x 246.5 (69 x 97)
Turner Bequest; N00501: B & J 139

While Turner had offered only qualified comments on the end of the Napoleonic War, his celebration of the return of peace was unrestrained. A year after he showed his *Field of Waterloo*, he exhibited a large and expansive view of Richmond Hill that was unequivocally joyous in its depiction of an archetypal national landscape replete with personal and patriotic associations. The view of the Thames from Richmond, already a famous one, is presented with classical grandeur, while the elegant figures, who have unveiled the national flag from a tree, are celebrating the birthday of the Prince Regent – an official date which was shared both with St George's Day and with Turner's own birthday. By this time, Turner was investigating the compositional and tonal structure of compositions in both oil and watercolour in preparatory watercolour studies, sometimes called 'colour beginnings'; that of Richmond Hill with its indications of a large crowd of figures is one of several that may be related to the 1819 oil.

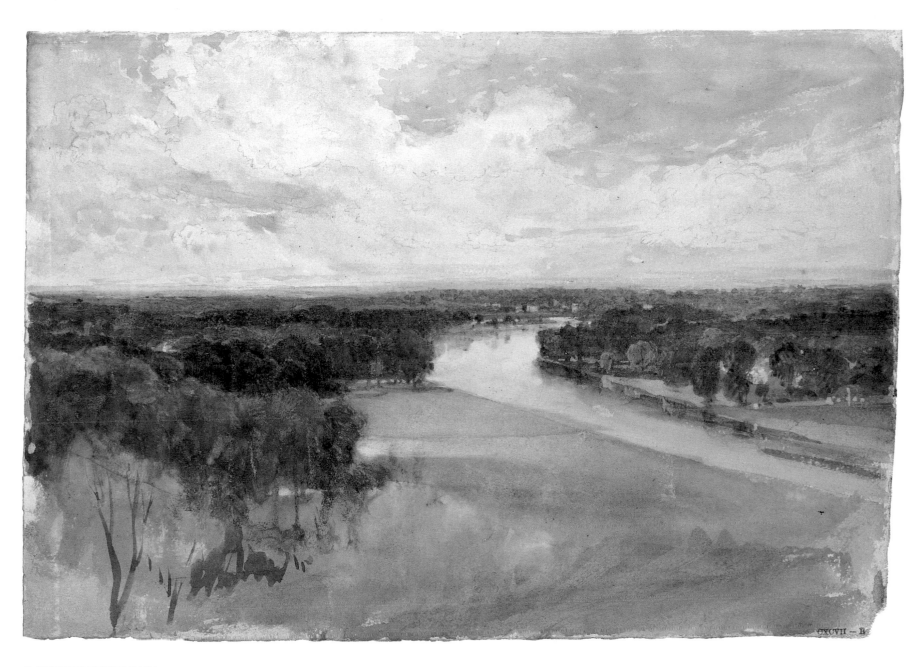

CXCVII — B

63 VIEW FROM RICHMOND HILL *c.*1815
Pencil and watercolour
18.8 x 27.2 (7 ³/₈ xs 10 ³/₄)

64 ENGLAND: RICHMOND HILL, ON THE PRINCE REGENT'S BIRTHDAY
1819
Oil on canvas
180 x 334.5 (70 $\frac{7}{8}$ x 131 $\frac{1}{4}$)
Turner Bequest; N00502: B & J 140

In August 1819 Turner set off for his first visit to Italy. He returned to London the following January. Tate has twenty-three sketchbooks used during the tour, many of whose pages have been removed and mounted separately. Turner's watercolour view of Como was originally made in his *Como and Venice* sketchbook, together with another, similar but without the boats on the lake. These were the first watercolours he made in Italy, having so far confined himself to pencil memoranda. Compared with the sonorous tones of many of his views of mountain lakes made on his first Alpine tour in 1802, and more recently with his drawings of the Rhine, these first impressions of Italy are brilliant and fresh, translucent tints being laid very lightly over white paper, the natural colour of which is allowed to flood the scene with an inner light. This subtlety of touch was soon apparent again in some of the Venetian studies Turner added to the same sketchbook. The most obviously beautiful of these are views of the city across water, its skyline set low beneath expanses of sky. By contrast, Turner's closer sketch of St Mark's and the Doge's Palace from the Bacino looks more functional, untidy even, both sky and water washed with a strong blue and the architecture brushed in with a beige tint. Here, Turner was perhaps already thinking of a picture of essentially architectural topography, within the tradition of Venetian *vedute* established by Canaletto. The stronger colour may also be a matter of timing – the effect being that of the middle of the day rather than morning or evening. When he reached Naples, during a tour south from Rome, Turner again chose white paper for some panoramic views across the bay to Capri and Sorrento. This was the more deliberate as other pages in the sketchbook he used for them, *Naples: Rome C* [?olour]. *Studies*, had been washed in advance with a grey ground. Here again, colour is used very lightly, mainly in the foreground and architecture, so that the glassy bay and distant mountains seem lost in a shimmer of autumn sunlight.

65 NAPLES, THE CASTEL DELL'OVO 1819
Pencil and watercolour
25.5 x 40.4 (10 x 15 ⅞)
Turner Bequest; CLXXXVII 6: D16093

66 VENICE: CAMPANILE AND DUCAL PALACE 1819
Pencil and watercolour
22.5 x 28.9 (8 ⅞ x 11 ⅜)
Turner Bequest; CLXXXI 7; D15258

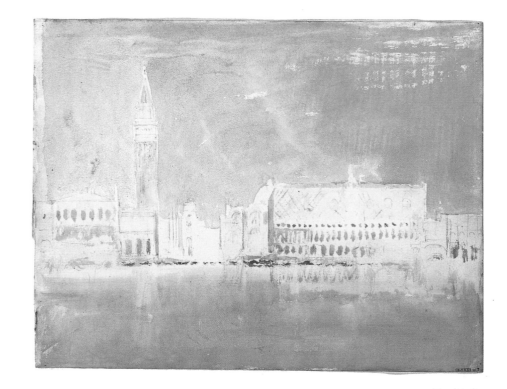

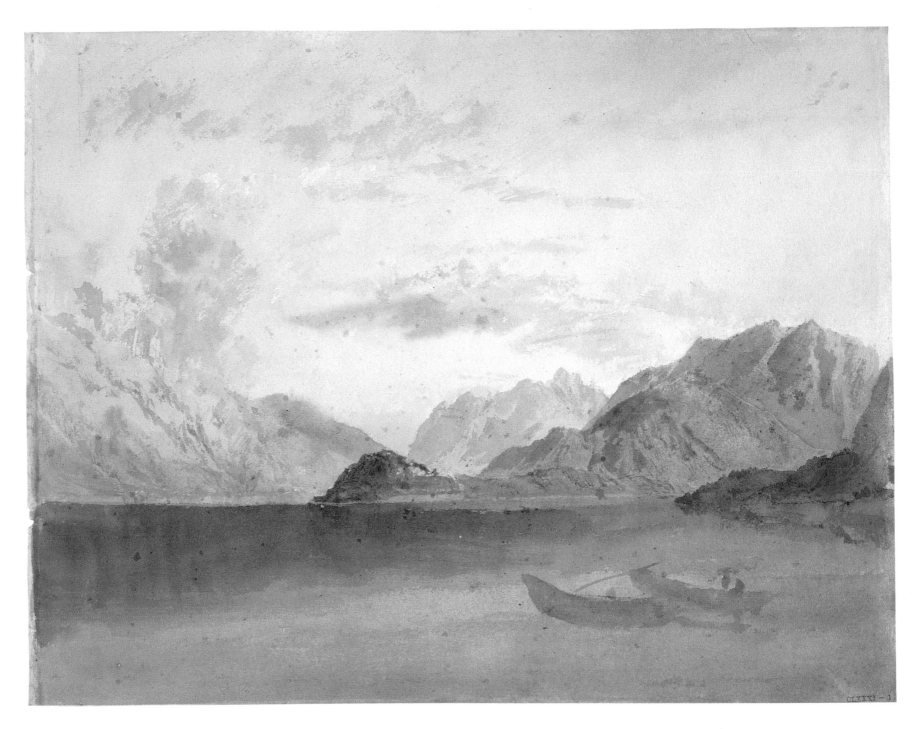

67 LAKE COMO 1819
Watercolour
22.4 x 29 (8 $^{7}/_{8}$ x 11 $^{3}/_{8}$)
Turner Bequest; CLXXXI 1: D15251

In October 1819, Turner reached Rome. Apart from his trip south, he was based in the city for more than two months, and the greatest concentration of his Italian drawings belongs to his stay there. Of Tate's sketchbooks with studies of Roman antiquities, architecture or scenery, three are larger and contain coloured views in watercolour or gouache of the city and surrounding Campagna. Turner's sunset view of the Campagna was originally in the *Naples: Rome C. Studies* book already mentioned. It is unusual in its timing, for Turner seems to have preferred walking in the Campagna in the cool of the early morning.

While Turner was in Rome, the tercentenary of the painter Raphael was being celebrated, and he went to see the bust of the master newly installed in a niche in the Loggia of the Vatican, which Raphael and his pupils had originally decorated. *Rome from the Vatican* was partly inspired by this. The large canvas was Turner's only exhibit at the Royal Academy in 1820, and was painted very quickly after his return to London in time for the opening. Instead of the bust, it showed only its pedestal, but brought Raphel to life in the foreground, with his mistress 'La Fornarina' and examples of his own work. The Loggia arches soar overhead. The picture is not restricted to Raphael's own

period, however. A demonstration of everything Turner had learned in Rome, it brings into view Bernini's later arcades around St Peter's Square, the ancient drum of the Castel Sant'Angelo, and the distant mountains beneath a dazzling blue Italian sky.

Rome was also a stunning, if not actually disturbing, demonstration of Turner's skills in expanded perspective, going beyond truth or obvious visual pleasure in its spatial inclusiveness. The *Bay of Baiae*, shown at the Academy in 1823 and the second picture to come out of the Italian visit, was more the sort of work that his admirers must have expected, being recognisably in the tradition of Claudean classical landscape. Yet on its frame, a friend of Turner's wrote SPLENDIDA (*sic*) MENDAX – a splendid lie. Turner, who was amused and did not remove the graffiti, had certainly altered and improved the scenery around Baiae, of which his on-the-spot drawings appear in Tate's *Gandolfo to Naples* sketchbook. He also added Ovid's story of the Cumaean Sibyl who, beloved by Apollo, asks the god if she could live as many years as the grains of sand in her hand. When she refuses his offer of eternal youth in return for her eternal love, she wastes away, leaving only her voice. For Turner, her tragedy epitomised the vanished splendours of Italy itself as they appeared to his generation.

68 THE ROMAN CAMPAGNA, SUNSET 1819
Pencil, watercolour and gouache
23.1 x 36.9 (9¹⁄₈ x 14¹⁄₂)
Turner Bequest, CLXXXVII 43: D16131

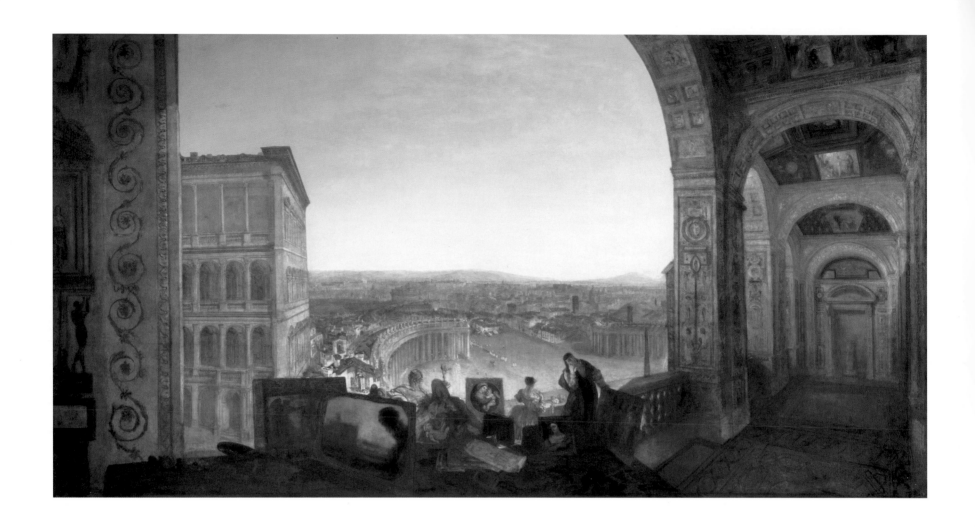

69 ROME, FROM THE VATICAN. RAFFAELLE,
ACCOMPANIED BY LA FORNARINA, PREPARING
HIS PICTURES FOR THE DECORATION OF THE
LOGGIA 1820
Oil on canvas
177 x 335.5 (69 ¾ x 132)
Turner Bequest; N00503: B & J 228

70 THE BAY OF BAIAE, WITH APOLLO AND THE
SYBIL 1823
Oil on canvas
145.5 x 239 (57 ¼ x 94)
Turner Bequest; N00505: B & J 230

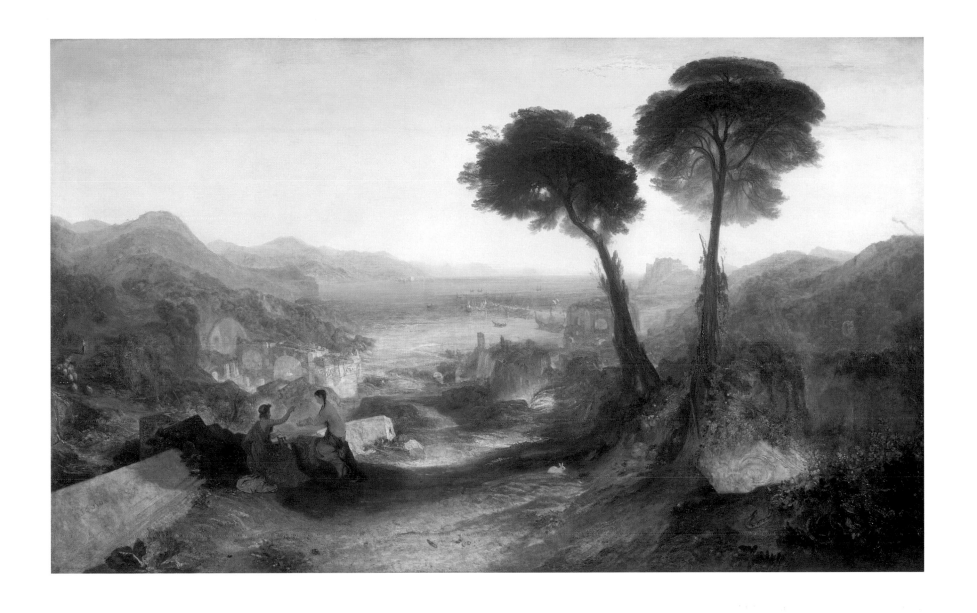

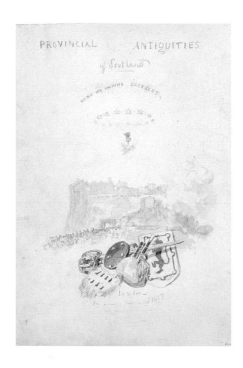

71 GEORGE IV'S PROCESSION TO EDINBURGH
CASTLE WITH THE SCOTTISH REGALIA 1825
Pencil and grey wash and watercolour
24.1 x 17.8 (9½ x 7)
Turner Bequest; CLXVII A: D13748

72 THE ARRIVAL OF GEORGE IV AT LEITH
HARBOUR c.1825
Pencil and grey wash
20.6 x 15.7 (8⅛ x 6)
Turner Bequest; CLXVIII B: D13749

In August 1822, Turner went to Scotland for the fourth time, travelling by sea from London. He was there largely to record the state visit of George IV to Edinburgh, of which he planned a series of pictures. His oil sketch of the King at the Provost's banquet, held in the Parliament House on 24 August, is one of four at Tate depicting the royal visit; related drawings are in Tate's *King's Visit to Scotland* and *King at Edinburgh* sketchbooks. It is probable that difficulties in securing a scheme to engrave his pictures led Turner to abandon them. The King's visit was stage-managed by Sir Walter Scott, who for the past four years had employed Turner to make illustrations for his book, *Provincial Antiquities of Scotland*. Although these were mainly of ancient buildings and monuments – studied specially on an earlier tour in 1818 – when Turner came to prepare designs for the title pages of the two volumes, he chose motifs based on the royal ceremonial. For the first volume, he depicted the procession on 22 August, when the regalia of the Kings of Scotland – which Scott had rediscovered – was paraded to Edinburgh Castle, and showed its climax when the King appeared on the ramparts and a salute was fired by the Castle guns. In the foreground, Scottish emblems such as bagpipes and a sporran form a symbolic pattern. The design was engraved for the book by George Cooke and published in 1826. For the second volume, in a design engraved by Robert Wallis, Turner showed the King's yacht, the *Royal George,* anchored in the port of Leith, approached by a barge bringing Scott to greet him, as happened on 14 August. Their meeting is figured in the foreground by the clasped hands emerging from sleeves bearing the English Garter and the Scottish Order of the Thistle. The sun rises over Edinburgh and the King's personal emblem, a white horse and star, are seen in its rays. These designs were among Turner's first exercises in the vignette form, which he often favoured for book illustration; they already show his gifts of concision and eye for the telling detail.

73 GEORGE IV AT THE PROVOST'S BANQUET,
PARLIAMENT HOUSE, EDINBURGH c.1822
Oil on mahogany panel
68.6 x 91.8 (27 x 36 ⅛)
Turner Bequest; N02858: B & J 248

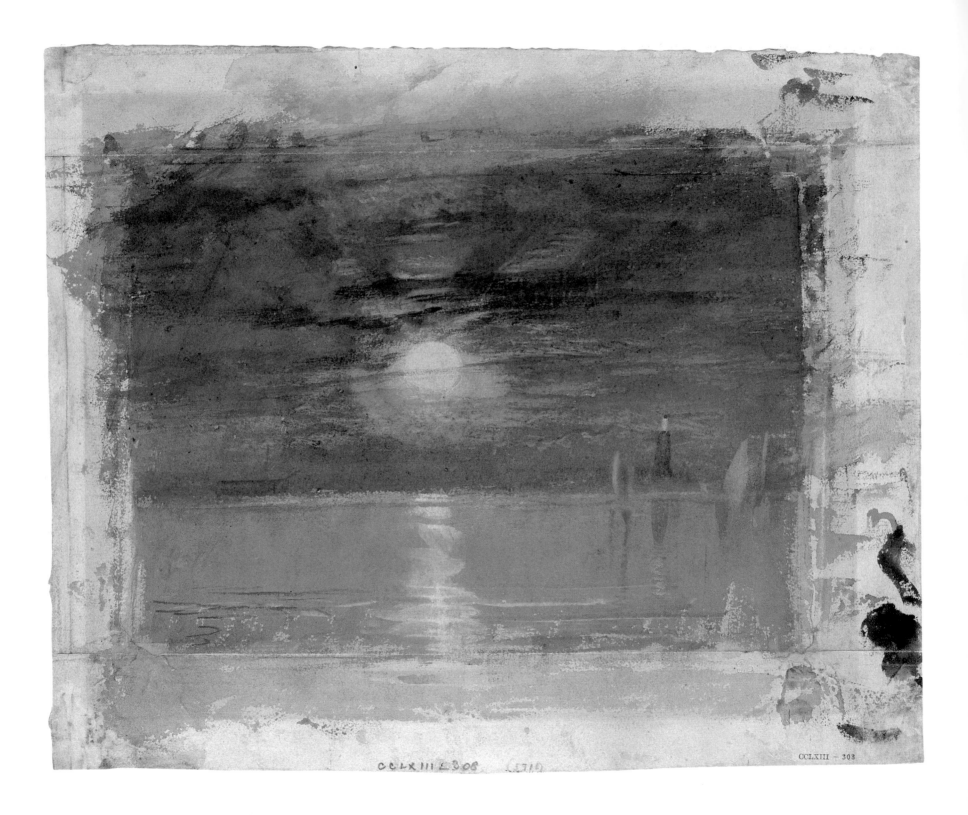

CCLXIII £ 308 (1710)

118

Among Tate's relatively few finished watercolours by Turner, is a set of sixteen of the *Rivers of England* made for engraving in a publication planned by W.B. Cooke. These remained in Turner's possession, for instead of selling them to the publisher, he hired them out for a fee. The view of Shields was engraved for the first part of Cooke's publication, which appeared in June 1823. Turner may have witnessed a scene like this – coal-ships being loaded at night at the wharves along the Tyne – during his journey up to Scotland in 1818. One of the functions of the *Rivers* series was to demonstrate the role of local industries and commerce, and here the nocturnal labours of the coal-heavers might seem to outweigh any picturesque scenic qualities. But in fact the powerful colouring, and contrasts of light and dark, especially the interplay of natural moonlight and the artificial beams of Shields lighthouse, give the watercolour a sombre grandeur, and moreover the composition is a modern, industrial reworking of a Claudean seaport. It shows the richness of imagery and cultural reference that Turner was now able to bring to his topographical designs. A couple of years later, Turner returned to aspects of its subject, and its particular lighting effects, for one of twelve prints made by him from his own drawings, known as the 'Little Liber'. They were experiments in mezzotint, whose velvety richness lent itself to the stormy or night scenes he chose for them. Turner drew *Shields Lighthouse* for one of the plates. As he developed the print through several states, he obscured the moon's halo with cloud, an effect anticipated in another Tate watercolour. Thomas Lupton's magnificently sombre mezzotint after Turner's earlier (lost) drawing of the Eddystone lighthouse, competing with the moon and stars against the darkness of a squally night, was perhaps one of the inspirations for the 'Little Liber'. It was published in 1824 as the first in a proposed series of *Marine Views*, also to be issued by W.B. Cooke.

74 SHIELDS LIGHTHOUSE *c.*1826
Watercolour
23.4 x 28.3 (8³⁄₄ x 11¹⁄₈)
Turner Bequest; CCLXIII 308: D25431

75 Thomas Lupton (1791–1873) after Turner
THE EDYSTONE LIGHTHOUSE 1824
Mezzotint on steel, third state
21 x 31.2 (8¹⁄₄ x 12¹⁄₄)
Purchased (Grant-in-Aid) 1986; T04820

76 SHIELDS, ON THE RIVER TYNE 1823
Watercolour
15.4 x 21.6 (6 ⅛ x 8 ½)
Turner Bequest; CCVIII V: D18155

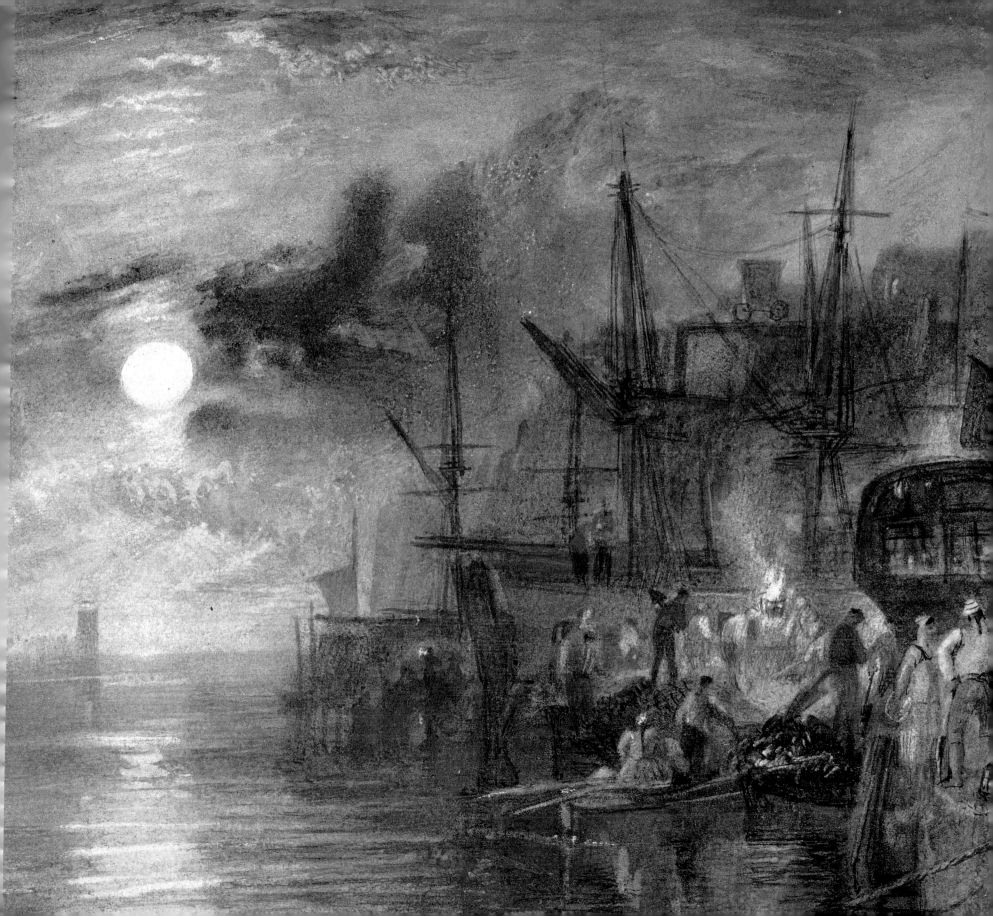

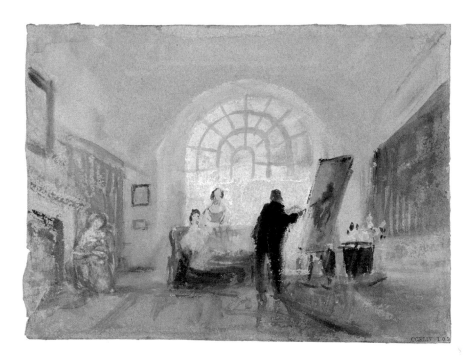

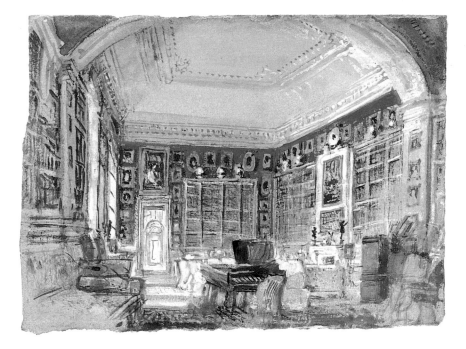

One of Turner's most generous patrons, and a warm friend, was the third Earl of Egremont. Like Fawkes's Farnley (no.56), his seat at Petworth in Sussex became a home from home where Turner could stay and work almost as one of the Earl's extended family. He was given the Old Library, upstairs in the house and with the advantage of a large window, to use as a studio. This is probably the room which appears in Turner's drawing of an artist at work on a picture. The window is similar, but not exactly the same as the one still *in situ* today (another Tate drawing renders it quite accurately), and the artist is probably not Turner himself; he seems to be at work on a portrait, perhaps of the lady seated nearby, while two others watch. Turner was notoriously secretive about his work, and unless he departed very much from type in the relaxed air of Petworth, it is unlikely that he would have painted with such an audience. The artist is probably Thomas Phillips, a portrait painter who was almost a fixture at Petworth. The drawing is one of Tate's large series of studies in gouache on blue paper of Petworth and its surroundings. Many are of the splendid interiors of the house, a few of them, like that of the perversely red-walled White Library, being more finished and rich in detail. Portraits by Phillips are shown hanging over the bookcases. Turner's own main project as an oil painter at Petworth was a set of four landscapes of the park and places nearby with an Egremont connection, to be installed in the panelling of the Carved Room (then the dining-room) beneath full-length portraits. These are still in the house today, but their distinctive shallow horizontal format, as well as his keenness to satisfy a special patron, prompted Turner to the unusual step of painting preliminary versions and a fifth alternative subject to scale first. Two of them, including the view of the park and Tillington church, were actually installed in the room in 1828, but were subsequently replaced, in this case by one showing a cricket match rather than Egremont's dogs rushing out to greet their master.

79 PETWORTH: THE ARTIST AND HIS ADMIRERS 1827
Watercolour and gouache on blue paper
13.8 x 19 (5 ½ x 7 ½)
Turner Bequest; CCXLIV 102: D22764

80 PETWORTH: THE WHITE LIBRARY 1827
Watercolour and gouache with some pen and ink
on blue paper
14.3 x 19.3 (5 ⅝ x 7 ⅝)
Turner Bequest; CCXLIV 16: D22678

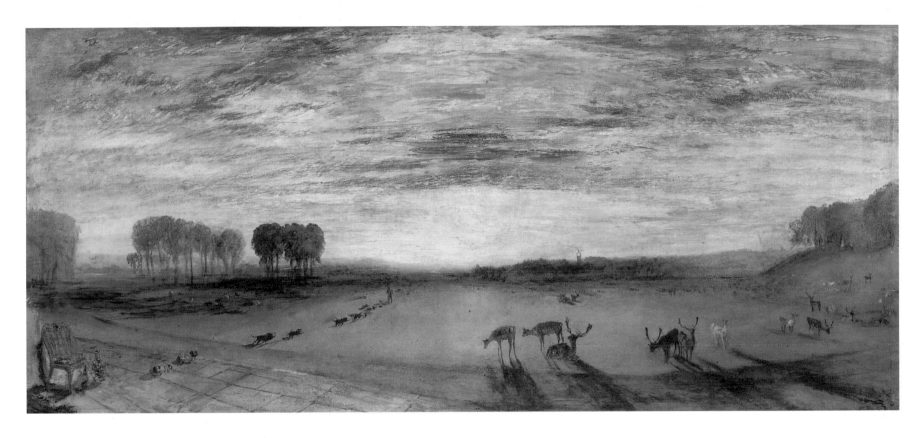

81 PETWORTH PARK: TILLINGTON CHURCH
IN THE DISTANCE *c.*1828
Oil on canvas
64.5 x 145.5 (25 3/8 x 57 3/8)
Turner Bequest; N00559: B & J 283

After visiting Petworth in the summer of 1827, Turner travelled
to the Isle of Wight to stay with the architect John Nash at his
summer house, East Cowes Castle. Nash had commissioned him
to paint two pictures of the Castle and the Cowes regatta –
ready for the Royal Academy exhibition the following year.
Tate has nine oil sketches associated with these subjects, which
were originally painted on two rolls of canvas; some may have
been painted on the spot. The sketch illustrated is one of two
related to the picture *East Cowes Castle, the Seat of J. Nash Esq:
the Regatta starting for their Moorings* (Victoria and Albert
Museum); it would have been made from a position somewhere
on shore. Just how involved Turner became in the regatta can
be seen from Tate's *Windsor and Cowes* sketchbook, where he
listed the names of yachts and their owners and colours. But,
during a stay of some six weeks, he explored other subjects
as well. He made numerous sketches of the castle itself, and its
grounds, sometimes on blue paper like that he had recently
used at Petworth.

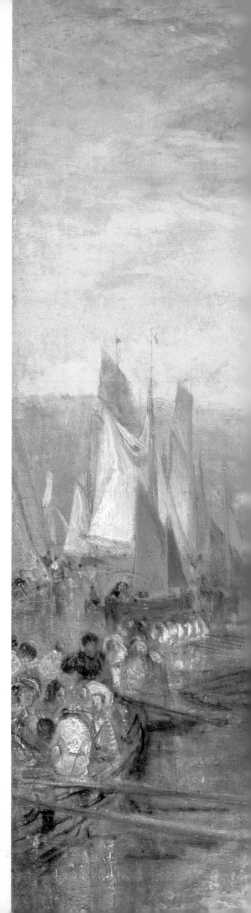

82 SKETCH FOR 'EAST COWES CASTLE,
THE REGATTA STARTING FOR THEIR MOORINGS'
no.3 1827
Oil on canvas
45 x 61 (17 ¾ x 24)
Turner Bequest; N01997: B & J 265

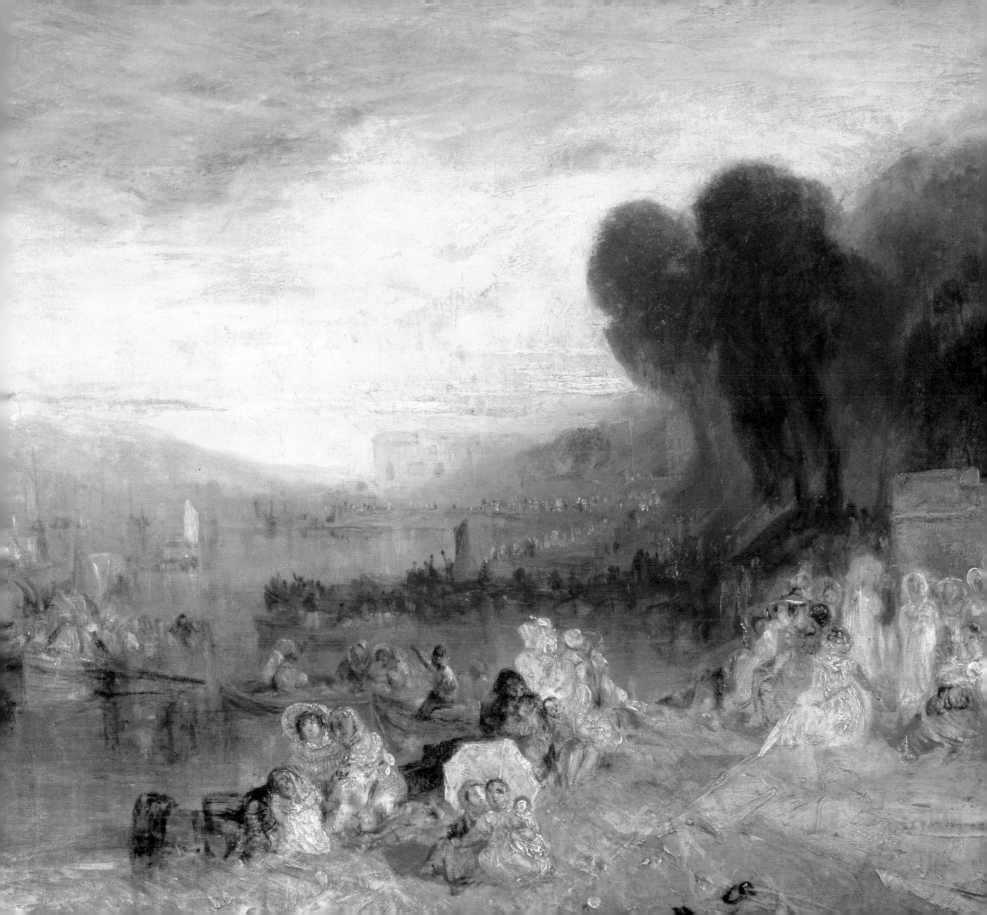

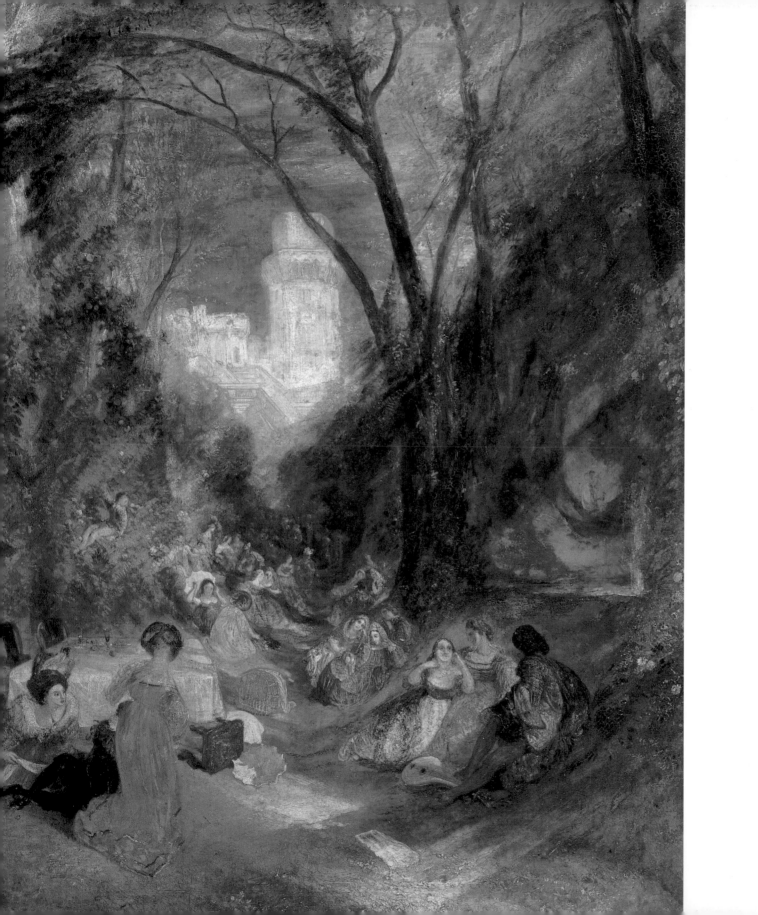

The tower of East Cowes Castle appears in the background of another picture exhibited in 1828, *Boccaccio relating the Tale of the Birdcage*. In a pseudo-historical composition that was surely partly humorous, Turner invented a story that was not part of Boccaccio's famous book the *Decameron,* and took up a delicate style and a subject of elegant figures at leisure outdoors from the French painter Watteau. His most direct source was an edition of the *Decameron* with illustrations by an English imitator of Watteau, Thomas Stothard, published in 1825. The picture also illustrates the power of white to bring a distant object near – the object being the castle. In 1831, when he exhibited his *Watteau Study by Fresnoy's Rules*, Turner demonstrated this colouristic principle again, acknowledging its supposed French inventor in his title and bringing Watteau himself into the picture together with examples of his work. This subject of an artist at work among his admirers was reminiscent of his earlier drawings at Petworth (nos.79. 80), and Turner showed the picture with a companion, *Lord Percy under Attainder* (also in Tate's collection), which was a tribute to works by Van Dyck he knew at the house, and showed an episode in the history of Lord Egremont's ancestors.

83 BOCCACCIO RELATING THE TALE OF THE
BIRDCAGE 1828
Oil on canvas
122 x 90.5 (48 x 35 ⁵⁄₈)
Turner Bequest; N00507· B & J 244

84 WATTEAU STUDY BY FRESNOY'S RULES 1831
Oil on oak panel
40 x 69.5 (15 ³⁄₄ x 27 ¹⁄₄)
Turner Bequest; N00514: B & J 340

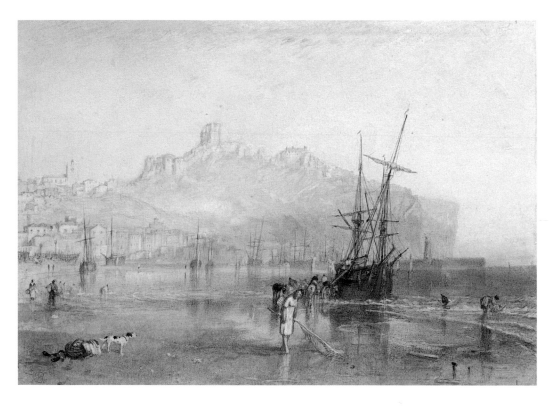

While his *Rivers of England* (no.76) were in production, Turner joined with Lupton, the engraver, in a project for a set of mezzotints of complementary 'Harbours of England'. These were formally announced as *Ports of England* in 1826. Turner made fourteen views for what should have been a series of twenty-four, and the plan was never realised as originally intended, although Lupton and John Ruskin issued twelve subjects as *The Harbours of England* in 1856. *Scarborough* is one of the six watercolours for the series that remained in Turner's possession and are today at Tate. This incorporated features from a watercolour Turner had made in 1811 for Walter Fawkes. Its golden morning lighting, serene mood and low-tide effect are exceptional in a group otherwise characterised by brisk and breezy conditions, often in open water off-shore. A similar morning calm pervades another east coast view, *Aldborough*. This is Tate's only watercolour from the great series Turner made for the publisher Charles Heath in the 1820s and 1830s as his definitive statement in British topography, *Picturesque Views in England and Wales*. It too has a Fawkes connection, for Turner visited this Suffolk town and made sketches he later used for his view on his way to visit him at Farnley in 1824. Tate's *Norfolk, Suffolk and Essex* sketchbook contains related memoranda, including a note of the Martello tower at Slaughden that is brought into prominence in the watercolour. As a memory of the recent Napoleonic Wars, it is counterbalanced by the dawn light and the foreground motif of figures repairing a mast, proclaiming the national regeneration to be experienced with the return of peace.

85 SCARBOROUGH *c.*1825
Pencil and watercolour
15.7 x 22.5 (6¼ x 8⅞)
Turner Bequest; CCVIII 1: D18142

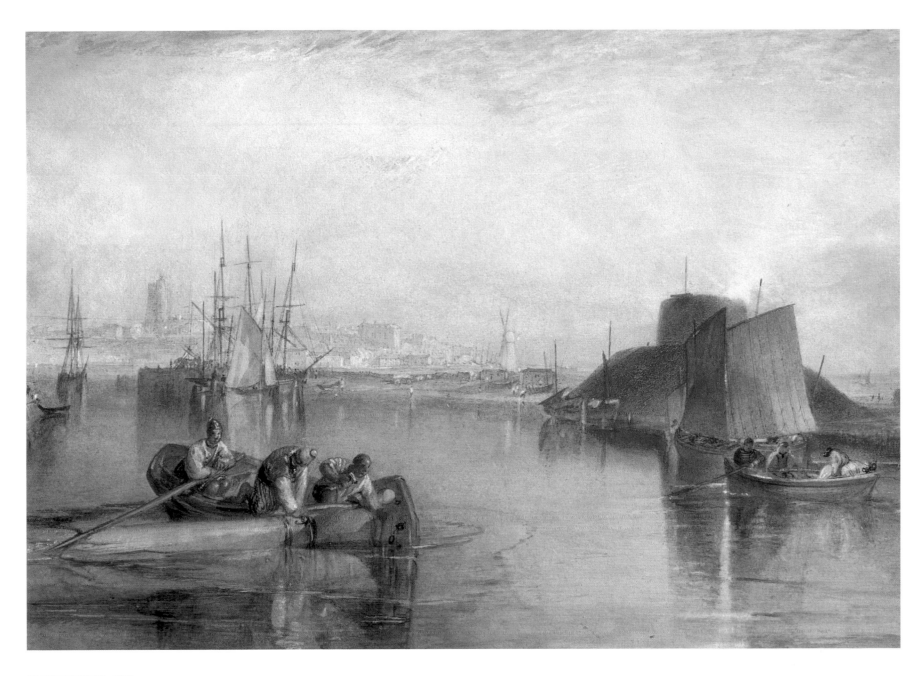

86 ALDBOROUGH c.1826
Watercolour and gouache
28 x 40 (11 x 15¾)
N05236

Having already commissioned his *England and Wales* watercolours, Charles Heath also engaged Turner for series of continental river scenery, beginning with the rivers of France. In 1833 there appeared a first volume of twenty-one views of the Loire and, in 1834 and 1835, volumes of twenty plates each, devoted to the Seine. *Wanderings by the Loire* and *Wanderings by the Seine* tapped into a large new market of middle-class travellers to the European mainland, and were to be followed by surveys of other great rivers which never materialised. Turner researched his subjects on the spot, travelling along the rivers himself. He toured the Loire in 1826. While his English subjects, the *Rivers*, *Ports* and *England and Wales* were designed in watercolour, he prepared the French ones in gouache on small sheets of blue paper. They were the only works made for the engraver in these materials, and set particular challenges of interpretation. The engraved Loire gouaches were not retained by Turner, but many associated subjects were and are today in Tate's collection, including the café scene which the artist probably drew at Nantes. Here view-making is exchanged for a lively record of a traveller's everyday experience. Robert Brandard's print of Blois shows what Turner's vividly coloured drawings looked like when published in black and white. Turner also experimented with pictures based on his Loire tour, and Tate's large, unfinished oil of a sunlit harbour has recently been identified as a view of Brest.

87 SOLDIERS IN A CAFÉ, POSSIBLY IN NANTES *c.*1826–8
Watercolour, gouache and pen and ink on blue paper
14 x 19 (5 ½ x 7 ½)
Turner Bequest; CCLIX 270: D40080

88 Robert Brandard (1805–1862) after Turner
BLOIS 1833
Engraving, first published state
9.4 x 13.7 (3 ¾ x 5 ½)
T04681

89 THE HARBOUR AT BREST: THE QUAYSIDE
AND CHATEAU *c.*1826–8
Oil on canvas
172.5 x 223.5 (68 x 88)
Turner Bequest; T05514: B & J 527

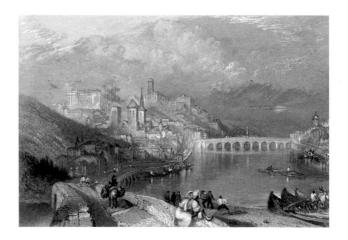

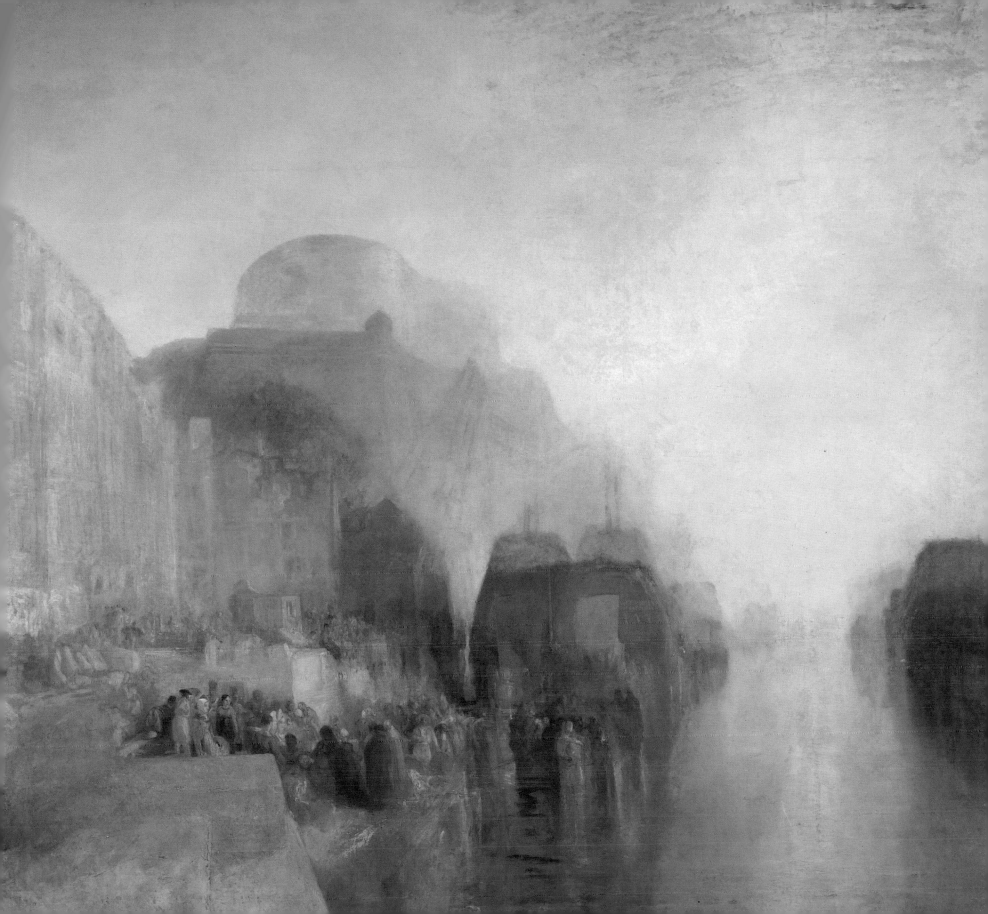

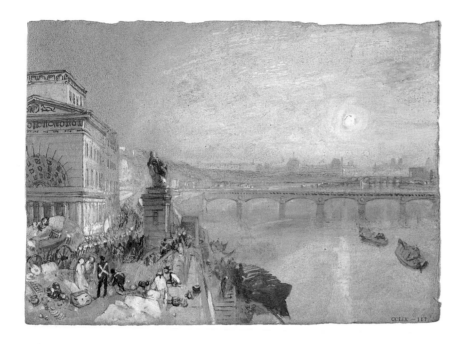

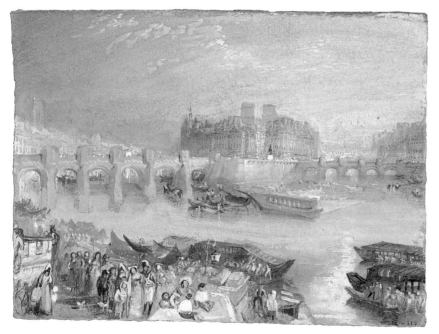

Unlike his Loire views, the fruit of a single tour, Turner's engraved subjects of the Seine which appeared in 1834 and 1835 were worked up from material gathered over a number of years – first of all on his visit to Paris in 1802, then (mainly) in 1821, 1826, 1829 and 1832. Both the published gouaches and a wealth of sketches and other views of the Seine are in Tate's collection. Paris was the subject of some of the most elaborate and complex of the finished views. Filled with crowds and sparkling light, they capture the energy of the metropolis with an enthusiasm that Turner never brought to his native London. The view of the Seine and the Barrière de Passy, which appeared in the 1835 Seine volume, is in reality of the Barrière des Bonshommes, the entrance to the city on the north bank of the Seine at Passy, marked by the Neoclassical guardhouse built by Ledoux. Turner based his image partly on sketches made in 1819 and 1826, but also on a print recently published in an English book on the July Revolution of 1830; its account of the fighting that had taken place on this spot prompted his columns of soldiers marching past the military check-point. Drawings on two pages of Tate's *Paris and Environs* sketchbook, used in 1832, provided the taut double perspective of the view of the Pont Neuf and Ile de la Cité, also engraved for the 1835 volume. As with the Loire, Turner began some versions of Seine material in oil, including an unfinished view of the port of Dieppe from the Quai Henri IV. Probably painted around 1827–8, this used to be thought to be an Italian scene.

90 PARIS FROM THE BARRIERE DE PASSY *c*.1833
Gouache and watercolour with pen and ink on blue paper
14.3 x 19.4 (5 ⁵/₈ x 7 ⁵/₈)
Turner Bequest; CCLIX 117: D24682

91 PARIS: THE PONT NEUF AND THE ILE DE LA CITE *c*.1833
Gouache and watercolour with pen and ink on blue paper
14.3 x 18.8 (5 ⁵/₈ x 7 ⁵/₈)
Turner Bequest; CCLIX 118: D24683

92 DIEPPE: THE PORT FROM THE QUAI HENRI IV ?1827–8
Oil on canvas
60.3 x 89.2 (23 ¾ x 35 ⅛)
Turner Bequest; N03305; D & J 316

In the summer of 1828, Turner set off again for Rome. In 1819 he had concentrated on his sketchbooks and drawings, but during this second stay he worked in oil. He set up a temporary studio in lodgings at 12 Piazza Mignanelli, recently occupied by a painter friend, Charles Eastlake, whom he had asked to assemble the necessary materials. The large view of an aqueduct is one of two large, somewhat unresolved canvases of Italian landscape in Tate's collection; they are of a size he used for exhibition pictures, and are probably works left unfinished rather than separate oil sketches. In December Eastlake wrote that Turner had 'begun several pictures … and finished *three*'; later he revised the total to 'eight or ten' works in preparation.[20] *Regulus* was one of the three 'finished' pictures, which were shown by Turner in a small exhibition in his second lodgings in the city near the Quattro Fontane. The other two, *View of Orvieto* and *Vision of Medea*, are also in Tate's collection. A brilliant reworking of the seaport compositions of Claude, *Regulus* told the story of the Roman general taken prisoner by the Carthaginians during the First Punic War; sent back to Rome to sue for peace on condition he would return to his captors, he actually persuaded Rome to continue the war, but kept his promise to return to Carthage and was tortured to death, blinded by the sun after his eyelids were cut off. The dazzling sunlight in the picture enables the spectator to share Regulus's experience.

Turner's Roman pictures were first shown in simple frames, improvised from painted rope tacked round the stretchers (a reconstruction can still be seen on Tate's *Vision of Medea*). The works shocked the international community of artists in Rome; Eastlake wrote that '"Regulus" is a beautiful specimen of his peculiar power, yet the wretches here dwelt more on the defects of the figures and its resemblance to Claude's compositions than on its exquisite gradation and the taste of the architecture.' Eastlake himself considered it 'more Italian than Italy itself'.[21]

93 REGULUS 1828
(reworked 1837)
Oil on canvas
91 x 124 (35 ¼ x 48 ¾)
Turner Bequest; N00519: B & J 294

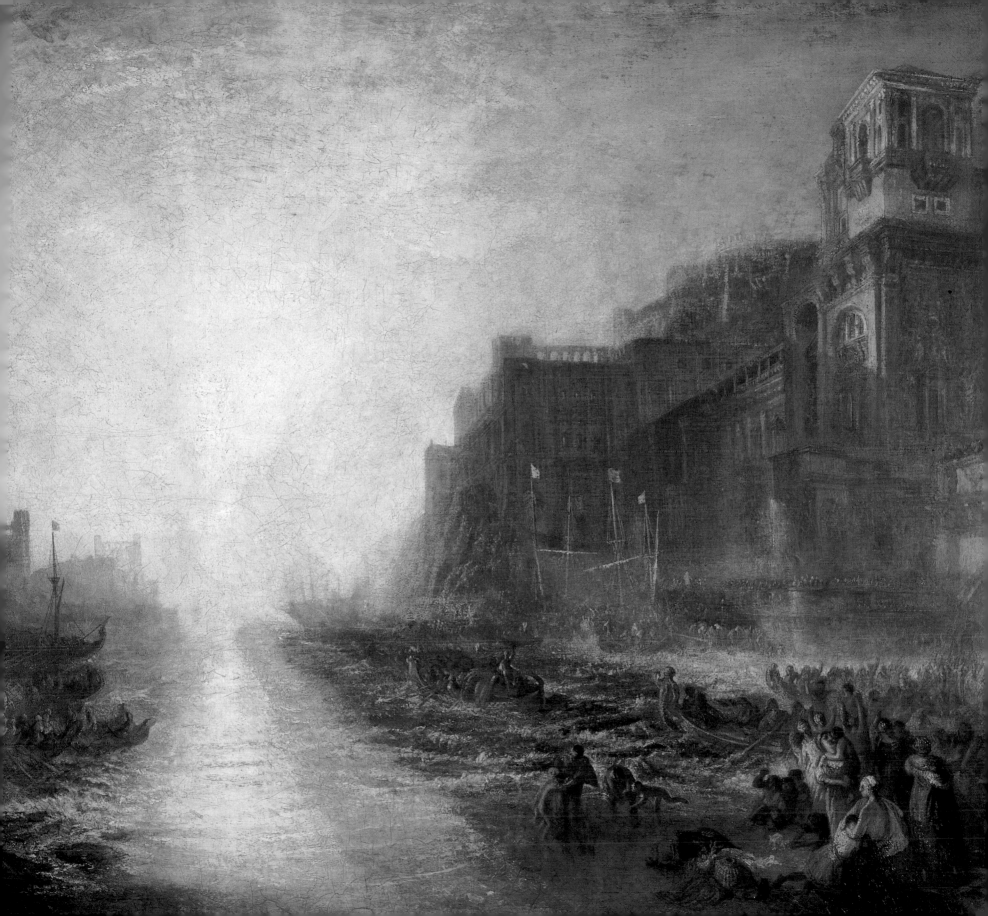

94 SOUTHERN LANDSCAPE WITH AQUEDUCT
AND WATERFALL 1828
Oil on canvas
150 x 249 (59 $\frac{1}{8}$ x 98 $\frac{1}{4}$)
Turner Bequest; N05506: B & J 300

Turner was a lover of poetry (as well as something of a poet himself). He was especially fond of the work of Byron, whose evocations of travel and the European landscape with its historical associations gave voice to his own impressions. He exhibited six pictures illustrating or accompanied by quotations from Byron's most famous poem, *Childe Harold's Pilgrimage*, and his tribute to Italy shown at the Royal Academy in 1832 was the most Byronic of all, taking Byron's own title as well as the lines from the poem describing Italy as 'the garden of the world', decayed but eternally beautiful. The landscape is largely imaginary, a combination of memories from Turner's two Italian tours. Among the most vivid passages in *Childe Harold* are those referring to Venice, where Byron was actually based when Turner visited the city in 1819. Turner took the opening couplet from the fourth canto of *Childe Harold* as his epigraph for his *Venice, Bridge of Sighs* when he showed it at the Academy in 1840; Byron describes standing on the bridge, 'A palace and a prison on each hand', at once embracing the grimmer realities underlying Venice's splendid past and its present condition, under Austrian rule, as a magnificent prison for its citizens.

Turner also illustrated Byron for publication. His splendid watercolour view of the Temple of Poseidon at Sounion, on Cape Colonna, south-east of Athens, was a larger elaboration of an earlier plate he had designed for a set of *Landscape Illustrations* to Byron, published by its engraver, Edward Finden. Byron had visited Sounion twice, carved his name on one of the temple's Doric columns, and commissioned a view of it by the German artist Jacob Linckh. Not having been there himself, Turner based his earlier view on a drawing made on the spot by the architect Thomas Allason. The larger version was probably made for engraving by J. T Willmore, the print being intended to form a pair with the engraver's plate, made in 1834, of Charles Eastlake's painting *Lord Byron's Dream* (Tate). The two plates would have formed a complementary pair on the theme of Byron's travels in Greece, and marked the tenth anniversary of the poet's death. In the event, Willmore did not engrave the Sounion subject until 1854.

95 THE TEMPLE OF MINERVA SUNIUS,
CAPE COLONNA *c.*1834
Pencil, watercolour and gouache with scratching-out
38.2 x 58.8 (15 x 23⅛)
Accepted by Her Majesty's Government in lieu of tax and
allocated to the Tate Gallery, 1999

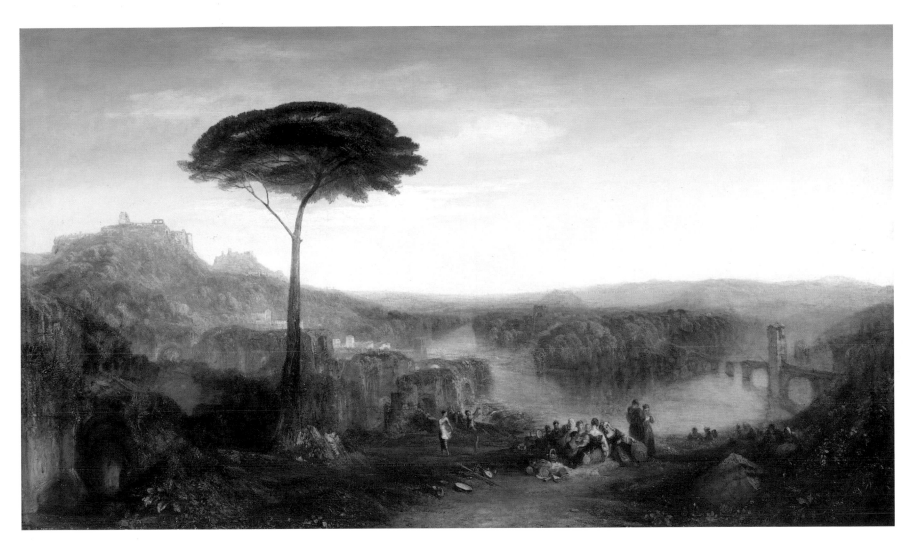

96 CHILDE HAROLD'S PILGRIMAGE – ITALY 1832
Oil on canvas
142 x 248 (56 x 97 ¾)
Turner Bequest; N00516: B & J 342

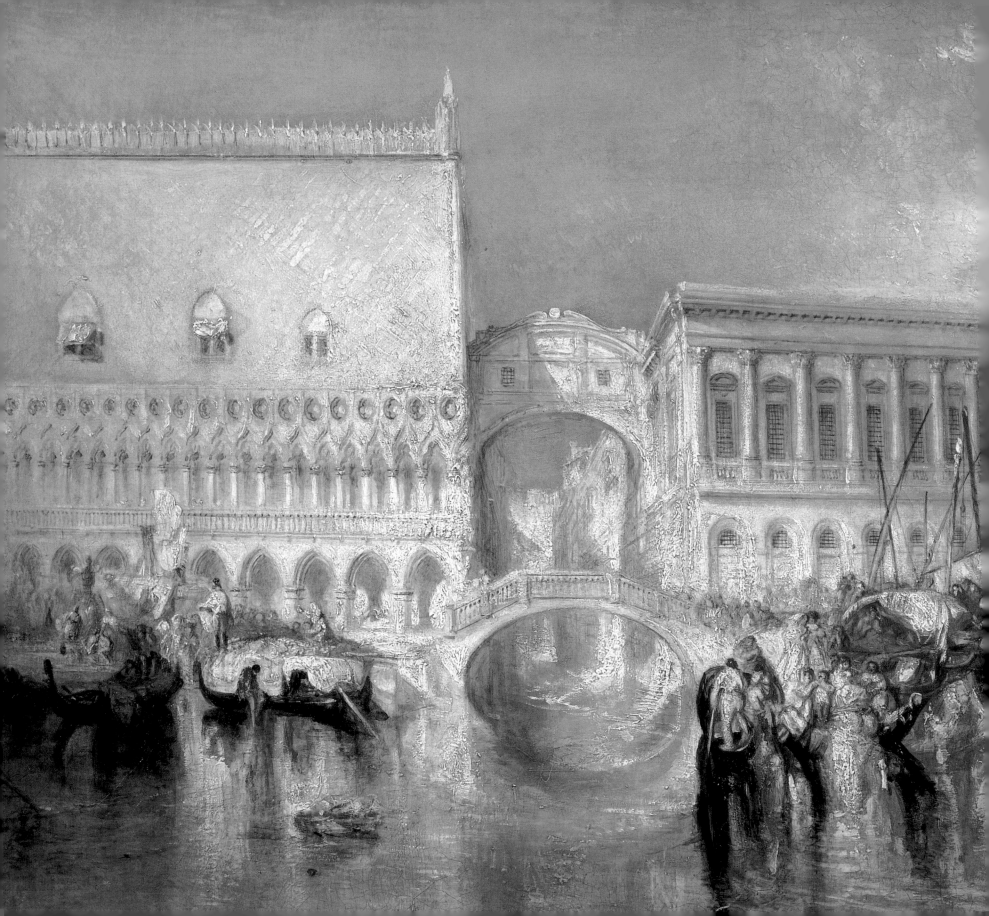

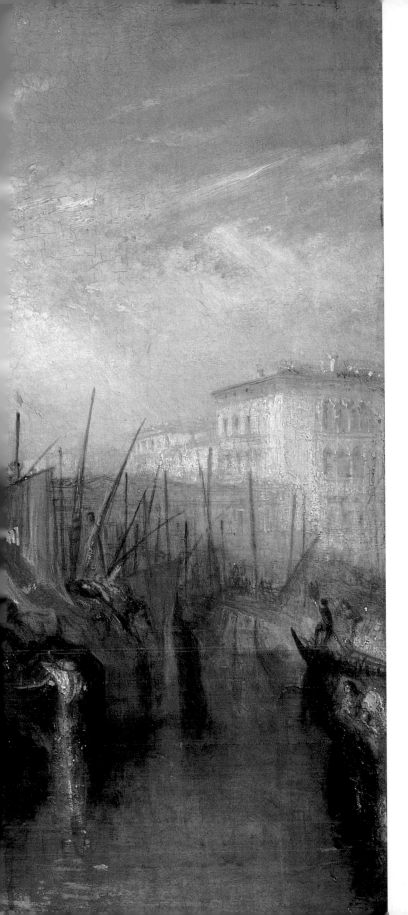

97 VENICE, THE BRIDGE OF SIGHS 1840
Oil on canvas
61 x 91.5 (24 x 36)
Turner Bequest; N00527: B & J 383

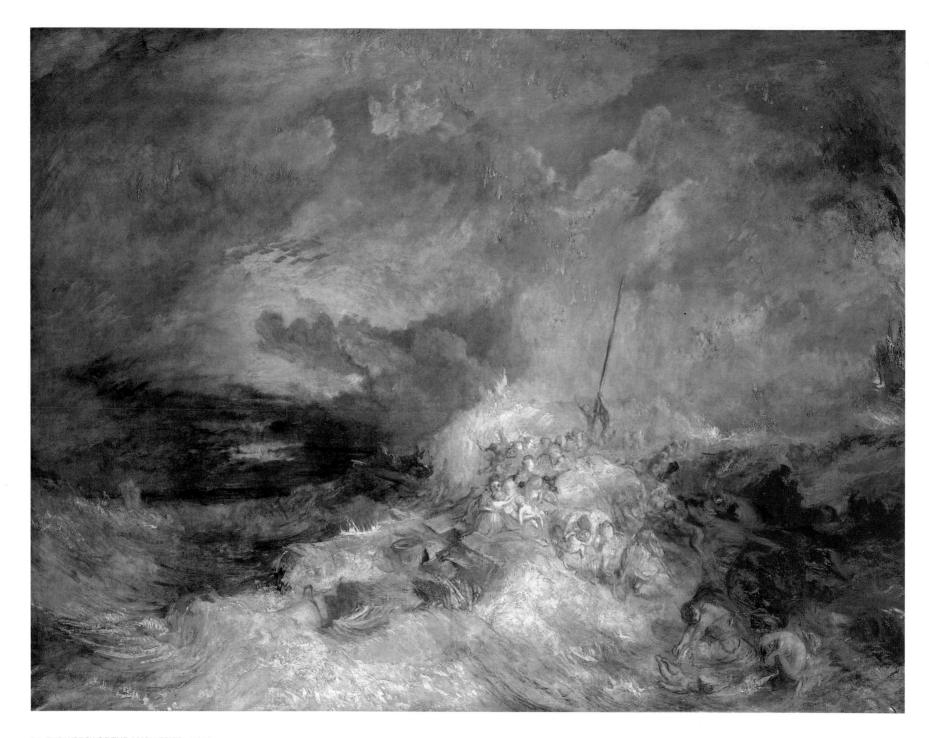

98 THE WRECK OF THE AMPHITRITE *c.*1835
Oil on canvas
171.5 x 220.5 (67 ¹/₂ x 86 ³/₄)

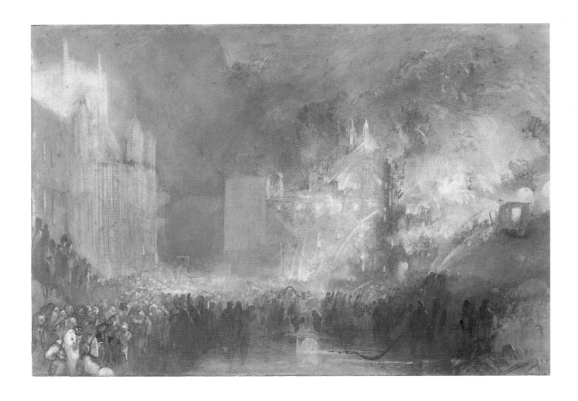

99 THE BURNING OF THE HOUSES OF
PARLIAMENT 1834
Watercolour and gouache, with scraping-out
30.2 x 44.4 (11 ⁷/₈ x 17 ½)
Turner Bequest; CCCLXIV 373: D36235

100 SATAN SUMMONING HIS LEGIONS c.1834
Watercolour
18.6 x 23 (7 ¼ x 9)
Turner Bequest; CCLXXX 78: D27595

On 16 October 1834, the old Houses of Parliament were destroyed by fire. Turner watched the blaze, part of the time from a boat on the Thames, and recorded his impressions in pencil in Tate's smaller *Burning of the Houses of Parliament* sketchbook. The watercolour illustrated here is one of nine in the collection, also originally in a sketchbook, which were presumably made shortly after the event, showing it from different viewpoints. Here, he shows the fire at close quarters, from the street outside, and gives as much attention to the huge crowds who gathered to witness it and had to be controlled by the army as well as the police. The watercolours may have been made to try out general effects for the two pictures he painted for the Royal Academy and British Institution the following year (Cleveland Museum of Art and Philadelphia Museum of Art), though they do not correspond very closely to them. The blaze may also have prompted Turner to some wider meditations on fire and water. About the same time, he prepared his vignette design of Satan summoning his legions on the burning lake, an illustration to Milton's *Paradise Lost* and intended – but not used – for an edition of his *Poetical Works* published by Macrone in 1835. Here, he may also have recalled Thomas Lawrence's Academy diploma picture of the subject, shown in 1797. The large oil of a doomed ship, apparently on fire or lit by flares, probably dates from the mid 1830s, and seems to be an unfinished picture. It has been identified as showing the wreck of the *Amphitrite* in the English Channel on 1 September 1833. A female convict ship, she went aground off Boulogne, and lost her consignment of 125 women and children after her captain and surgeon refused French assistance, on the grounds that they were only authorised to land in New South Wales. The fiery atmosphere, anticipated in sketches of a burning ship in Tate's *Fire at Sea* sketchbook, gives a Satanic tinge to the scene. The picture's composition suggests that Turner had in mind another recent picture of cruelty and disaster at sea – Géricault's *Raft of the Medusa* (Louvre), which had been seen in London at the Egyptian Hall in 1820.

During his travels, Turner took a keen interest in contemporary art and architecture. In Copenhagen, in September 1835, he sketched the city's chief buildings, old and new. His drawing of the interior of the severely Neoclassical Vor Frue Kirche (Church of Our Lady, now the cathedral) was made in his *Hamburg and Copenhagen* sketchbook, one of two in the collection recording a journey through Germany and Denmark. In Turner's characteristic shorthand, it shows, and names three, of the plaster versions, put up in the church in 1829, of the statues of Christ and the Apostles modelled in Rome by Bertel Thorvaldsen in 1821. Thorvaldsen had apparently been influenced by Greek marbles from Aegina, which he had restored for the King of Bavaria. Turner had seen these marbles in Munich in 1833, on a long journey through Germany and Austria to Venice. He had also drawn the new gallery, the Glyptothek, constructed for them by the Neoclassical architect Leo von Klenze, and examined other new buildings by him in progress in the city. Then, too, he would have heard of the Walhalla, a temple to German culture, under construction to Klenze's designs on the Danube near Regensburg. Turner visited it in 1840, on a further tour of Austria and south Germany, and painted his picture of its official opening in 1842 for the Royal Academy the following year. He showed it with verses praising the return of peace exemplified by the Bavarian King's patronage of architecture,

science and the arts. In 1845, he repeated the compliment by sending the picture to an exhibition in Munich itself, but, on account of its ethereal technique, it was misunderstood as a satire.

Klenze's German contemporary and rival as an architect was Karl Friedrich Schinkel, and in 1835 Turner saw his new buildings for the Prussian Crown in Berlin. A page from Tate's *Dresden and Berlin* sketchbook shows the exterior of Schinkel's new gallery, the Altes Museum, Johann Boumann's Domkirche across the Lustgarten from Unter den Linden, and the interior of the museum's portico with its double staircase. Visible in the portico is the cast of the Warwick Vase, presented to the Prussian King by the Tsar of Russia and installed there in 1834.

101 From the *Hamburg and Copenhagen* sketchbook 1835
COPENHAGEN: THE INTERIOR OF THE CHURCH OF OUR LADY
Pencil
15.5 x 9.2 (6⅛ x 3⅝)
Turner Bequest; CCCV 32r: D30883

102 From the *Dresden and Berlin* sketchbook 1835
BERLIN: VIEW OF THE ALTES MUSEUM
Pencil
16.1 x 8.7 (6 ½ x 3 ½)
Turner Bequest; CCCVII, 30v, 31: D31079, 31080

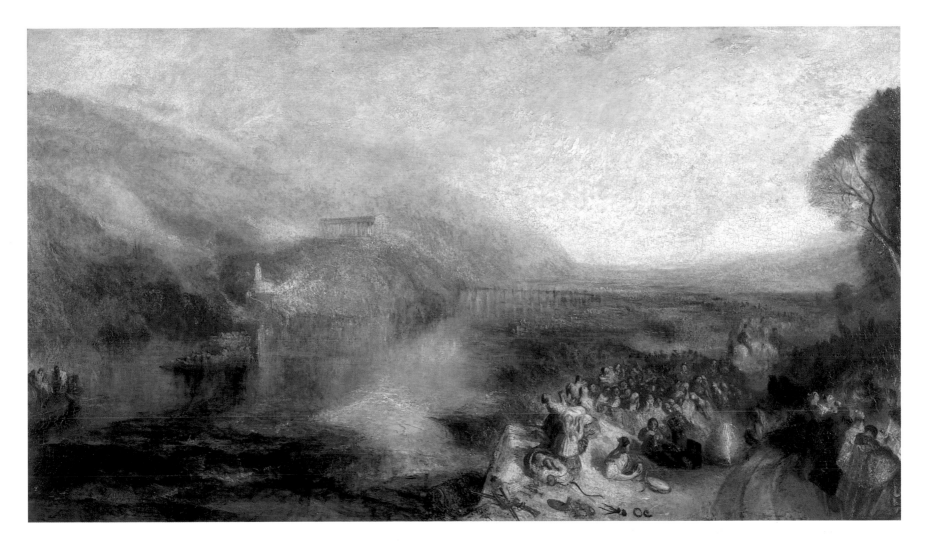

103 THE OPENING OF THE WALLHALLA, 1842 1843
Oil on mahogany panel
112.5 x 200.5 (44 $\frac{1}{4}$ x 79)
Turner Bequest; N00533: B & J 401

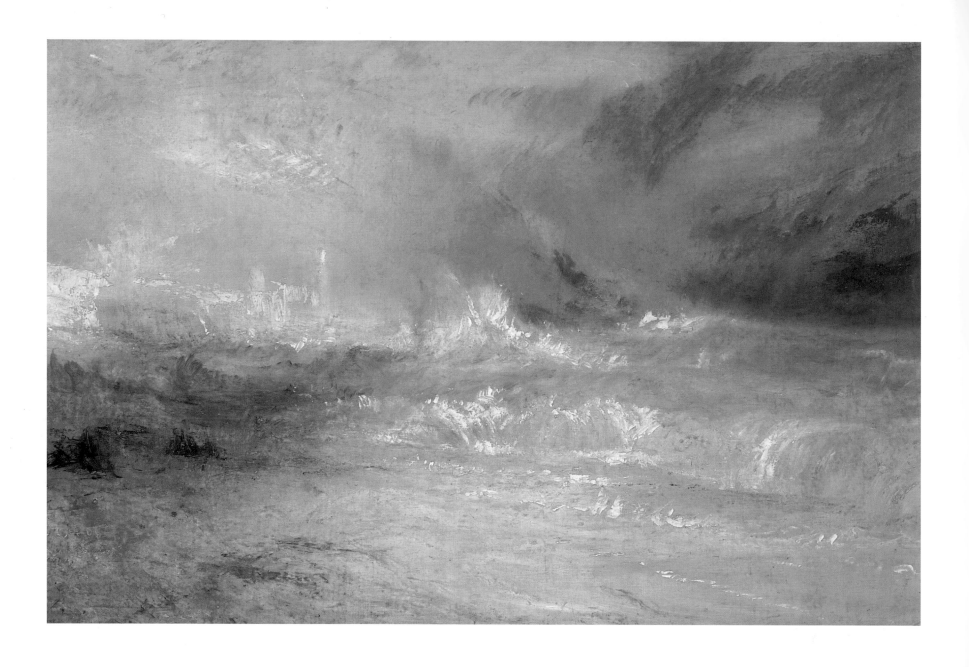

148

In his later years, Turner was a regular visitor to Margate, which, since he knew it as a boy, had been transformed into a busy marine resort, served by steamer services from London. He lodged with Mrs Booth, his landlady and, probably, mistress in a house at Cold Harbour, which looked over the beach towards the pier. The view from her windows, and his walks along the shore, prompted Turner to make a number of studies of the sea, both in watercolour and oil. His sketch of breaking waves is one of two in the collection on a wide landscape format, which are closely related in technique and colouring. Margate's pier and lighthouse probably appear in the left distance. Although such studies must have helped to inform Turner's finished marine pictures with a sense of realism, they concentrate on the sea itself as a natural element moved by wind and tide. *The New Moon*, exhibited at the Royal Academy in 1840, shows a similar view towards the pier, but the water calm at low tide. It is on a mahogany panel and was evidently painted rapidly, partly while already in its frame; this suggests that it was developed on the Academy Varnishing Day from a preliminary sketch perhaps begun at Margate. Turner's little narrative of a spoiled child's petulance, recounted in his title, may well be a recollection of an incident on the beach.

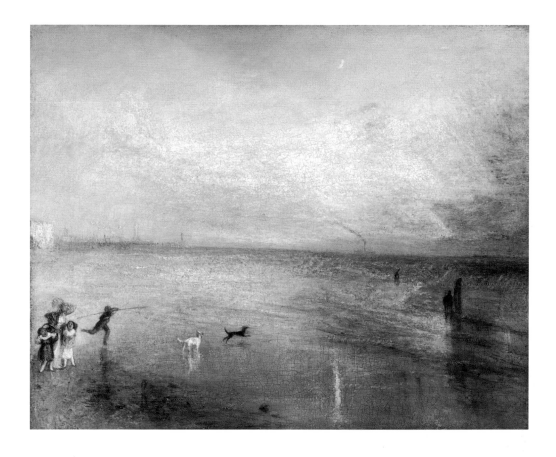

104 WAVES BREAKING ON A LEE SHORE *c.*1835
Oil on canvas
60 x 95 (23 ½ x 37 ½)
Turner Bequest; N02882: B & J 458

105 THE NEW MOON; OR, 'I'VE LOST MY BOAT,
YOU SHAN'T HAVE YOUR HOOP' 1840
Oil on mahogany panel
65.5 x 81.5 (25 ¾ x 32)
Turner Bequest; N00526: B & J 386

While some of Turner's oil sketches and studies of the sea were painted on odd-sized canvases or wood panels that, presumably, lay readily to hand, there is also in Tate's collection a group of canvases of the standard 3 x 4 feet that he used for exhibition pictures. While these may have been intended for further work, to render them exhibitable, they are, in the state he left them, among the boldest and most impressionistic of all his works in oil. *Rough Sea* is the most daring of all in its flecks and streaks and spots of impasto, and in its silvery palette conveying a foggy, winter light. This may be another Margate scene, with its pier beaten by waves and spray. *Snow Storm*, exhibited at the Royal Academy in 1842, at once shows a clear relationship to Turner's marine sketches in its expressive handling and the vortical sweep of its composition, and how far he transformed them for exhibition. Its full title describes exactly what the paddle-steamer is doing in such challenging conditions, and constructs an elaborate autobiographical anecdote to prove the truth of what has been observed. Later, rebuffing a friend who had tried to compliment him on the picture's realism, Turner claimed he had been tied to the ship's mast to witness the storm, and had not expected to survive, but had afterwards painted the picture to 'show what such a scene was like'.[22] His story, and his location of the event to Harwich, were probably invented, and the picture's air of conviction the cumulative result of a lifetime's experience and study of weather and the sea.

106 SNOW STORM – STEAM-BOAT OFF A HARBOUR'S MOUTH MAKING SIGNALS IN SHALLOW WATER, AND GOING BY THE LEAD. THE AUTHOR WAS IN THIS STORM ON THE NIGHT THE ARIEL LEFT HARWICH 1842
Oil on canvas
91.5 x 122 (36 x 48)
Turner Bequest; N00530: B & J 398

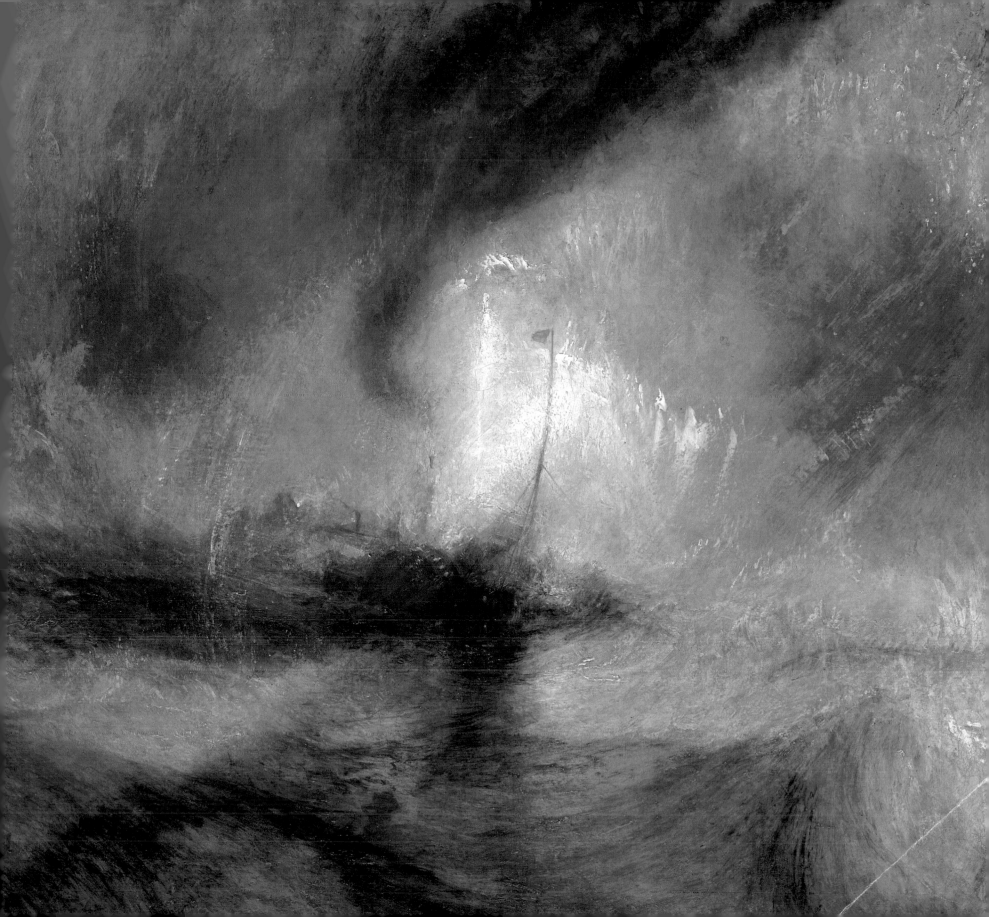

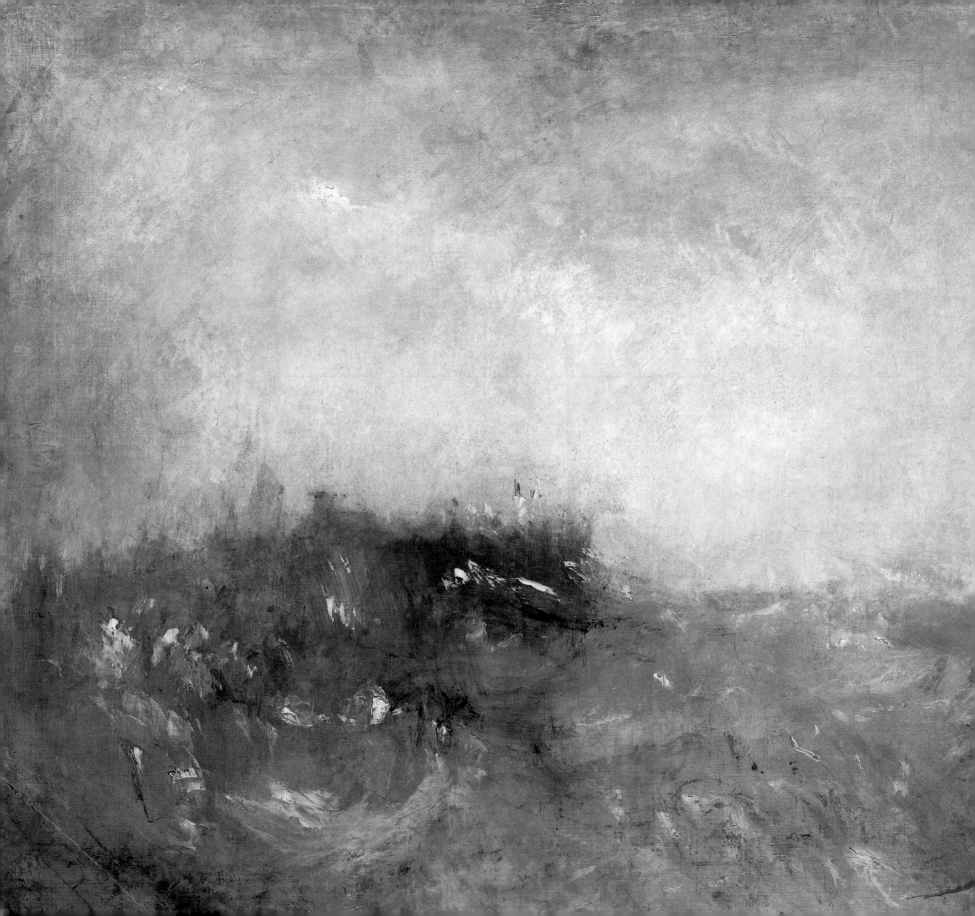

107 ROUGH SEA *c.*1840–5
Oil on canvas
91.5 x 122 (36 x 48)
Turner Bequest: N05479: B & J 471

In the 1840s, Turner painted some pairs of pictures on a new, square format. *Peace* and *War,* exhibited at the Royal Academy in 1842, were one such pair, in which both the colouring – dark and cool, and vividly bright – and the themes and meanings were contrasted. *Peace* is not, despite being opposed to a picture of Napoleon in exile on St Helena, about the end of the Napoleonic Wars, but depicts the burial at sea off Gibraltar of Turner's colleague and friend, the painter Wilkie, who had died aboard ship on his way back from the Holy Land in 1841. The sombre colouring at once times the event to night and expresses a mood of mourning; unable to attend Wilkie's commital in person, Turner sent the picture to the Academy, much as his contemporaries sent black-veiled carriages to represent them at funerals. The relationship to the exiled Napoleon was probably more apparent in his day than it is now – though even then it puzzled many viewers. *War* in fact also refers to another contemporary artist – Benjamin Robert Haydon, who was best known for his many pictures of Napoleon musing over his achievements and defeat. Whereas the mild-mannered Wilkie had always lived in exemplary harmony with his colleagues, and had been a devoted friend to Haydon since their student days, Haydon had quarelled with everybody else and was by now living in a professional isolation almost as lonely as Napoleon's. While paying tribute to Wilkie, Turner delivered an implied rebuke to Haydon – whom he nevertheless admired in his own way and would have preferred to see reconciled with his colleagues. His pictures were painted to offer a lesson on how artists should and should not live their lives. When Haydon was driven to suicide in 1844, Turner sadly remarked that he had 'stabbed his mother' – a reference to Haydon's attacks on the Royal Academy, his former teacher, to whom Turner himself always remained fiercely loyal.

108 WAR. THE EXILE AND THE ROCK LIMPET 1842
Oil on canvas
79.5 x 79.5 (31 ¼ x 31 ¼)
Turner Bequest; N00529: B & J 400

109 PEACE – BURIAL AT SEA 1842
Oil on canvas
87 x 86.5 (34 ¼ x 34 ⅛)
Turner Bequest; N00528: B & J 399

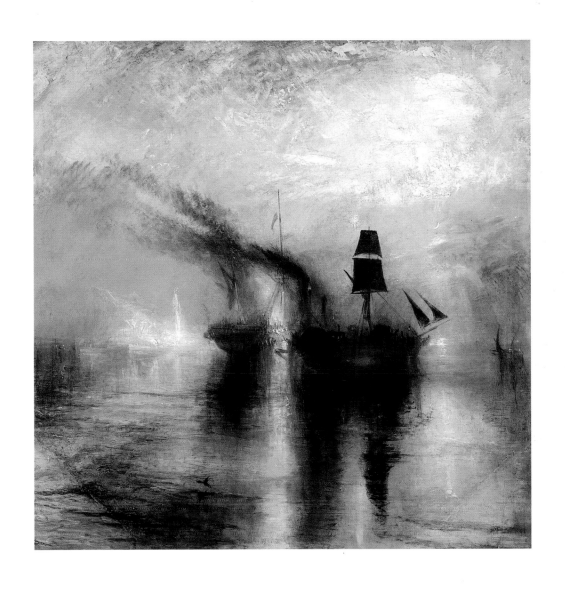

Turner exhibited pictures of Venice every year between 1833 and 1846, save in 1838 and 1839. They were among the most popular of his late works and many found buyers. *The Dogano*, exhibited at the Royal Academy in 1842, was bought by Robert Vernon, and in 1847 became the first Turner to hang in a public collection when it was selected for immediate display from his gift to the National Gallery – a gift that was fundamental to Tate's development for its quantity of works by recent and living British artists. The picture had first been seen at the Academy as effectively one of a contrasting pair with *Campo Santo, Venice* (Toledo Museum of Art), bought by another of Turner's patrons, Elhanan Bicknell. *The Dogano*, a view of the Venetian customs house, represented the city's former commercial prowess, the *Campo Santo*, as a cemetery scene, its subsequent decline. Fading splendours were also the theme of *The Sun of Venice*, which failed to sell in the Academy in 1843. Turner's fishing boat, 'Sol de Venezia', sets out at dawn, as yet heedless, as he described in accompanying verses, of 'the demon that in grim repose/Expects his evening prey'. In Turner's fatalistic, Romantic view, Venice offered a melancholy example of historical inevitability. But he also showed it subject to the more benign transformations wrought by weather and light. In his view of the Giudecca, one of many late watercolours of the city in the collection, it melts into mist, its buildings hardly more substantial than their reflections in the Lagoon.

110 VENICE: THE GIUDECCA FROM THE LAGOON 1840
Watercolour
22.1 x 32.2 (8 ¾ x 12 ¾)
Turner Bequest; CCCXV 12: D32128

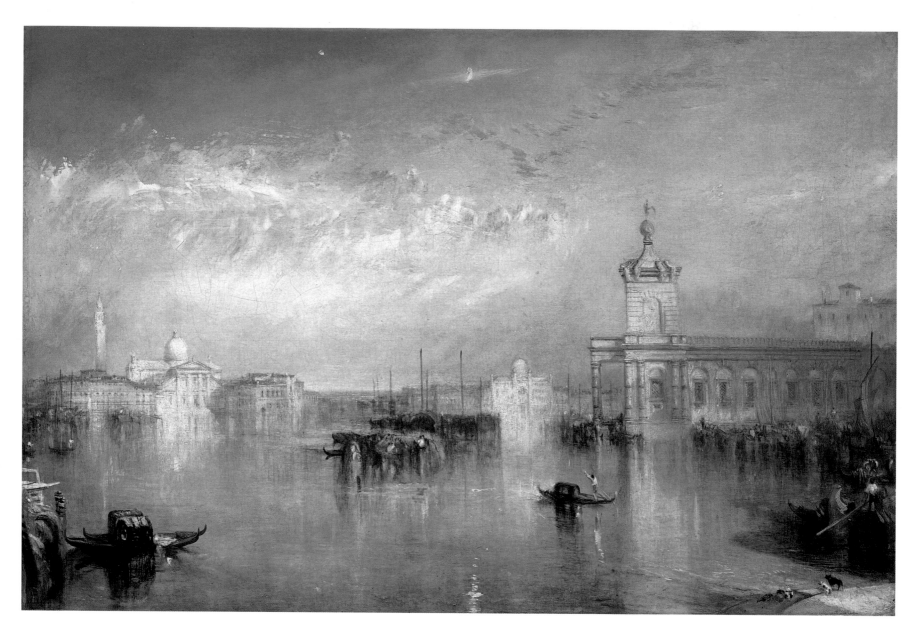

111 THE DOGANO, SAN GIORGIO, CITELLA,
FROM THE STEPS OF THE EUROPA 1842
Oil on canvas
62 x 92.5 (24 ¼ x 36 ½)
Presented by Robert Vernon; N00372: B & J 396

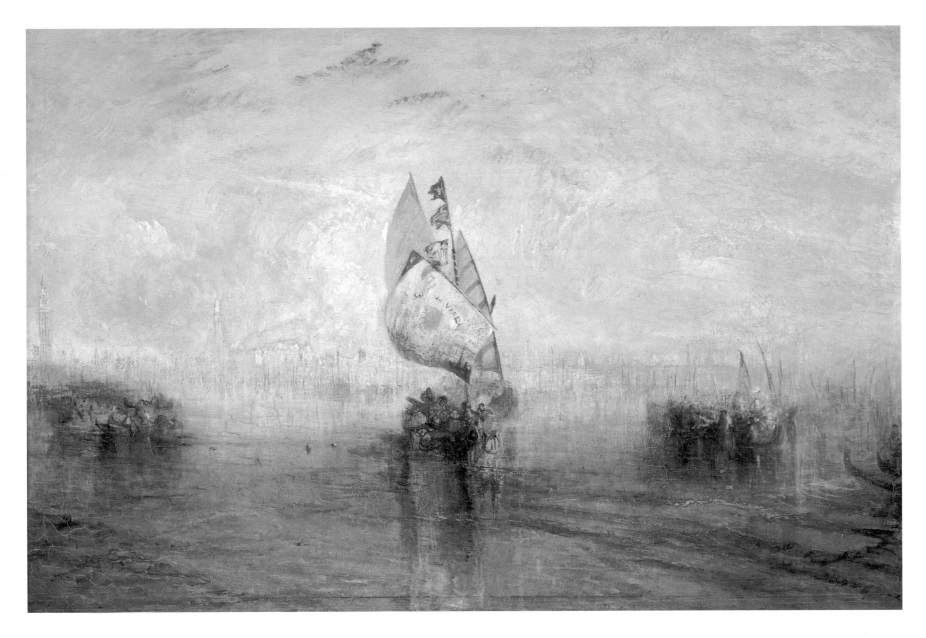

112 THE SUN OF VENICE GOING TO SEA 1843
Oil on canvas
61.5 x 92 (24 ¼ x 36 ¼)
Turner Bequest; N00535: B & J 402

In the early 1840s Turner took regular summer holidays in Switzerland, staying by the lakes, where he could watch the changes of light and weather over the mountains and water. As always, he took a variety of sketchbooks with him, some loose-bound that could be kept rolled up in his pockets and taken out as the occasion demanded. These were sometimes filled with watercolour studies, but he also used smaller books for small pencil memoranda in the abbreviated style he had developed for notations on the spot. Often these occur several to a page, with the book turned in different directions so as to fill all the available space. His rapid sketches of Swiss towns, probably including Baden, were made in a sketchbook used in 1842; the date can be established from the inscription 'July 5' on one page, for it was only in that year that he was abroad that day. The blank drawing pages were bound together with an almanack for that year, giving such information as 'Places of Amusement open to the Public gratuitously'.

From material gathered in 1842, Turner made a set of 'sample studies' in watercolour, to attract commissions for finished watercolours. That of the Lake of Zug is inscribed with the name of his patron Munro of Novar, for whom he made a finished version of the subject the following year (New York, Metropolitan Museum). Ruskin, who described the sample version as 'Elaborate and lovely', was himself the client for Turner's finished version of Tate's *Pass of Faido*, also made in 1843. He recorded that Turner 'showed me this blotted sketch when he came home. I asked him to make me a drawing of it, which he did, and casually told me afterwards (a rare thing for him to do), that he liked the drawing he had made.' Ruskin also preserved Turner's graphic description of the scene as 'that litter of stones I tried to represent'. He himself considered the finished version as 'the greatest work he (Turner) produced in the last period of his art', wrote of it at length in his book *Modern Painters* as the epitome of the artist's genius for geological truth, and kept a chunk of gneiss rock from the spot depicted to prove it to his visitors at Brantwood.[23]

113 From the *Lake of Zug and Goldau* sketchbook 1842
SWISS TOWNS
Pencil
17.3 x 7.3 (6 ⁵/₈ x 2 ⁷/₈)
Turner Bequest; CCCXXXI 20v, 21: D33445, 33446

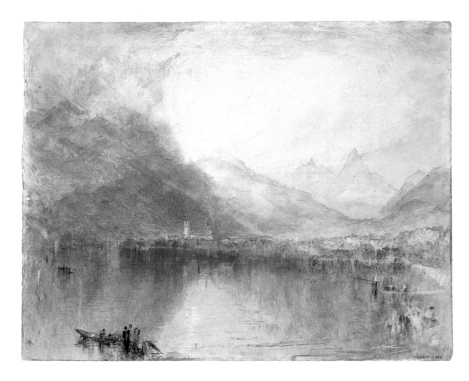 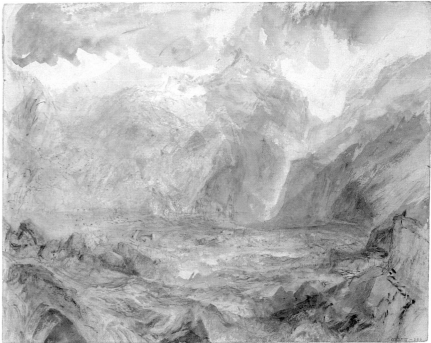

114 SAMPLE STUDY FOR 'LAKE OF ZUG:
EARLY MORNING' 1842
Pencil, watercolour, and pen and ink with scratching-out
22.8 x 29 (9 x 11 ½)
Turner Bequest; CCCLXIV 280: D36129

115 SAMPLE STUDY FOR 'THE PASS OF FAIDO' 1842
Pencil, watercolour and pen and ink
22.9 x 29 (9 x 11 ½)
Turner Bequest; CCCLXIV 209: D36055

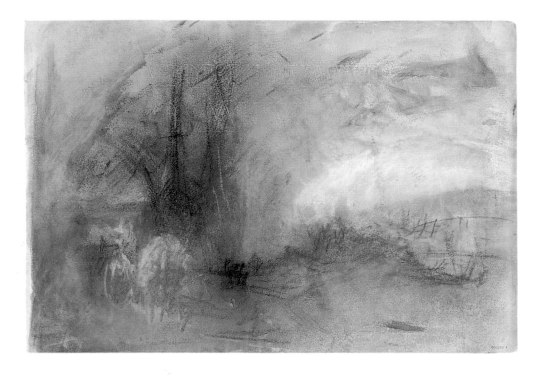

116 WHALERS (BOILING BLUBBER) *c.*1845
Coloured chalks on paper prepared with a grey wash
22.1 x 33 (8 ¾ x 13)
Turner Bequest; CCCLIII 6: D35245

Among Turner's later marine pictures in the collection, three depicting incidents in the whaling industry form a distinctive group. One, *Whalers*, was shown at the Royal Academy in 1845, together with another canvas of the same title which found a buyer (New York, Metropolitan Museum), while *Whalers (boiling Blubber) entangled in Flaw Ice* appeared in the exhibition the following year with the dramatically titled *Hurrah! For the Whaler Erebus! Another Fish!* The first two pictures had probably been commissioned by Turner's patron Elhanan Bicknell – the owner of his *Campo Santo – Venice* – an entrepreneur who had become rich through the Southern Sperm Whale fishery. Bicknell seems at best only to have taken possession of one of them very briefly, before returning it to Turner. However, this did not prevent Turner from returning to the theme the following year, perhaps again with the same patron in mind, and, taken together, the pictures present a sequence of events beginning with the pursuit and sighting of a whale and ending, in the picture illustrated, with the boiling of the whale's blubber aboard the whaling ship to produce oil. At the same time, the pictures tell a concurrent story of the struggles of the sailors themelves, from the first approach of bad weather to the onset of an ice storm that traps their ship; in this last scene they are shown struggling to free her from the ice while their shipmates carry on with the industrial task at hand. Turner took most of his information from Thomas Beale's book, *Natural History of the Sperm Whale … A sketch of a South-Sea Whaling Voyage* (1839), and acknowledged it in his captions for the 1845 pictures. All four proved controversial when first exhibited. In fact, they are evidence of Turner's remarkable grasp of fresh and unfamiliar material, and his ability to adapt pictorial traditions – in this case marine painting – to contemporary and topical concerns. Moreover, while they represent his late style as an oil painter at its most sparkling and diffuse, the subjects seeming almost to grow organically from the movements of the medium itself, the care with which he actually prepared the composition of the blubber-boiling scene is evident from his drawing, originally in his *Whalers* sketchbook.

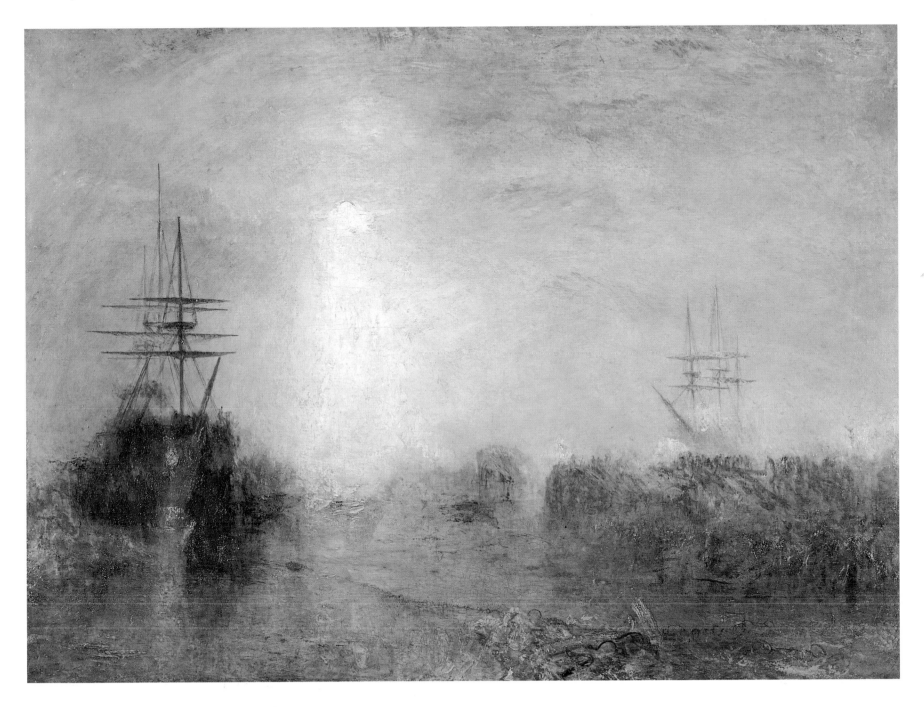

117 WHALERS (BOILING BLUBBER) ENTANGLED IN FLAW ICE,
ENDEAVOURING TO EXTRICATE THEMSELVES 1846
Oil on canvas
90 x 120 (35 3/8 x 47 1/4)
Turner Bequest; N00547: B & J 426

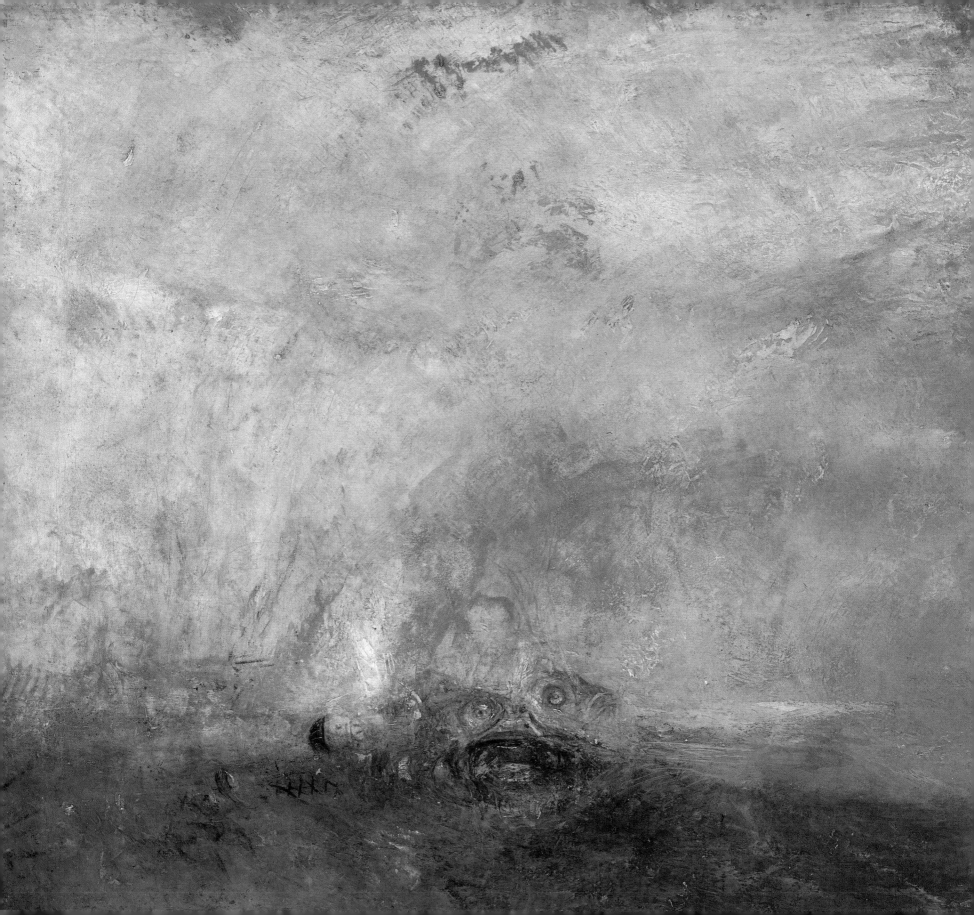

Probably about the same time as he was painting his whaling pictures, Turner indulged in some more fantastic imaginings of creatures of the sea, and his *Whalers* sketchbook also once contained his drawing of a composition similar to his oil of sea monsters at sunrise. Here, he transforms the realities of his long experience as a fisherman, his walks along the shore at Margate and his recent reading of whaling literature into a private fantasy, much as he had once transformed the scenery of the upper Thames valley into vistas of ancient Rome or Carthage. In other, equally personal watercolours and oils, he sought to reduce his vision of coast and sea to the barest minimum of subject and materials. His sketch of figures on a beach is one of fourteen little oils on millboard in Tate's collection, all of which show similar viewpoints, looking out to sea, and motifs of shining sands, breakwaters, beachcombers or distant ships. Their spontaneous, rudimentary technique, in which forms are suggested by the merest dabs of solid colour over pale grounds, is close to that of numerous watercolours in the collection on similar themes. Many of these can be associated with Turner's last visits to Margate, but few can be precisely dated. There are, however, close parallels with drawings known to have been made in 1845, when he made spring and autumn visits to Margate, and across the Channel to Boulogne, Dieppe and Picardy. His health broke down that year, and these were his last trips abroad.

118 SUNRISE WITH SEA MONSTERS *c.*1845
Oil on canvas
91.5 x 122 (37 x 48)
Turner Bequest; N01990: B & J 473

CCCLXV — 21

119 BLUE SEA AND DISTANT SHIP c. 1843–5
Watercolour
28.3 x 44.4 (11 ½ x 17 ¼)
Turner Bequest; CCCLXV 21: D36311

120 TWO FIGURES ON A BEACH WITH BOAT c.1840–5
Oil on millboard
24.5 x 34.5 (9 ⅝ x 13 ⅝)
Turner Bequest; D36681

Undine and *The Angel* form another remarkable pair of pictures in Tate's collection. These too proved mystifying when shown at the Royal Academy in 1846. The first is a typically Turnerian – that is thoroughly unsystematic and eccentric – mixture of myth and history. The story of Undine, which Turner probably knew mainly from recent adaptations on the London stage, had been written by the German Romantic, Friedrich de la Motte Fouque. A sea-sprite, she was born without a soul, but is able to gain one by marriage to a human – in return for which, however, she takes on all the burdens of the world. In Jules Perrot's ballet *Ondine*, which had been staged in London in 1838, she entices a revolutionary fisherman, Matteo, into her watery realm. Instead, Turner has chosen to marry her to Masaniello, a real historical character who led a fisherman's rebellion in seventeenth-century Naples. In his picture, their union of the elemental and material becomes a comment on his own art, and his approaching death. As a keen fisherman himself, and an artist who increasingly had to defy criticism of his work, he probably identified with Masaniello, while his hero's wedding to the sprite whose apparation shimmers before him was surely a metaphor for his own pictorial embrace of the elements of water, air and light. *The Angel* presents a brilliant contrast to its companion's intense blues and whites. The Archangel Michael appears at the Day of Judgement with his flaming sword, while in the foreground Adam and Eve lament over the body of Abel and Judith stands over the decapitated Holofernes. Here Turner associates love and death, this time with the implication that at the end his own art as well as human life will be judged. Again there may be an implied rebuke to modern critics, for with the work Turner quoted both the Book of Revelation and a couplet from his poet-friend Samuel Rogers describing 'the feast of vultures when the day is done'.

121 UNDINE GIVING THE RING TO MASSANIELLO,
FISHERMAN OF NAPLES 1846
Oil on canvas
79 x 79 (31 ⅛ x 31 ⅛)
Turner Bequest; N00549: B & J 424

122 THE ANGEL STANDING IN THE SUN 1846
Oil on canvas
78.5 x 78.5 (31 x 31)
Turner Bequest; N00550: B & J 425

In many of his late works, both those he kept to himself and those he exhibited, Turner was evidently concerned with summing up his art and experience. Some time in the 1840s, probably towards the middle of the decade, he made nine paintings based on compositions from his earlier *Liber Studiorum* (no.47). *Norham Castle* is one of three in Tate's collection, the others having been dispersed in Turner's lifetime or shortly after his death. Although not exhibited by the artist, the picture has become an icon of his late style. The *Liber* variations were painted on Turner's standard 3 x 4 feet exhibition canvas, and it is possible that they were 'lay-ins', intended for completion later, perhaps at the Royal Academy Varnishing Day; on the other hand, Turner may have regarded them as complete in themselves, and wanted to test the market for a new style. While not based on a *Liber* composition, Tate's sunrise over a lake is closely related in size, subject and technique. Here, Turner may have drawn on his views of Swiss lakes, and it is significant that his treatment of these luminous canvases seems to owe so much to his mature handling of watercolour. In revising the *Liber*, Turner chose images that he had originally classed as 'Pastoral' – idealised, structured compositions in the classical tradition of Claude that could now be submitted to the transforming power of light. In both these dawn scenes, the sun is transcendent. In *The Visit to the Tomb*, it is seen setting. This was one of four pictures, of which three are in Tate's collection, shown as Turner's last exhibits at the Academy in 1850. These too were modelled on Claude, and retold Turner's favourite classical story of Dido and Aeneas. In this one, Dido is probably taking Aeneas to see the tomb of her husband Sychaeus, in the futile hope of moderating her new passion; Turner's epigraph for the picture read, 'The sun went down in wrath at such deceit.'

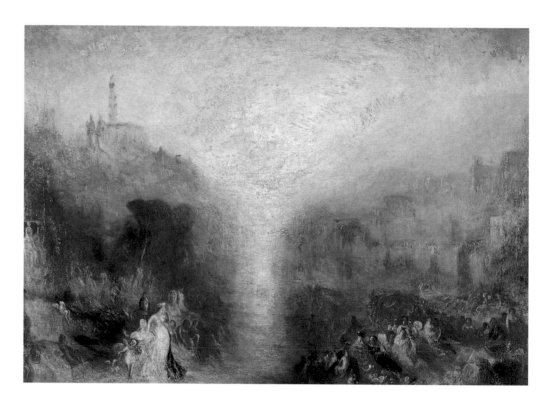

123 THE VISIT TO THE TOMB 1850
Oil on canvas
91.5 x 122 (36 x 48)
Turner Bequest; N00555: B & J 431

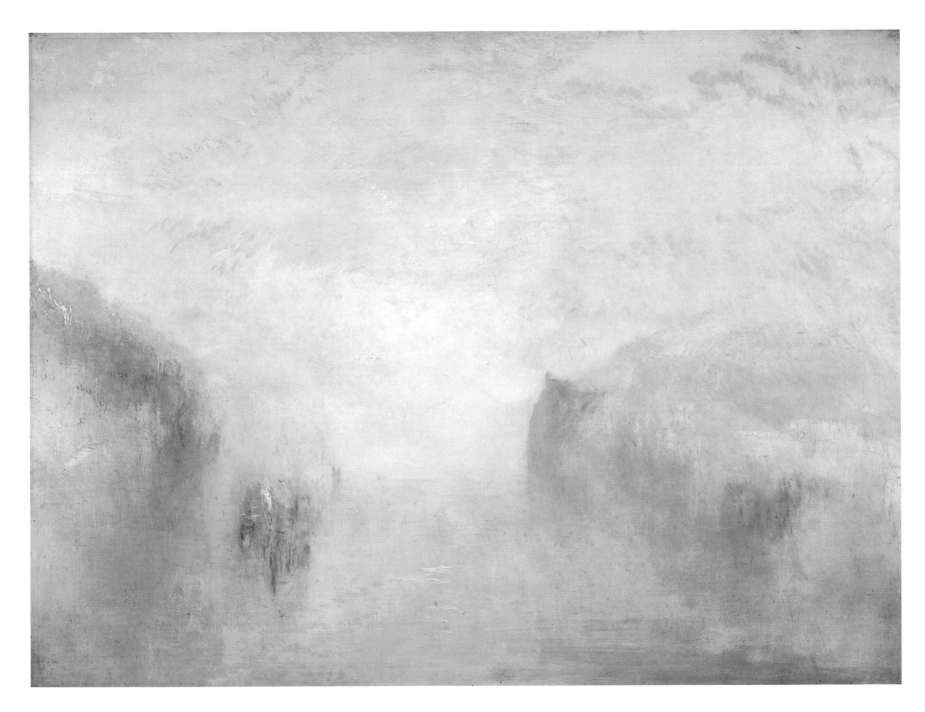

124 SUNRISE, WITH A BOAT BETWEEN HEADLANDS
*c.*1840–50
Oil on canvas
91.5 x 122 (36 x 48)
Turner Bequest; N02002: B & J 516

125 NORHAM CASTLE, SUNRISE *c.*1845–50
Oil on canvas
91 x 122 (35 ¾ x 48)
Turner Bequest; N01981: B & J 512

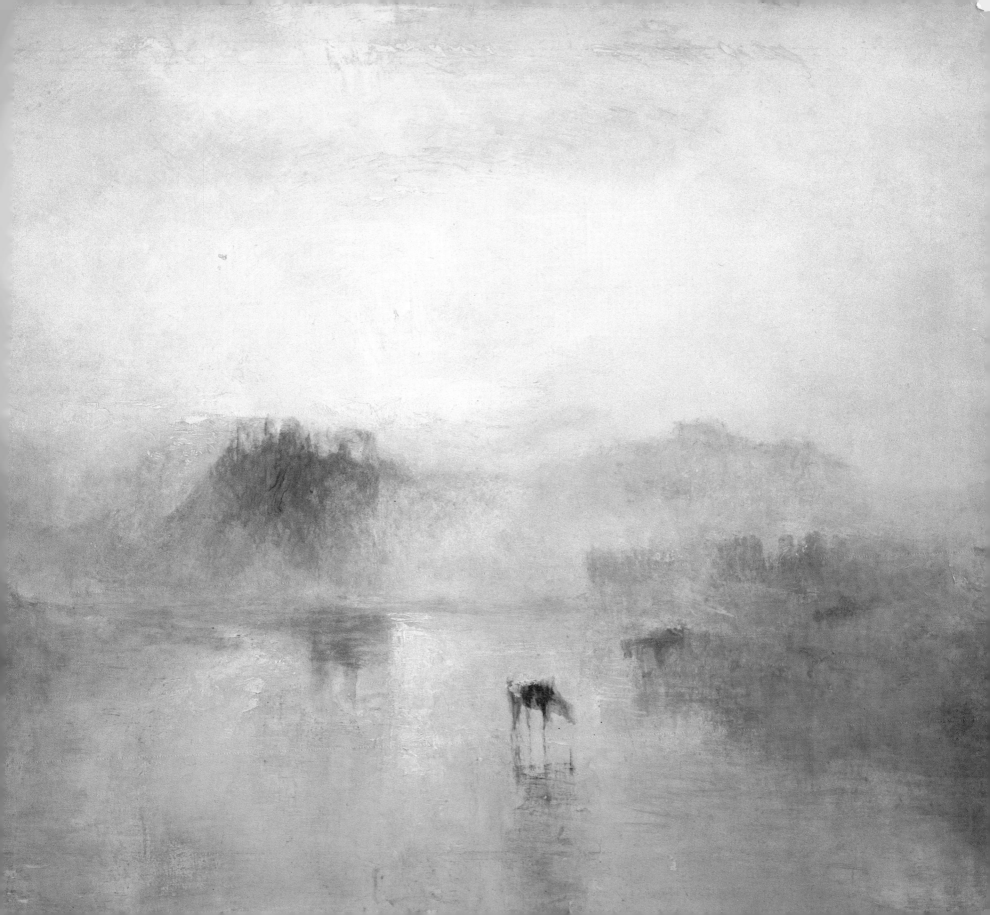

Notes

1 Ruskin, *Diary*, 22 June 1840, in *The Works of John Ruskin*, ed. E.T. Cook and A. Wedderburn, XXXV, London 1903–12, p.305

2 J. Farington, *Diary*, 8 May 1799, in K. Garlick et al. (eds.), New Haven and London, 1978–84

3 Turner to George Jones, 13 October 1828, in J. Gage (ed.), *Collected Correspondence of J.M.W. Turner*, Oxford and London 1980, p.141

4 Lawrence to Joseph Severn in C. Powell, *Turner in the South. Rome, Naples, Florence*, London 1987, p.19

5 Koch, *Moderne Kunstchronik* (published 1834), in J. Gage, *Colour in Turner. Poetry and Truth*, 1969, pp.104–5

6 Quoted by A. Wilton, *Turner in his Time*, London 1987, p.244

7 Johann Dominicus Fiorillo in A. Haus, *J.M.W. Turner: Gemälde, Aquarelle*, exh. cat. Berlin, Nationalgalerie, 1972, p.95

8 Délécluze, 'Salon 1824', *Journal des Débats*, Paris, 30 November 1824, p.2

9 Constable, 28 June 1813, in R.B. Beckett, ed., *John Constable's Correspondence*, Ipswich 1962–8, II, p.110

10 *Art Union*, London, 15 May 1841

11 Leitch in Gage, *Colour…*, p.32

12 Ruskin, *Works, op. cit.*, XIII, pp.478–80

13 W. Thornbury, *Life and Correspondence of J.M.W. Turner*, London 1877, p.15

14 Whitaker, 8 February 1800, in L. Herrmann, *Turner Prints: The Engraved Work of J.M.W. Turner*, Oxford 1990, p.21

15 Farington, *Diary*, 6 February 1802

16 J. Landseer, *Review of Publications of Art*, 1808, in M. Butlin and E. Joll, *The Paintings of J.M.W. Turner*, New Haven and London 1984, p.18

17 See C. Powell, 'Turner's Travelling Companion of 1802: A Mystery resolved?', *Turner Society News*, 54, London, February 1990, pp.12–15 and D. Hill, *Turner in the Alps. A Journey through France and Switzerland in 1802*, London 1992

18 Trimmer in Thornbury, *op.cit.*, pp.120–1

19 A. Cunningham, *Life of Wilkie*, London 1843, pp.143–4

20 Eastlake in C. Powell, *Turner in the South …*, p.141

21 *Ibid.*, p.141

22 Ruskin, *Works*, XIII, p.162

23 *Ibid.*, VI, p.37, V, p.122

Further Reading

The Turner literature is vast. Only a small selection of general books is listed here, in addition to those already cited in footnotes. Each of these has a full bibliography in which more specialised material may be found.

A. Bailey, *Standing in the Sun: A Life of J.M.W. Turner*, Liverpool 1997

A.J. Finberg, *The National Gallery: A Complete Inventory of the Drawings of the Turner Bequest*, 2 vols., London 1909

J. Gage, *J.M.W. Turner. 'A Wonderful Range of Mind'*, New Haven and London 1987

J. Hamilton, *Turner. A Life*, London 1997

E. Joll, M. Butlin and L. Herrmann, *The Oxford Companion to J.M.W. Turner*, Oxford 2001

A. Wilton, *The Life and Work of J.M.W. Turner*, London 1979

Index